THE
ORION
PROPHECY

The **New Science Series**:
- THE TIME TRAVEL HANDBOOK
- THE FREE ENERGY DEVICE HANDBOOK
- THE FANTASTIC INVENTIONS OF NIKOLA TESLA
- THE ANTI-GRAVITY HANDBOOK
- ANTI-GRAVITY & THE WORLD GRID
- ANTI-GRAVITY & THE UNIFIED FIELD
- ETHER TECHNOLOGY
- THE ENERGY GRID
- THE BRIDGE TO INFINITY
- THE HARMONIC CONQUEST OF SPACE
- VIMANA AIRCRAFT OF ANCIENT INDIA & ATLANTIS
- UFOS & ANTI-GRAVITY: Piece For a Jig-Saw
- THE COSMIC MATRIX: Piece For a Jig-Saw, Part II
- THE A.T. FACTOR: Piece For a Jig-Saw, Part III
- THE TESLA PAPERS

The **Mystic Traveller Series:**
- IN SECRET TIBET by Theodore Illion (1937)
- DARKNESS OVER TIBET by Theodore Illion (1938)
- IN SECRET MONGOLIA by Henning Haslund (1934)
- MEN AND GODS IN MONGOLIA by Henning Haslund (1935)
- MYSTERY CITIES OF THE MAYA by Thomas Gann (1925)
- THE MYSTERY OF EASTER ISLAND by Katherine Routledge (1919)
- SECRET CITIES OF OLD SOUTH AMERICA by Harold Wilkins (1952)

The **Lost Cities Series**:
- LOST CITIES OF ATLANTIS, ANCIENT EUROPE
 & THE MEDITERRANEAN
- LOST CITIES OF NORTH & CENTRAL AMERICA
- LOST CITIES & ANCIENT MYSTERIES OF SOUTH AMERICA
- LOST CITIES OF ANCIENT LEMURIA & THE PACIFIC
- LOST CITIES & ANCIENT MYSTERIES OF AFRICA & ARABIA
- LOST CITIES OF CHINA, CENTRAL ASIA & INDIA

The **Atlantis Reprint Series:**
- THE HISTORY OF ATLANTIS by Lewis Spence (1926)
- ATLANTIS IN SPAIN by Elena Whishaw (1929)
- RIDDLE OF THE PACIFIC by John MacMillan Brown (1924)
- THE SHADOW OF ATLANTIS by Col. A. Braghine (1940)
- ATLANTIS MOTHER OF EMPIRES by R. Stacy-Judd (1939)
- SECRET CITIES OF OLD SOUTH AMERICA by H.T. Wilkins (1952)

THE
ORION
PROPHECY

by
Patrick Geryl
and Gino Ratinckx

Adventures Unlimited Press
Kempton, Illinois
Enkhuizen, Netherlands

The Orion Prophecy

First Printing

November 2001

ISBN 0-932813-91-7

Published by
Adventures Unlimited Press
One Adventure Place
Kempton, Illinois 60946 USA
auphq@frontiernet.net

www.adventuresunlimitedpress.com
www.adventuresunlimited.nl
www.adventuresunlimited.co.nz
www.wexclub.com/aup

10 9 8 7 6 5 4

THE
ORION
PROPHECY

CONTENTS

PART IV THE CATASTROPHE

PART V MATHEMATICAL PROOF

 • An Important Part of the Sunspot Cycle
 • The Period of the Magnetic Fields of the Sun
 Calculated out of the Sunspot Cycles of the Maya
 • The Dresden Codex Decoded
 • Our Time Calculation and the Foundation of Atlantis
 • The Similarities Between the Egyptians and the Maya
 • Connection Between the Venus Cycle and the
 Egyptian Series of Numbers
 • Mayan Sunspot Cycle Calculated from the Egyptian
 Zodiac
 • Measurements with the GPS II in Egypt
 • More Secret Codes of the Zodiac of Atlantis

APPENDIX
• Calculations from Chapter 6
• Calculations from Chapter 14
• Calculations from Chapter 16

INTRODUCTION

I am writing this book out of sheer anger, despair and misery. My life's dream was destroyed by a series of discoveries. These all point to an imminent world catastrophe, the largest ever for humanity. Never before was the earth so densely populated, therefore this will be a disaster without equal. I was broken and deeply shocked when I realized this. I couldn't sleep for nights in a row. It began to rule and dominate my life. After all, I had my life neatly planned up to now. For years I have been living on a hunger diet based on fruits and vegetables. This was going to lead me to the grand age of 120. I had invested in several pension funds so I could retire rich. I could then enjoy something like 60 years of my life! And all that in good health. Those who have read my previous books know what I'm talking about. Tests on animals have shown clearly that this is indeed possible; their lifespan increases by something like 30 to 100 percent when they are fed on a hunger diet. I could not possibly ignore this fact and so I decided to do the same. The prospect of retiring rich and traveling far and wide greatly appealed to me. Then, however, my dream fell to pieces. According to the book *The Mayan Prophecies* the earth will be destroyed on 21-22 December, 2012. The conclusions in that book seemed correct to me although the author only revealed a tiny part. According to the Maya, the sun's magnetism would turn around on that day, which would cause the earth to topple over with fatal consequences for mankind. I was deeply shocked. An enormous disaster was awaiting us, one without equal. I was paralyzed. Then I cursed and swore wholeheartedly. After all, I could only collect my pensions in 2015! Twenty years ago I signed this clause of not cashing in before the due date. That would enlarge the amount payable and I would be able to live a life of luxury for decades. I was completely convinced that I had made a golden deal. But that was before I read that particular book.

That's when my certainties in life as well as my dreams collapsed. I decided to investigate. If this disaster is truly going to happen, then I had to substantiate it with hard evidence. It concerns the survival of mankind.

Naturally, I went to investigate and succeeded in unveiling this imminent global disaster. Prepare yourself to read the most shocking findings of our modern civilization. The natural disaster which will strike us will exceed everyone's comprehension. Your pensions will be worthless — so I canceled mine. No single government will take measures to try to survive it. Nobody will believe it — until it is too late. That's why you will have to take control yourself and design your own survival strategy. I will act as a databank. Survival after such an immense disaster shall be extremely hard if nothing has been prepared. Food supplies will be destroyed, medical care non-existent, rescue workers themselves will have perished. In short, without careful planning we won't make it. Therefore we must urgently form groups to start working on this enormous task. "Noah's Arks" will have to be built to get us through the tidal wave. Food and energy supplies will have to be built up. An endless number of things have to be done, and we only have a few years left before the fatal date. I hope that many volunteers will come forward to put into practice the survival strategy outlined in this book.

PART I

ASTONISHING
DISCOVERIES

1.
THE ZODIAC OF DENDERA

After having read *The Mayan Prophecies*, I stumbled upon some other works in this genre. According to the authors of the book *When the Sky Fell*, Atlantis was shifted to the South Pole due to an enormous shift in the earth's crust some twelve thousand years ago. It was based on another book, *The Path of the Pole*, by Professor Charles Hapgood. In a foreword for the First Edition of *The Path of the Pole*, Albert Einstein writes:

> I frequently receive communications from people who wish to consult me concerning their unpublished ideas. It goes without saying that these ideas are very seldom possessed of scientific validity. The very first communication, however, that I received from Mr. Hapgood electrified me. His idea is original, of great simplicity, and—if it continues to prove itself—of great importance to everything that is related to the history of the earth's surface.
>
> A great many empirical data indicate that at each point on the earth's surface that has been carefully studied, many climate changes have taken place, apparently quite suddenly. This, according to Hapgood, is explicable if the virtually rigid outer crust of the earth undergoes, from time to time, extensive displacement over the viscous, plastic, possibly fluid inner layers. Such displacements may take place at the consequence of comparatively slight forces exerted on the crust, derived from the earth's momentum of rotation, which in turn will tend to alter the axis of rotation of the earth's crust.
>
> The author has not confined himself to a simple presentation of this idea. He has also set forth, cautiously and comprehensively, the extraordinary rich material that supports his displacement theory. I think that this rather astonish-

ing, even fascinating, idea deserves the serious attention of anyone who concerns himself with the theory of the earth's development.

In later editions Professor Charles Hapgood writes:

Advancing knowledge of conditions of the Earth's crust now suggests that the forces responsible for shifts of the crust lie at some depth within the earth rather than on its surface.

Despite this change in the character of the proposed explanation of the movements, the evidence for the shifts themselves has been multiplied many fold in the past decade. The main themes of the book—the occurrence of the crust displacements even very recently in geological history, and their effects in forming the features of the earth's surface—therefore remain unchanged.

When a crust slide happens, some continents move toward the poles and others away from the poles. A giant tidal wave crosses the whole earth. Survivors couldn't do anything but flee from their doomed land the day Atlantis moved under the South Pole. And that these things indeed happened will be clearly proven in this book. Immediately after the event, agriculture sprang up in different locations in the world. This clearly linked the perishing of one world and the founding of new cultures on faraway continents. Thus the Atlanteans stood not only at the origin of the Mayan culture, but at the Indian, Chinese and Egyptian as well. Almost everybody is familiar with the legend of Atlantis, the land that vanished in terrible earthquakes of unknown intensity. The Greek philosopher Plato recorded this in ancient Egypt. If all this is true, then there has to be a connection between the Mayan and the Egyptian prophecies.

I struggled through several works on the Egyptian culture and became more and more impressed with their grand achievements.

A kaleidoscope of temples, pyramids, works of art, sphinxes,

etc. passed my eye. But I didn't find the connection. This was frustrating. I told several friends about my unsuccessful attempts, until one friend asked me: "Have you read *Serpent in the Sky* yet?"

"No, who wrote it?"

"John Anthony West. He was on television the other day with a documentary on the sphinx. They showed evidence of the sphinx being thousands of years older than has always been thought, and that the secret knowledge of Atlantis might be hidden right under the sphinx."

"There it is!" I thought. If the Atlanteans had important data with them, then these had to become interwoven into the Egyptian world. I started to read the book. It struck me that I had greatly underestimated the intelligence of the Egyptians. Their mathematics were on an extremely high level; you can find examples of this in the book. I was really astonished. I also learned that no one has succeeded yet in translating an important part of the hieroglyphs. "Damn," I was thinking, "if I have to start here, this will be an impossible task." I read almost ninety percent of the book. I learned an awful lot, but didn't get any closer. Then I began the chapter "Egypt: Heir of Atlantis." In that chapter West started to investigate the age of the sphinx, after a suggestion of the French philosopher R.A. Schwaller de Lubicz, who said that the patterns of erosion on the sphinx point to it being much older than had always been assumed. He would make it his life's task to prove this. Indeed this would prove that the Egyptian civilization is thousands of years older than what is generally believed, and that it arose from Atlantis! I was near the end of the book but still didn't find anything useful for my quest. I was ready to quit, until, when glancing at the last page but one, my attention was drawn. There I saw pictures and drawings of the Zodiac of Dendera. It looked radiant and mysterious at the same time. I had never been a believer of the predictions of the zodiac. Its existence almost made me laugh. But then, in one split second, my way of reasoning and my life as well were changed thoroughly. More and more perplexed, I looked at the ancient print. It was a sublime work of art, a unique thing in archaeological science. Even more, it was magic,

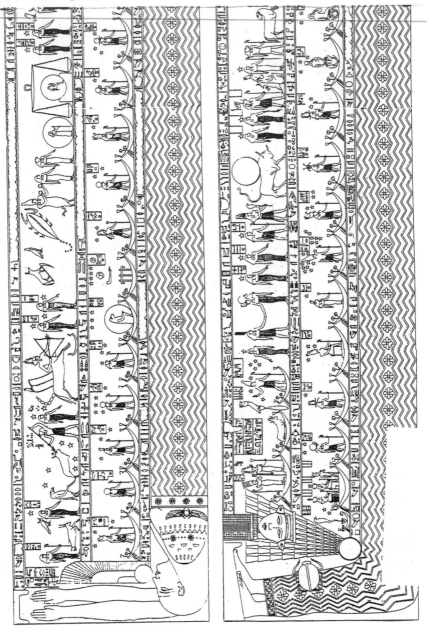

Figures 1 & 2.
The right-angled Zodiac of Dendera, one of the most enigmatic creations of
the Old Egyptians.

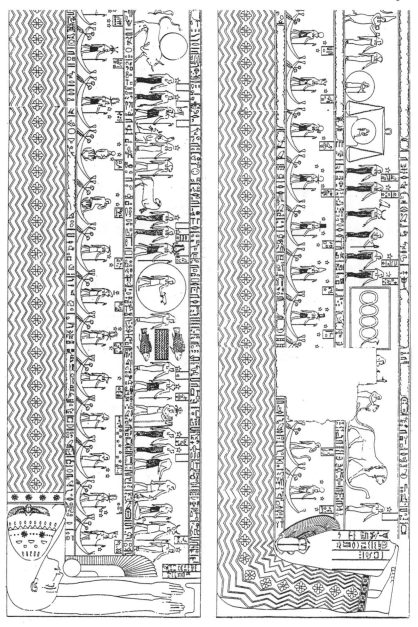

inspiring, enchanting. I knew Cotterell found many more codes in the tombstone of Palenque than one would imagine at first sight. I had the feeling that here, too, this would be the case. But how to crack the code? The hieroglyphs were far beyond my comprehension, and the drawings—this much was clear—contained an awfully difficult code.

An Enigmatic Secret from the Past

This piece of work wasn't made to be laughed at and then put aside. Many people believe in the predictions of the zodiac. Let us assume it is based on reality. Let us also accept that the makers of the zodiac wished to share a certain wisdom. For instance, the day of the end of Atlantis and the day of the next cataclysm. That must be it! It can't be anything else but this!

The zodiac predicted the exact date of the next end of the earth! It was my intuition which brought me to this conclusion. Later on it became clear that my intuition was right! I felt I would gladly give a part of my life to solve these riddles. Of course, I wouldn't be able to do this on my own. I urgently needed help from an Egyptologist. This was the only way to reveal the ancient mysteries.

But whom should I enlist? I made a few contacts but they weren't interested. But then luck took a turn in my favor. A journalist from the Belgian newspaper *Het Belang Van Limburg* saw an article about me in the largest Dutch newspaper, The Telegraph. In this article I explained living on a hunger diet of fruit and vegetables in order to become as old as possible. Up till then I was the only one in Belgium and The Netherlands trying this; in the USA there were easily a hundred volunteers, but here the interest was low. The journalist decided she wanted to meet me and write an article. She even wrote it the same day, because the following day she was leaving on a trip. The article was to appear two or three days later. Of course, every following day I bought the newspaper she worked for. Then the largest pedophile scandal in Belgian history broke out. It was all over the papers, and my article was set aside for a while. Nevertheless, I bought her paper on

Saturday, August 17, 1996. Coincidentally, I looked through an article on astronomy wherein they spoke of the astronomer Gino Ratinckx, who was specifically interested in archaeo-astronomy. More precisely, he was looking for a similarity between certain star constellations and the location of ancient temples: the Giza pyramids for instance are placed according to the constellation of Orion. He was intensely interested in this. The article mentioned his address and phone number; he lived just outside of Antwerp, very close to me. I cut out his article and put it aside because, before contacting him, I wanted to read the book *Keeper of Genesis* in which Bauval and Hancock brilliantly prove where the Atlanteans buried their secret knowledge. After having read it, I called Gino Ratinckx; this phone call would change my life forever.

"Mr. Ratinckx, this is Patrick Geryl speaking. I read an article on you and I would like to meet you."

"What would you like to talk about?"

"In the book *The Mayan Prophecies* it is described how the author cracked the code of the Maya. I have a book containing the zodiac of Dendera. I am convinced that it holds codes in a similar way. Can you help me crack them?"

"Oh, but that won't be a problem. I made a study of the temple of Dendera for my examination in archaeology."

Hearing this, my heart was filled with joy and I asked: "Is it possible to meet you to discuss this?"

"This Wednesday night suits me."

It was Monday evening, and in two days I would possibly have a real breakthrough in my research. I asked him, "Is eight o'clock all right with you?"

"Come to my place. And oh, you can call me Gino."

The First Meeting

Wednesday night, ten to eight. Nervously I rang the doorbell. Gino opened the door; he definitely seemed an agreeable man to me. He took me to the first floor. His computer stood on a chaotic desk. Looking around I saw some nice antique furniture, and the

19

walls were covered with his wife's paintings. We sat down at the table and I showed him the pile of books I had read.

"Look," I started, "according to the Maya, the year 2012 will bring a disaster because there will be a shift in the sun's magnetism. And now I've seen this picture and drawings of the zodiac, and for one reason or another, I am convinced there are codes hidden in it."

"Well, you're in the right place. I participated in the research on the meaning of some Mayan codes."

Well, I thought, this couldn't be better! So I continued: "Do you have any idea how we can handle this?"

"Ideas are not the problem for me, but I have a problem writing them down. A fluently written book is something I can't produce."

I smiled—that was just the thing for me. I had already written six books; in one of them I proved that the theory of relativity was incorrect. Up till now I hadn't mentioned this. With Gino being an astronomer, he might easily have been scared off by hearing about me disagreeing with Einstein. But he seemed friendly enough and so I tried anyway: "You can leave the writing to me. I have written several books already, including one in which I prove that quasars are inconsistent with the theory of relativity!"

This captured Gino's attention; somewhat surprised he asked, "Really? And can you explain that to me?"

"You know that when the speed of an object increases, its mass also increases, according to Einstein's calculations. The closer you get to the speed of light, the larger the increase of mass. Now, imagine there is an incredibly large bulk of mass at the end of the universe. With its gravitational forces it "pulls" at the star systems in the center of the universe. Slowly they start to move in its direction. Over billions of years the mass of the suns belonging to such a system increases. Of course they lose mass through radiation, but through mass increase they gain it! Everybody knows that when the mass of a planet increases, the gravitational force also increases. On the moon, for instance, you can easily jump ten meters, but on Jupiter you can hardly move. Due to this increase

in mass of a star system, the system itself will be subject to a continuous shrinking process. Finally the system will collapse and become a quasar."

Surprised, Gino looked at me and answered, "That's the first time I've heard this theory. It seems logical to me. Can you show me more proof?"

"If the speed of a sun were increased to the speed of light, its mass would increase. All astronomers know that a sun's lifespan depends on the quantity of its mass. The heavier the sun, the faster the aging process. Let's take our sun. It has a life expectancy of ten billion years. A sun with twice this mass only has a life expectancy of 800 million years. This is because the inner gravitational forces increase so much, the nuclear reactions speed up. A sun gaining in speed and therefore in mass, will be burnt sooner and will have a shorter life! I call it the quantum-gravitation paradox!"

Gino reacted with enthusiasm. He asked, "Are there any other consequences?"

"I wrote down the major consequences in my book A New Space-Time Dimension. A rather important consequence is that the galaxy is expanding at an accelerating rate.[1,2] Another one is that ninety percent of the universe contains explosive star systems, which are perishing because of the increase in gravitational force. From a strictly scientific point of view, extraterrestrial life is impossible there. So life has to be limited to the center of the universe. Of course this still includes many star systems, but a whole lot less than what everybody thinks. TV series such as 'Star Trek' and 'Deep Space 9' are thoroughly wrong. Their story is about worlds that couldn't possibly exist!"

"What you are telling me here could be correct. If that were to be published it would generate quite a bit of consternation. But OK, we have something else to do first: crack the Dendera code."

Gino grabbed a book from the shelf: "I think I have precisely what you need. In here we have the decoding of the Egyptian Book of the Dead. Until the time of this book, nobody had succeeded in decoding the holy scriptures. This author, Albert

Slosman, did it. You will be surprised by its contents!"

With awe I took the book in my hands. Immediately I became aware of an intense feeling. This was it! In here I would find the codes of utter importance! That same evening I started to read the book and I found clues for a catastrophe.

[1] Confirmed by astronomers in 1998.

[2] On Friday, 23 November 1990, the Belgian television (BRT) spent 15 minutes broadcasting this theory. At that time Patrick Geryl was the only one in the world who forecasted accurately the accelerating expansion of the universe! In 1983 he also predicted correctly that IRAS would find billions of galaxies in the Infrared! Again, he was the only one who made this statement at that time. This was published in the Belgian newspaper *Het Laatste Nieuws* on February 11, 1983. His correspondence with G. Neugebauer from the California Institute of Technology and Peter Clegg from the Queen Mary College (University of London) confirms this. Both were responsible for the interpretation of the results of IRAS. All these facts prove the validity of his theories.

2.
CLUES FOR A CATASTROPHE

Reading the book *Le livre de l'au-delà de la vie* was not simple at all. I didn't understand French all that well and reading a simple text was hard for me. This was much more difficult. A sequence of uncommon words, mysterious codes, holy scriptures and archaic wordings tempered my enthusiasm. I had to read it seven times to understand it. Luckily, my intuition hadn't left me and it didn't take long before I understood the importance of some of the codes. All the rest was less important for my research. What I had read was enough to turn the world of Egyptology upside-down. Translations of the Egyptian Book of the Dead were disastrous. They were so filled with flagrant errors and misinterpretations, there was nothing left of its original meaning. Only Albert Slosman succeeded in translating the holy scriptures correctly. I could clearly distinguish his shocking conclusions. In the first place, the title of the book was a poor choice. It should be "The Book of Light" instead of "The Book of the Dead." Why this title? Because it describes precisely the heavenly events that took place during the downfall of Atlantis! Furthermore, it describes how the survivors were led by the sun in their flight to Egypt. But most important of all were the events on the sun itself. It is the central theme of the scriptures. Especially the fact that the sun radiated the light of the light, in other words an incredible intense light. And thus the title "The Book of Light." To report the correctness of Albert Slosman's findings, the original hieroglyphs are given below, together with the translation of the first verse:

I am the Highest of All, the First, the Creator of Heaven
and Earth, I am the molder of the human bodies,

𓊪𓃀𓏏𓃀𓈖𓏏𓏏𓊪𓈖𓏏𓏏𓏤𓈖𓊪𓏏

and the supplier of the Spiritual Parts. I have placed the sun upon a new
horizon as a sign of benevolence and as proof of the Alliance.

𓇌𓏤𓈖𓃀𓏏𓃀𓈖𓏏𓏏𓊪𓈖𓏏𓏏𓇌

Explanation: he lifted the rising of the sun to a
new horizon so the new earth became reality.

𓏏𓈖𓂋𓃀𓏏𓈖𓂋𓃀𓈖𓏏𓊪𓈖𓏏𓏏𓇌𓊪

In order to do so, the Commandments of the Creator,
verified by the Highest of All, were, acting via the Souls of
the Ancestors, transmitted to the Youngest Ones,

𓈖𓏏𓀀𓈖𓏏𓏏𓊪𓇳

their bodies brought back to life through the
coming into operation of the Eight Places.

In this correct translation, astronomic codes cast a whole new
light on the origin and the religion of Egypt. If you compare this
translation with the other translations, the differences are really
dramatic. The Egyptologists make nothing out of it but abraca-
dabra.

However, in Slosman's interpretation one can find logical
things, asking for further studying. Furthermore, it appears the
Atlanteans knew and used the zodiac to process astronomical data.

The day of the destruction: "I have put the sun upon a new
horizon." You are reading a correct translation. A little further in
the book it says the sun "turns" in the zodiac (= belt). This means
the sun moves through signs of the zodiac. The only correct inter-
pretation of this is that not the sun, but the earth turned around

its axis! This turning of the axis caused the sun to rise at a new horizon! In other words, the earth's crust had shifted, exactly as I read in other books!

The theory of *The Path of the Pole* maintains that the crust of our planet has undergone repeated displacements. And they happened very fast—a matter of days—or hours. Hapgood explains that the outer shell of the earth shifts from time to time, moving some continents toward the poles. As a result of his studies, Hapgood asserts in a prefatory note in his book *The Path of the Pole*:

> Until a decade ago the idea that the poles had often changed their positions on the earth's surface was regarded as extreme, improbable, and unsound. It was advocated strictly by cranks. Nobody who was anybody in the scientific world would have anything to do with it.
>
> Fashions change. Today every book dealing with the earth sciences devotes space to polar wandering and continental drift.
>
> This book will present evidence that the last shift of the earth's crust (the lithosphere) took place in recent time, at the close of the last ice age.

As you have read earlier, the Egyptians speak in their texts as eyewitnesses of these dramatic events! It took my breath away when I started to realize this. In an intermediate note I found that this event, "the great cataclysm," happened the 27th of July in the year 9792 BC. Here are the glyphs:

I am the Fierce Burning Light

⬛)║⌐⋋╲⁞⦵⌣⚡⦀⫝̸⟍⫠⫐⦙⫐⟍⫤⟍⌐⦙⟍

navigating in the belt and permitting from far in
heaven the judging of the actions of everybody

⌐⦙║⅀⌐⫠)⫠⦙)⟍⫐⦙⟍⟍⦙⟍⫠∩⅃

Explanation: His name is Osiris (Orion). Description: He is the seed
of the contents of all human bodies. Second Description:

⌐⦙⦀⟍⫐∩⫼⫤⅀⫠⟍⦙⟍⦙⟍⦀⦙⦀∩

His name commands from above the Spiritual Parts
in the human bodies. Third Description:

⌐⫝̸⦀⦵⦙⟍⦙⌐⟍⦙⫐⟍⦙⦵⦙⟍⦙⫐⦙⫐⦵⦙⟍⫠⟍⦙⟍

The name of the Glorious One shines
eternally in the Infinity. He grows every day

⌐⦙⫤⦀⟍

at the firmament of stars.

Explanation: the fierce burning sun shows that the magnetic field of the sun has turned. This is accompanied by violent outbursts on the sun's surface, through which the sun seems to be "on fire" (see Figure 3).

The star configuration Orion is singled out as the chief culprit of this event. He judges the human souls and their survival. Later it is mentioned that Orion is directly connected to the code to calculate the shift of the magnetic field of the sun. Thus the Orion

Figure 3.
Ancient texts
describe a
catastrophic
change in the
magnetic field
of the sun.

code of the pyramids of Giza! They were put there to warn us that Orion is of utmost importance to us and needs to be studied meticulously. In the writings of Ibrahim Ben Ebn Wasuff Shah, we read: "The Giza Complex was built to memorialize a tremendous cataclysm in the Earth's planetary system which affected the globe with fire and flood."

I called Gino and explained it to him. "Gino, this is Patrick. I have a problem. According to the holy scriptures, Orion would match with certain codes on the day of the cataclysm. Could you find this?"

"Now, that's a problem indeed. I can only partly reconstruct the position of the stars and planets in the future, as well as in the past. Do you have any idea which codes we are looking for?"

"Not really. I can't get them decoded properly. I've been rack-

ing my brains about it for days but it's not coming."

"Well, yes, that can be problematic. The possibilities are enormous."

Then something occurred to me: "Wait a minute," I called out, "the codes of the past have to match exactly the codes of 21-22 December of the year 2012! They have to! If the stars and planets during the perishing of Atlantis had a certain position, it points to a similarity with that event. That was their way of describing it!"

Gino immediately agreed with my findings and would go to work in the next couple of days. But then he was away on holiday for more than a week and the work remained unfinished. He called me when he was back: "Alarming news Patrick. The positions of Orion and Aldebaran match both data precisely. I calculated it manually and it occurs three times in twelve thousand years! The other date is 3114 BC. That could be correct because several peoples, amongst them the Maya, start their era from this point."

There it was! I felt like doing somersaults! With this proof it was indisputably demonstrated that the date of the world's destruction in 2012 came from the Atlanteans! Moreover the Egyptians had to know this date also. But that was for later. Nobody could deny this: the date of the destruction of Atlantis was 100% correct. This made Slosman's work incontestable in one blow. The entire Egyptologist world can do anything they want, but Atlantis was a fact! And with it also the oncoming perishing of our world! That I solved this so fast made me speechless. Months later Gino would tell me that his calculations were no real proof. But by then we had deciphered the real codes of the destruction from the holy scriptures of the Egyptians. With this we had the definite proof of the correctness of our theory. Half an hour later I was watching the sky of 2012 with Gino.

"Watch carefully," said Gino. "I programmed the horizon on Cairo. You can see Venus rising right above the pyramids followed by other constellations and Orion."

It left me gasping. "Oh," Gino exclaimed, surprised, "Here is

something I missed before!"

I stared at the computer program and asked, "What do you mean?"

"Venus passes through the signs Serpent and Scorpio. The serpent is an important mythological symbol for both the Maya and the Egyptians. But the scorpion was feared as well."

"They possibly received their names because of the events in Atlantis, or of those coming in 2012," I said.

"That's possible. That way, both the Serpent as well as Scorpio could give a symbolic deadly bite to Venus. It might explain a lot!"

I shivered with excitement, but also with fear. My supposition seemed to be true: the earth would indeed be hit by a gigantic cataclysm. The codes showed this clear enough. Damn! Then it was true after all! Excited by this series of discoveries I went home. That night I couldn't sleep. I thought it all over again. The previous cataclysm happened in the age of Leo (10,960 to 8800 BC).

The sphinx, about which there is so much talk nowadays, did not only have an astrological or mythological meaning but also a practical one. She was made by the survivors of Atlantis to warn us about what had happened! But that is only a part of the story. This sphinx, together with other codes of the pyramids, have to provide us with an indication of the time of the next cataclysm! That is what the whole Egyptian "religion" is about! It is a gigantic archaeo-astronomic monument telling us exactly what happened and what will happen again! They couldn't have made it any grander! And still we ignored it for so long. Now that it is almost too late the codes start to radiate their warning signs. If the world is not be informed, mankind will be reduced for thousands of years to a primitive state again! This was my task. Pulling the alarm! It made no sense to wait any longer. I decided to start a book immediately to try to get the primary conclusions published. Nobody can ever blame me for doing nothing. I only hope this ominous message will be understood in time. You don't start the necessary preparations one year in advance. You then won't have enough time or manpower to succeed in the largest

rescue operation of all times.

Then I dreamt that the earth shook and trembled and billions of people died in a crushing tidal wave. The next day I started to write my warning message.

When the sun passed the sixteenth degree of the sign Leo in the year 9792 BC, all hell broke loose. A burning light from the sun reached the earth. The sky seemed to come down, but in fact the earth tilted. The symbol of the two lions is an illustration of our evidence:

Figure 4.

The opposite Lions as a symbol that East became West and vice versa.

The correct interpretation of the symbol of the two lions is as follows: the earth's crust had shifted, so the continents weren't in their original position any more. But there is more: when the sun rose again at the horizon, it was at a new horizon, because the earth turned the other way around! The Egyptians symbolized this by attaching a braided cross, symbol for eternal life in Egypt. This sun would stay at its horizon until the day of the next cataclysm, after which a new cycle of doom and arising can start. How destructive the last cataclysm was, is described by Profes-

sor Frank C. Hibben in *The Lost Americans*:

> It looks as though in the midst of some cataclysmic catastrophe of twelve thousands years ago the whole Alaskan world of living animals and plants was suddenly frozen in midmotion in a grim charade. ... The large animals that had given their name to the period became extinct. Their death marked the end of an era.
>
> But how did they die? What caused the extinction of forty million animals? This mystery forms one of the oldest detective stories in the world. A good detective story involves humans and death. These conditions are met at the end of the Pleistocene. In this particular case, the death was of such colossal proportions as to be staggering to contemplate. ...
>
> We have gained from the muck pits of the Yukon Valley a picture of quick extinction. The evidences of violence there are as obvious as in the horror camps of Germany. Such piles of bodies of animals or men simply do not occur by any ordinary natural means. ...
>
> Throughout the Alaskan mucks, too, there is evidence of atmospheric disturbances of unparalleled violence. Mammoth and bison alike were torn and twisted as though by a cosmic hand in Godly rage ... The animals were simply torn apart and scattered over the landscape like things of straw and string, even though some of them weighed several tons. Mixed with the piles of bones are trees, also twisted and torn and piled in tangled groups; and the whole is covered with fine sifting muck, then frozen solid.

This happened the last time. Now we are facing a next cataclysm. Will it be in the last part of the age of Pisces, which comes to an end in the year 2016? Or in the age of Aquarius? We are urgently searching the answer to this question. The moment of the next cataclysm is described in the Dendera zodiac. Cracking the code is a difficult process, but we are making progress. We indeed know from Slosman's book that the position of the stars

during the previous cataclysm has to match their position in the
year of the next one. Easy, isn't it? I sincerely hope it really is that
easy. But next to the symbolic zodiac are several other codes and
glyphs complicating the case terribly. We expect some help from
Slosman's other book *Les Divines Combinaisons* (The Heavenly
Combinations). In this book he tries to decipher the codes. But
this book appeared only in a limited edition and was jeered at by
the official Egyptologists. Gino's mother-in-law is doing every-
thing she can to find a copy. All our hopes are on her, but no luck
yet.

A Terrible Secret from the Past

When comparing data from the holy scriptures with data from
other books I read, an awful lot becomes clear. It is brought for-
ward that a burning light reached the earth. According to the Maya
there will be a switch in the sun's magnetic poles in 2012. Enor-
mous electromagnetic forces will then be liberated—with un-
known strength—from the interior of the sun. Giant sun-flames
will send a gigantic wave of particles to the earth. Recently this
phenomenon has been observed and confirmed in two suns. Dur-
ing several hours they exhibited an explosive activity, after which
they returned to their normal state. Astronomers were wonder-
ing if this were one-time event or if it could occur more often.
They can be sure it will occur again! Our sun is also showing this
kind of pattern.

The particles that are spewed out will put the earth's atmos-
phere "into flames" and have a really destructive effect on the
Van Allen Belts. Because of the continuous stream of electromag-
netism, the magnetic field of the earth will get overcharged. Tril-
lions of particles will reach the poles. Unknown electric forces
will be generated, a nightmare for everybody involved. When
the poles are filled with auroras from the falling particles, the in-
evitable will happen: the earth's inner electromagnetic field will
get overcharged and will crash. A mega short-circuit with super
lethal effects. The planet's entire atmosphere, without magnetic
protection, will be bombarded by falling particles. The earth's

magnetic field functions to protect us by directing electromagnetic particles to the poles, but this would become impossible. The particles would penetrate the earth from all sides and generate intensive radiation, in luminosity as well as in radioactivity. Burning, intensely burning is how you could describe the entire sky. Or, as the holy scriptures say: "the light of the light is around the world now." And that is the prelude to the cataclysm. The iron core of the earth is magnetic. Because of the switching of the magnetic core, the earth will start to move to the other side! Because of this, the outer earth's crust will break off! In other words the outer layer is "floating." It's on the loose, no longer attached to its "master." If you are on the planet at that moment, it will tilt some thousands of miles in a couple of hours. Looking up in the sky it will seem as if "the sky is coming down," as it is described in the old scriptures! Giant quakes will occur. Earth plates are moving, mountains are rising where first there was nothing, land parts break open and collapse, mountains collapse, land is sinking into the ocean, volcanoes erupt in many places. In short, the most terrible nightmare cannot be terrible enough to describe this world's destruction. How dramatic the events from 12,000 years ago were, you can read in *The Path of the Pole*. Hapgood writes:

Comparatively radical vertical changes in the positions of land masses are evidenced by a considerable number of ancient beaches which are now found at great elevations above sea level, and sometimes far inland from the present coasts. Thus the geologist P. Negris claimed to have found evidences of beaches on three mountains of Greece: Mount Hymettus, Mount Parnassus, and Mount Geraneia at, respectively, 1,400 feet, 1,500 feet, and 1,700 feet above sea level. He found a beach on Mount Delos at 500 feet.

Upon the coast of southern California may be found all the features of wave-cut shores now in perfect preservation, and in some cases as much as fifteen hundred feet above the level of the sea. These features are monuments to the grandest of earthquake disturbances which in recent

times have visited the region.

It would be possible to multiply endlessly the evidence of the raised beaches, which are found in every part of the world. Many of them may imply changes in the elevations of the sea bottoms, such as are suggested by Umbgrove.

One of the most remarkable features of the earth's surface is the great rift valley of Africa. The late Dr. Hans Cloos pointed out that the high escarpment along one side of this valley was once, quite evidently, the very edge of the African continent: not just the beginning of the continental shelf but the very edge of the continental mass. In some vast movement that side of the continent was tremendously uplifted, and the sea bottom was uplifted with it as much as a mile and became dry land. This is so interesting, that I quote Cloos at length in *Conversation with the Earth*:

Sunken and Uprising Continents

There are two rims to the African continent. Twice the fundamental problem arises: why do the continents of the earth end so abruptly and plunge so steeply into the deep sea? ... Even more astounding, what is the meaning of the high, raised and thickened mountain margins that most continents have?

... The short cross-section through the long Lebombo Chain looks unpretentious, but it illuminates events far from this remote plot of the earth. For here the old margin of the continent is exposed. Not so long ago, during the Cretaceous Period, the sea extended to here from the east. The flatland between the Lebombo hills and the present coast is uplifted sea-bottom. ... What we see are the flanks of a downward bend of High Africa toward the Indian Ocean.

But we see much more: the sedimentary strata are followed by volcanic rocks to the east of the hills. Some parallel the strata like flows or sheets, poured over them and tilted with them. Others break across the

sandstone layers and rise steeply from below. This means that as the continent's rim was bent downward at the Lebombo Hills, the crust burst, and cracks opened through which hot melt shot upward and boiled over.

So the eastern margin of Africa at the turn of the Paleozoic Period was a giant hinge on which the crust bent down, to be covered by the ocean. What we see here is merely a cross-section ... one can go further north or south, and even to the other side of the continent and discover that great stretches of this unique land have suffered the same fate. The oceans sank adjacent to the continents, and the continent rose out of the ocean.

So it is clear, continents rose and bent down on a gigantic scale. And they will do it again in 2012. This brings us back to our story. When, after hours and hours, the wave of charged particles declines, the magnetism of the interior of the earth can be restored. However, the poles will still be shifted, because the pole closest to the sun will have received the full blow. The floating of the earth's crust will stop, again accompanied by apocalyptic earthquakes, collapsing land parts, unknown tectonic activity and erupting volcanoes. But then, as if that wasn't bad enough, the largest catastrophe will happen: because of inertia, the movement of the oceans can't be stopped. As a gigantic rolling-machine a tidal wave will cover the earth. According to ancient tradition, the height of such a wave reached up to 1.5 kilometer in many places! This was why, and not without reason, the Maya were scared. Hidden high up in the mountain was a maiden temple. After the disaster they would have to take care of repopulating of the world.

Ancient Science

This is the science of the ancients and I undoubted strongly believe them. Why? Because our magnetic field is one of the least

understood wonders of the universe. In "Geomagnetic Revers-als" in *Science*, 17 January 1969, Allan Cox states: "There is an embarrassing lack of theory to account for the present geomagnetic field." In the year 2000, nothing has changed. What do scientists think now? Our magnetic field is electromagnetic. Everybody knows that. How come? Well, as our planet rotates, magnetism is induced in much the same way that it's induced by the flow of an electric current through a coil of wire. In other words, earth is a gigantic dynamo with a north pole and a south pole. That's it. Don't ask them more—they really don't know!

Polarity reversals do occur. Geologists have proven that. It happens every 11,500 years, but nobody knows why. All specula-tion leads to an "unknown force" that causes reversals—but still, no answers. Embarrassing? You bet! That leads us to the sun— there you can see how powerful a magnetic reversal can be! Mag-netic forces are the very trigger of millions of nuclear explosions in the sun. This is because our sun is a magnetic star. It has a north pole and a south pole, and an equator.

Like the earth, the sun rotates. The sun rotates very fast, more than 4,000 miles an hour at the surface, creating millions of mag-netic fields that heat the sun's corona to more than one million degrees. Just one exploding solar flare from a short-circuit in one magnetic field, gives as much energy as two billion hydrogen bombs! Imagine such a thing exploding on earth, and you can quickly calculate what the damage would be.

Then you have sunspots. Their most predominant property is their intense magnetic field. A sunspot's magnetic strength is immense—20,000 times more powerful than the earth's. Sunspots burst through the sun's surface every 11 years: the sunspot cycle. At the beginning of each cycle, magnetic polarity on the sunspots reverses, creating gigantic nuclear explosions!

That brings us back to the ancients. They had found a theory about the magnetic fields of the sun. In his book *The Mayan Proph-ecies*, Cotterell describes this theory, presenting the Mayan calcu-lations of the reversals in the magnetic field of the sun. After thou-sands of years, there is a really big one! When that happens, enor-

mous sun flares escape from the sun and fall into the earth's poles. Then wham! The earth's magnetic field reverses and the earth starts spinning the other way! Just like when a dynamo starts turning the other way, the north pole becomes the south pole and vice versa! Did you read that? The earth starts spinning the other way and the poles reverse!

After reading these notes I was gripped by a terrible fear. It's clear that a world disaster of unknown proportion is in store for us. Almost the entire world population will perish in it. Europe will slide back to the era of glaciers and become uninhabitable because the warm Gulf Stream will be gone. North America will be worse. It will disappear in one moment under the ice of the South Pole, just as Atlantis did! I felt so desperate I could have killed myself! Luckily I didn't have the time for it, because I had to finish my research first. That this is going to happen is without doubt. In his book *The Path of the Pole*, Professor Charles Hapgood writes:

> I have found evidence of three different positions of the North Pole in recent time. During the last glaciation of the North America the pole appears to have stood in Hudson Bay, approximately in Latitude 60 degrees North and Longitude 83 degrees West. It seems to have shifted to its present site in the middle of the Arctic Ocean about 12,000 years ago.
>
> The radioactive dating methods further suggest that the pole came to Hudson Bay about 50,000 years ago, having been located before that time in the Greenland Sea, approximately in Latitude 73 degrees North and Longitude 10 degrees East. Thirty thousand years earlier the pole may have been in the Yukon District of Canada.

If the North Pole changes, the South Pole changes also. Hapgood writes the following:

> Powerful confirmation of another of the corollaries of a

pole located in Hudson Bay comes from Antarctica. With a North Pole at 60 degrees North Latitude and 83 degrees West Longitude, the corresponding South Pole would have been located at 60 degrees South and 97 degrees East in the ocean off the Mac-Roberston Coast of Queen Maud Land, Antarctica. This would place the South Pole about seven times farther away from the head of the Ross sea in Antarctica than it is now (see the figure). We should expect, then, that the Ross Sea would not have been glaciated at that time.

We have confirmation of precisely this fact.
Put equinoctial precession, a displacement of the earth's crust

PATH OF THE SOUTH POLE

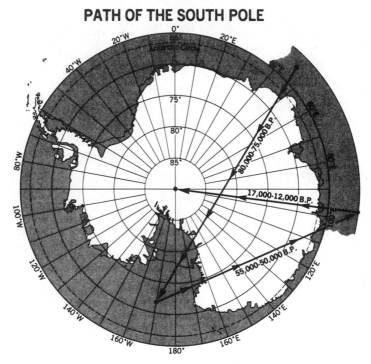

Figure 5.
The path of the South Pole, according to Hapgood.

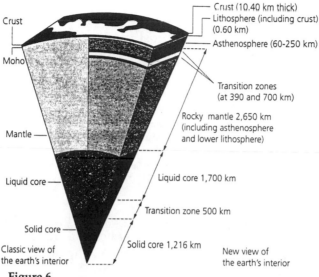

Crust

Crust (10,40 km thick)
Lithosphere (including crust)
(0.60 km)

Moho

Asthenosphere (60-250 km)

Transition zones
(at 390 and 700 km)

Mantle

Rocky mantle 2,650 km
(including asthenosphere
and lower lithosphere)

Liquid core

Liquid core 1,700 km

Transition zone 500 km

Solid core

Classic view of
the earth's interior

Solid core 1,216 km

New view of
the earth's interior

Figure 6.
New view of the earth's interior.

and magnetic reversals together, and you've created a colossal killer. It drives islands and mountains ever higher into the sky and causes extinctions on a gigantic scale. That there is a link between ice ages and magnetic reversals is undeniable. Ice played a major role at almost every extinction in history. Steven M. Stanley of John Hopkins University says that climatic cooling was the 'dominant agent' in the Cambrian extinction, as it was in the Permian, the Denovian, etc.

A little more than a hundred years ago people were astonished at the suggestion that great ice sheets, as much as a mile thick, had once lain over the temperate lands of North America and Europe. People later accepted the idea of not one but a series of ice ages. As time went on evidences was found of ice ages on all the continents, even in the tropics. It was found that ice sheets had once covered vast areas of tropical India and equatorial Africa. Coleman, one of the leading authorities on the ice ages, wrote in his book *Ice Ages Recent and Ancient*:

It was found, too, that these ice sheets were distributed

in what seemed a capricious manner. Siberia, now including some of the coldest parts of the world, was not covered, and the same was true of most of Alaska, and the Yukon Territory in Canada; while northern Europe, with its relatively mild climate, was buried under ice as far south as London and Berlin; and most of Canada and the United States were covered, the ice reaching as far south as Cincinnati in the Mississippi Valley.

Recent writers agree that the situation described by Coleman is essentially accurate. Professor J.K. Charlesworth of Queen's University, Belfast, expresses his opinion that: "The cause of all these changes, one of the greatest riddles in geological history, remains unsolved; despite the endeavors of generations of astronomers, biologists, geologists, meteorologists and physicists, it still eludes us."

Coleman, who did a great deal of field work in Africa and India studying the evidences of the ice ages there, writes interestingly of his experiences in finding the signs of intense cold in areas where he had to toil in the blazing heat of the tropical sun:

On a hot evening in early winter two and a half degrees within the torrid zone amid tropical surroundings it was very hard to imagine the region as covered for thousands of years with thousands of feet of ice. The contrast of the present with the past was astounding, and it was easy to see why some of the early geologists fought so long against the idea of glaciation in India at the end of the Carboniferous.

Some hours of scrambling and hammering under the intense African sun, in latitude 27 degrees 5 minutes, without a drop of water, while collecting striated stones and a slab of polished floor of slate, provided a most impressive contrast between the present and the past, for though August 27th is still early Spring, the heat is fully equal to that of a sunny August day in North America. The dry, wilting

glare and perspiration made the thought of an ice sheet thousands of feet thick at that very spot most incredible, but most alluring...

So we now know that ice ages and pole shifts happen frequently. In a few years it is going to happen again. But still I had many questions that remained unanswered, such as: if suddenly your country is demolished, how can you escape if you didn't get any warning? In *When the Sky Fell* it was clearly written that rather soon after the disaster in Atlantis, agriculture started in various places in the world. And with the same crops and the same techniques. These clearly had to originate from the same civilization! Intrigued I read this and thought about it. It seemed an insoluble riddle. An impossibility. If your country disappears in one blow, you can't take off with a load of cereals and build such a civilization as the one in Egypt. I couldn't solve this until one day I received the book *Le Grand Cataclysme* (The Great Cataclysm) by Albert Slosman. It was sent to me by Anne Papillon from Paris. Two months before, I had met her in Antwerp and told her about my research; she started searching the bookshops in Paris for me and found a second-hand copy of the book. With high expectations, I started reading.

3.
THE GREAT CATACLYSM

I've rarely read a book with as much astonishment as I did this one. It didn't let me down. Slosman really knows how to grasp one's attention. From the start he warns the reader that this is not a novel but real history, a story which truly happened. It was very hard work to decode the hieroglyphs describing the last years of Atlantis. Thanks to his enormous efforts we are now familiar with the secrets of a civilization that vanished in one day in a gigantic cataclysm! In a minute I will give a short summary of *Le Grand Cataclysme*. It is shocking and directly applicable to us. A little further on you will understand why. But first you need to know that the knowledge of the Atlanteans on the movement of stars and positions of planets was far more superior than ours. It is of utmost importance to know this because it leads to the unraveling of their secrets. You see, they perceived the end of Atlantis with their astronomic knowledge. The day Atlantis sank under the waters—27 July 9792 BC—Orion, Venus and a few other stars and planets occupied some "code positions." Those high priests that escaped the cataclysm took their knowledge with them and stored it in the labyrinth (The Circle of Gold) in Egypt. And right there the master plan was drafted to warn mankind of the next cataclysm. This incredibly shocking story needs to be known all over the world. Because in 2012 the stars are in the exact same positions as in the year Atlantis went down.

Osiris

The story of Osiris (Orion) starts in the year 10000 BC. L'An-Nu, the high priest of Aha-Men-Ptah, assembled the council. He had worrying news: with "Mathematical Calculations of Star Configurations" he had been able to calculate the date of the end of their world. This was based on the happenings of the previous cataclysm—21 February 21312 BC—when Atlantis was partly

destroyed (the earth turned 72 degrees in the Zodiac). His message was extremely painful and hard: "Brothers, today we are assembled to speak about the terrifying events that will happen to our great-grandchildren! Without hesitation we have to organize an exodus of our people to other regions; this means an enormous effort for a very long time!"

A murmur and then a wave of protests could be heard, but the high priest was inexorable: "This is not based on religious scriptures, but on mathematical combinations which can be understood by anybody chooses. All movement of stars and planets happens in harmony, following a God-made law. What we know for certain is that the "Mathematical Celestial Combinations" have influence on all organisms on earth through the configurations they represent. That is one. Secondly, the calculations of my predecessors, as well as of the scientists from our "Double House of Life" from Septa-Rerep are set: a catastrophe of unknown proportions awaits us. During the previous one, the north of our country became an enormous iceberg and other parts of the world were demolished. This time, our entire country will disappear. I recalculated that what our scientists have calculated so many times before, and the only thing one can say is that our country will vanish completely under the waters! Nothing will remain, and if no measures are taken there will be nobody left to tell our country's history, because it will belong to the realm of the dead!"

Most listeners were quiet because they were impressed by what they heard. One of the oldest members interpreted the general excitement: "I don't doubt the power of your words! It is logical that if we accept this Great Cataclysm as a certainty, the exodus has to be discussed here in a quiet way. But this means the construction of tens of thousands of ships! Not to mention all the food for millions of people! This requires generations of preparations!"

L'An-Nu spoke again: "The Heavenly Law determines the harmony of the heavens and the mathematical movement through time of the earth. Based on this 'Those who have Knowledge of

the Numbers' were able to determine the exact date, as well as the law causing the catastrophe. It will happen on 27 July 9792 BC, 208 years from now. And it is inevitable! So be hasty, honorable members of the council, to take the necessary measures so that in two centuries everybody can leave this country and commence a second fatherland. The first signs of what is waiting for us are already visible on the horizon where the sun is more reddish at its awakening! This is where I end my argument: the east will have the color red, as red as our blood, because our empire will belong to the dead!"

This produced the desired effect. From that day on they started taking the necessary precautionary measures for a flawless exodus.

The years passed. In 9842 BC the first child of King Geb and Queen Nut was born. It was a son, and his mother named him after the constellation dominating the southern sky: Osiris or Orion. He was predestined to become the 589th master of Aha-Men-Ptah. (Later, Aha-Men-Ptah was called Atlantis by the Greek philosophers.) In 9841 BC his brother Seth was born, and a year later the twin sisters Isis and Nepthys. The two girls were loved by everyone, but Seth behaved like a small tyrant. He envied his sisters' success and was extremely angry at not being the heir to the throne. Isis liked laughing and could often be seen in the company of Osiris. King Geb observed a close relationship between these two and decided they should marry each other. In the presence of a large audience the marriage was solemnized. Seth was absent because he was furious when learning about the marriage. He left in a rage after threatening revenge and fratricide!

From the union of Isis and Osiris, Horus was born. Meanwhile Seth assembled a continuously growing army. Many of his rebels chafed at performing the inflicted, coercive measures for the oncoming cataclysm. They refused to participate any longer in works for something they didn't believe in. In these difficult times, Osiris became the new master at the age of thirty-two. It was 9805 BC, only thirteen years away from the date of the cataclysm. Osiris immediately took measures to be assured of the fidelity of the

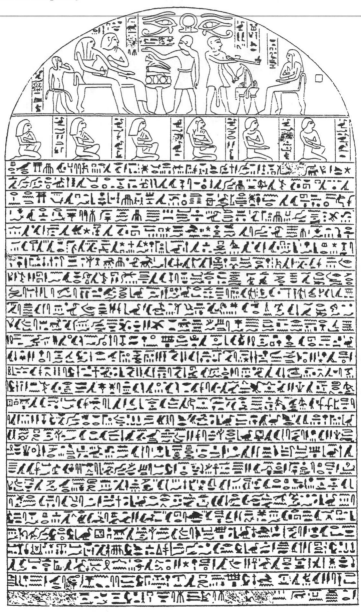

Figure 7.
Glyphs of the lives of Isis and Osirs.

remaining states of the country. He formed an army which did not only have to conquer the rebels but protect the harbors and the storage buildings as well. The thousands of boats were guarded after it was realized that many of them were gone and now served as fire-wood. A thorough reorganization took place to assure a smooth evacuation for those who remained loyal.

The rest of the land was in chaos, caused by Seth. An unbelievable amount of material meant for the exodus became useless, demolished, broken or stolen. Seth exercised a murderous dictatorship and proved the terror by sending back two ambassadors of the palace in their coffins, their heads severed from their bodies. His message was clear: I will not negotiate.

Only three years remained. Horus was 24 when his uncle incorporated his seventh state and ordered the immediate destruction of 4,000 "Mandjits." These unsinkable ships were meant to insure the survival of 30,000 people of that province! After this senseless destruction there was a standoff for about three years. A couple of weeks before the cataclysm, Seth intensified his attacks vigorously. On the evening of July 26, he succeeded in taking the capital by surprise. Indeed, everybody was preoccupied with the oncoming cataclysm, which interfered with taking measures for defense.

The result was disastrous. There was plundering and murder. Only the royal palace hadn't been taken. Seth discussed the necessary strategy with his captains, but decided not to attack because his troops were too drunk. In this state they wouldn't be able to conquer the elite troops that were under the command of Horus. The opposition also knew Seth took no captives, and they would fight vigorously for their lives. So he thought of a trick. He sent a messenger to the palace offering an honorable surrender, under the condition Osiris himself would come to him to sign it. In spite of the warnings of Geb, Nut and Isis, the king decided to go. He left the defense in the hands of his son Horus. Six men and an officer escorted him. Osiris drove to the meeting place through the burning ruins of his capital. Before they could even react, lances punctured the hearts and heads of his escort and the men were

brutally murdered. The king was lightly wounded and was brought to a room where Seth with his commanding officers were waiting impatiently. Convinced of his triumph, Seth looked down on his brother who only gazed at him with deep sadness. Then he flew into an irrational rage. He took one of his captain's swords and drove it into his brother's body; no sound came from Osiris's lips. Then he ordered his captains to follow suit. Osiris died without making a sound. Seth looked around him, noticed the hide of a bull and pushed the body that was still warm upon the hide which consisted of two parts and pulled them tight together. Then he ordered his captains to bring this "package" to the sea and throw it in. The carnivorous fish and crabs would feast on it.

In the palace, Nepthys, who was gifted with the vision, saw

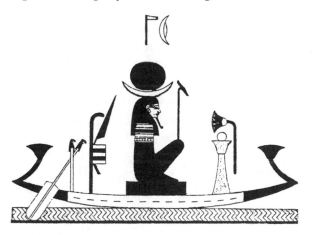

Figure 8.
Osiris retook his place at the right of God, indicating that the earth will turn the other way.

the tragic events. She related them to Horus, who decided to launch a counterattack. In no time he assembled two thousand men, explained to them what had happened and what he expected them to do. With their hearts filled with anger they started the attack. Every rebel they encountered was killed instantly. Soon they reached the place where Horus' father was murdered. They

were spectators of an apocalyptic scene: it was filled with bodies, murdered in a beastly manner, but Osiris was not there. Horus continued the reconquest and soon received enforcements from the inhabitants and remaining brigades. Just before dawn the capital was freed indeed, but completely demolished!

The moment the sun was due to rise above the horizon—nothing happened.

It was 27 July 9792 BC and it would be the last day of Atlantis. An unreal dawn appeared, without sun or sky—a sultry reddish haze, of a diffuse clarity because of its thickness, smothered everything. This not only absorbed every sound, but also the light of the sun. Breathing was difficult because the sharp smell of death dominated the atmosphere. All over the continent people understood the inevitable was about to happen. The instinct for survival afflicted everybody with intense fear of the drama to come. There are no words to describe the panic that followed! In the annals it is recorded in detail, and the mayhem described can be understood when thinking about the scary outlook the people faced. The morning passed on without anybody being able to tell the time, because the sun remained invisible behind the sultry fog which turned to a blood red color.

Horus understood this was the end of his country. He also realized that if the discouragement of his people was this large, it would be much worse with the rebels; he decided to take advantage of this and strike a definitive blow to his uncle's troops. He explained this briefly to his commanders, who were very excited by the idea. He promised the soldiers they would be able to leave in time with their families. The choking silence of the fog was driving the troops crazy, and because of the unbearable smell and the reddish phenomenon, they nearly went out of their minds. This resulted in their violent encounter with the enemy seeming something almost like a dream, for the blur was still hindering clear sight.

Then the heavenly fury made itself known in its omnipresence. Soft earthquakes finished the battle. Nobody could win because everybody would perish! Many were thrown to the ground

with shaking bodies by the sinister cracking. This went on and on with the same intensity while the impenetrable fog seemed to clear up.

In the palace, Geb took the lead again. The former monarch had no other choice since his son was dead and Horus had not yet taken the oath. Based on the royal enactment he decided to start the general exodus immediately. Everybody had to leave everything, without any hope of seeing it again. First the order was sent to the harbor, so the planned measures and actions could start, and prevent as much panic as possible. The royal soldiers were all there to help the fleeing populace leave.

In the royal harbor were thousands of "Mandjits," known for being "unsinkable." They were rigorously protected and had complete survival kits aboard: water bottles, barley cakes, cereals, etc. The evacuation had been practiced long before and worked flawlessly. In no time hundreds of thousands of people were embarked. At the same time, the evacuation of the royal family and the high priests began. Everybody went to the boats appointed to them long ago. For these people the measures that had been taken years and years ago were paying off now. The high priest calmly gave his orders, and they were followed meticulously. An armada of followers brought the treasures into safety. Nobody had any idea of the extent of the catastrophe, but everybody imagined the worst.

A hundred miles away, the thousand-year-old volcanoes became active again. With enormous power they threw rocks, earth and dust into the air; the fog thickened again. A rain of smaller stones and pieces of all sorts fell on the capital and the harbor, wounding and killing many. In the panic that ensued, all self-control was gone. A real rush to the harbor began, and everybody threw away everything they were carrying to be able to run even faster. Every sparkle of human thought was driven away by a pure animal survival instinct. The soldiers were run over by this stampede of people. The throng jumped on the papyrus boats, which were coated with resin and bitumen to make them impermeable and indestructible. Terror caused by the horrible, unimaginable events made people forget all notions of safety. Instead

of coming on board with no more than ten per boat, people were fighting to get on board of the first Mandjits they reached. Hundreds of ships sank together with all their passengers just after leaving, or even before taking off. Thousands of unfortunates died in the harbor, which would not exist for much longer.

From far away one could hear the volcanoes again. Lava was thrown in the air and the terrorized remaining population perished in a stream of fire. Gallons and gallons of hellish liquid fire found their way over villages and cities, destroying and covering everything on their way.

Throughout this infernal course of events Nepthys and Isis were looking for the body of Osiris. Nepthys led her sister through the mist of invisibility. Of the soldiers accompanying them, only three were left. Because the "seer" had great difficulty concentrating on where the body wrapped in the bull's skin was, exactly, the search was hard. The omnipresent panic, and the thousands of corpses, complicated her task. They seemed to be the only ones still alive in this immense graveyard where birds, animals and people had died. Was it worth continuing the search if they would die anyway?

That was exactly what Seth was wondering about. After the first trembles, the major part of his brigades took off. Those who had laughed with disbelief at the predicted end of their world were hurrying to escape their disobedience of God's laws. But for many it was too late. Seth realized that his rebellion against the heavenly laws had even accelerated the inevitable process. He was left alone, stupefied and incomprehensive about his lost honor and kingdom.

Horus gave his remaining men the freedom to leave in an orderly way. He decided he would stay behind and look for his uncle to kill him in revenge for his father. Two men were now left in the forest, both of their heads filled with tragic events, both knowing they had to kill the other in order to survive.

Again the heavenly fury broke loose. The tumult in the harbor was now at its highest. Hundreds of thousands were pushing in the heavy fog to get on board of a ship. No soldier could perform

his duty in this mass of people crushing themselves to death. The first rows were simply pushed into the water. At that moment the remaining rebels reached the harbor. With merciless violence they cleared themselves a path to the boats. Everybody who was in their way was thrown in the water or killed, after which the soldiers crowded together in front of the boats. But in their fear, they made the same mistakes as those before them: they overloaded the boats with too many men. Within seconds they sank and the drowned people joined the piles of floating bodies. Others went to the royal harbor where the exodus was taking place calmly, but in a great hurry. The rebels caused serious bloodshed, and took off to the sea in purloined boats. Fortunately the high priest and his family, together with several boats with priests, had already left. Because of the heavy fog they could not hear or see a thing of this murderous episode in the last day of their kingdom!

In the meantime, the commanders were approaching each other without being aware of it. The fog made them invisible and inaudible to each other. Seth looked around when a gust of wind opened the fog; he saw Horus, who was meditating about twenty meters away. Filled with hatred, aching to kill his brother's son, he stepped forward. Again the earth was shaking and aired a fearsome symphony. Its echo was heavy and sinister. The lava was streaming again and continued its destructive work. Trees broke as if they were only twigs and then caught fire. The roaring fire killed everything in its path, both vegetable and animal. Nothing could escape it. It was accompanied by a disgusting smell. Seth, who was at that moment only three steps away from his nephew, was seized with fear. He was gripped by an irrational panic and attacked without thinking. His cry was lost in the roaring noise of the burning forest when his sword grazed Horus' shoulder. Another blow hit his nephew in the face. Horus clasped his hands to his face and they were soon filled with blood. Seth was sure of his victory and ran away, trying to escape from the torrent of lava which was approaching. Even if Horus were still alive, he would surely die in this phantom-like stream of fire. Enormous burning clouds came forth from the lava, which streamed on with mon-

Figure 9.
Glyphs describing the fight between Horus and Seth.

strous hissing sounds. It came nearer and nearer to the son of Osiris who, alone and heavily wounded, was left to the mercy of the heavens. He had lost his right eye and the other was filled with blood; a knee was shattered and a shoulder broken. But he was still alive, although he could neither see nor move. He knew the inferno was closing in on him and he hoped Isis and the rest of the family had been able to get away in time. The boiling stream reached the nearby trees and destroyed them within seconds. A heavy sigh escaped from his lungs. He felt the intense heat that would burn him to ashes in no time. Then the miracle happened. Horus was lying against a granite outcrop, and the lava couldn't flow through it, only around it, which left Horus in safety for a while.

At the coast Nepthys was finally successful. She saw a small bay with an enormous fig tree. There, on a branch over the water, should hang the hide with Osiris' body in it. This proved to be true. Isis sighed with relief; their delay in leaving this earth was fruitful! The two sisters carefully took hold of the hide and the soldiers put it on one of the small Mandjits laying there abandoned. After a short discussion, the queen ordered her sister to join their family along with the soldiers. Isis left on her own to look for her son, the lawful heir of the now lost kingdom. Alonel, she reached the royal palace where Geb and Nut were about to leave. They had been waiting desperately for news of their son and grandson. Confronted with Isis' resolute decision to look for her son, Geb gave his last orders. Without further delay Nut and the remaining leading men had to leave. Their destination was the end of the park where the channel began. Over there, two large galleys strong enough to sail the wildest seas, were waiting. A new country would need a new mother, Dame of a new Heaven, who in the absence of Osiris and Horus had to teach the survivors how to live in their second fatherland. Its name would be Ath-Ka-Ptah—meaning literally 'Second Soul of God'—which would later be changed phonetically by the Greeks to Ae-Guy-Ptos (or Egypt in English).

Nut, who had disliked leaving her loved one, was driven on

by the uncontrollable elements. An enormous explosion in the center of the capital shook the survivors and drove them on through the chaos. Geb, who had decided to accompany his daughter, had taken several stallions in order to move as fast as possible. As he viewed all the damage and chaos, he doubted Horus would still be alive. But Isis didn't want to hear about quitting. Confidently she urged him on, though that was not easy in the fog. Suddenly, out of nowhere, it started to clear and for the first time that day there was light. The volcanic activity in the distance, which had spewed thousands of tons of lava, came to a standstill. An unearthly silence surrounded them. This had to enable them to find Horus! But where to look for him? Isis put her arms towards the sky and prayed: "Oh Ptah-Hotep, King of the Heaven: open Thy flood-gates to stop the fire. Save the son of Your son! Order that this day of the great cataclysm should not become the day of the Great Mourning. Oh Ptah-Hotep, King of the Earth: Order the Great Stream to open all its reserves."

Six thousand years later this prayer is still be engraved in the tombs of The Valley of the Kings in Luxor, and in Dendera as well. And in the annals of the book *The Four Times* is recorded: "Isis' prayer was answered and a reddish rain started to fall on the earth, as if the blood of the dead was spread over the torn land." Some hours later the lava had cooled down and was hard enough to allow Geb and Isis to climb over it. The queen, desperate with sorrow, didn't know which way to go in this desolate landscape. Just like her father she was completely soaked and exhausted and could hardly move on over the hardened rocks. Then Isis saw the body she was looking for. And it seemed to move! She cried tears of joy. Horus thought he was hallucinating—his mother could not be so close! But a hand touched him and a beloved voice spoke to him: "Have no more fear my son; God showed me the way to reach you and to save you."

In her hand, Isis collected some water that was streaming from the rock and washed the blood from Horus' good eye. Then Horus could see his mother and he also cried with joy. He tried to get up, but would have fallen down heavily if he had not been sup-

ported by his grandfather, who told him about his shattered knee. With the help of Isis they took him by the shoulders and carried him slowly to the horses which were waiting patiently. There Geb spoke with a voice that would not accept any contradiction: "Isis, you have to leave immediately. Osiris hid a Mandjit under the roof at the Holy Lake. You both hurry to get there and leave as fast as possible to the open sea. There is only one set of oars on board and it should be easy to depart. I am too much of a dead weight to come with you. Besides, I still have some things to arrange in the palace. Don't think about me, that is an order! Think only about your son. Go."

"But, father!"

"Go! That is an order!"

It was impossible to oppose him and Isis left with the other horse beside her. During the drive she talked encouragingly to her son. She knew he had to be in unbearable pain, and tried to help him forget for a moment. They reached the ship without further difficulty. Isis sat at the oars and started rowing vigorously to the strait, where she would probably be able to switch to a larger boat and Horus could be taken care of by other survivors. After she passed both the small and big channel, the first real seismic shock began. The earth was thrown to the heavens while an intense flashing light streaked the sky before it vanished into the waters in Dantesque jumping flames. Horus didn't notice any part of these last convulsions of his world—he was unconscious.

During that day, a day seemingly without end (the 27th of July), the destiny of Aha-Men-Ptah was sealed. At the southern end of the sinking continent, the Mandjits—believed to be unsinkable—were floating. Now was the time to prove their reputation. In the west the sky still glowed from the cataclysmic events with the color of blood. But was this really the west? A storm was on its way. Waves of a height of several meters crashed down on the Mandjits. Some of the water entered the holds which made it more difficult for the boats to remain upright. After a relatively calm period the violence started again. This time it was a cyclone, and

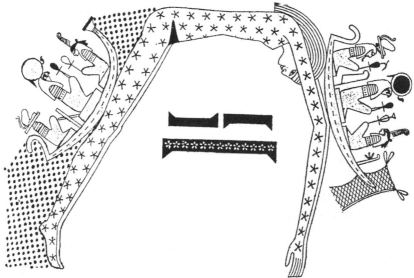

Figure 10.
This is one of the most fundamental pictures written on the walls of the
Egyptian temples. It shows the escape of Osiris, Horus and Isis. At the left the
flood and at the right the almost-destroyed Mandjits. In the middle Queen
Nut. She protects them.

some of the fragile papyrus boats were smashed to pieces. Left
on these enormous masses of water, the surviving captains of the
boats tried to fight this terror of nature. They had not yet sur-
passed the limit of the impossible. In the reddish, but now calm
sky, they suddenly saw the sun rise with abrupt movements. Des-
perate, they watched this happening. They took hold of the boat
railings to make sure they were still aboard. A few minutes later
the sun disappeared again, and night followed! To their amaze-
ment the stars were following the same fast rhythm. Then also
the moon appeared and moved at such a speed through the sky
that it seemed it was going to crash on the fleet! The entire night
had passed in less than one hour! Nobody knew what was hap-
pening; nobody could tell whether this day would be followed
by another one or not. The horizon stayed crimson with an un-
earthly clarity, phantom-like and enigmatic! Everybody thought

this would be their end, as it had been the end of their world, perished in titanic earthquakes. Everything was gone, except the haze!

At the horizon, all was calm again. A jet of burning stones was launched from far away and the turbulent sea lit up. While the rain of fire came down, the survivors realized they had witnessed the last convulsions of Aha-Men-Ptah. This was too hard to believe for many, because for generations and generations their land had been the center of the world. And now it was falling apart, mingling with the rising waters, leaving them for good. Those with good eyesight saw through a purple haze how the last mountains disappeared under water: Nothing! Nothing left!

This sinking made the waters rise to new heights. An enormous tidal wave twelve meters high and several kilometers wide came rolling towards them, taking with it everything in its path. Hundreds of people were thrown into the see, but luckily many had tied themselves to the masts, with the ropes that were hanging from the sails. Isis and Horus were tied together in their lost ship, and so were Nepthys and Nut and their companions. Seth, as well! He had managed to escape by himself and was now looking for the "Sons of the Rebellion."

In the meantime, Horus started strategizing, trying to forget his unbearable pain. He would not be saved by staying on this ship; in order to survive he had to choose a destination where he could go ashore safely. How could all this have happened, he wondered. From the "Master of Mathematical Celestial Combinations" he had learned that the earth was a sphere, as were the moon and the sun. The observation, followed by minute calculations of geometric figures formed by the planets and the celestial bodies, had revealed a unique universal law. And this law led into this great cataclysm. But the earth would continue to exist, even if largely demolished by the events. That was hopeful!

In a flash, Horus realized suddenly that the Mandjits wouldn't stay seaworthy. They had been treated with bitumen, which was already melting in the heat. Soon they would start leaking and then they would vanish in the deep. After this realization, he fell

into dream-filled sleep again. Why, he wondered, did the priests point to unbelief as the main cause of the cataclysm? Did their creator feel no mercy for them? He would have to go over it all again to be able to understand it! A shout from his mother brought him back to reality. He opened his remaining but heavily wounded eye. Through a haze he asked, "Are there problems with the Mandjits mother?"

"No! It's the day which seems to be rising from the right side."

"From the right side? But that's impossible! That is only possible if we're going in the wrong direction!"

"It most certainly is the east Horus, because there is land visible in the west."

This new riddle left Horus bewildered. It was about time to find a solution for all these apocalyptic events. A lamentation of cries came from all the boats when they saw this inexplicable movement of the sun. Everybody was struck with fear. But the day passed on with the sun at the wrong side without anything happening and peace came over them again. Isis changed clothes and was recognized by her people. When they were near, she spoke with a loud voice: "I speak to you all: if you are ready to live in peace with God, who created you to his image, then a second fatherland awaits you: Ath-Ka-Ptah. There the rays of a second sun will take care of our resurrection."

On another boat Nepthys was thinking. At the head of the ship lay the body of her beloved brother, securely wrapped in the bull's hide. Suddenly she "saw" a dead person! Something she could not possibly explain...

Then she was filled with joy. She understood a miracle was happening. In front of her Osiris appeared in the starry sky! He, who was born as a God and associated with this constellation, was reborn in the sky! Their Father, to let them know about his omnipresence in all circumstances, gave life back to His Son!

Nepthys did not know why, but she suddenly was filled with self-confidence!

Here the story of the death of Atlantis comes to an end. All the facts will later be interwoven in the Egyptian religion. The

constellation Orion, after which Osiris was named, will find its image on earth in the three pyramids of Giza. The fact that Orion (Osiris) "awoke" again in the starry sky will become the driving force behind the Egyptian star religion. All succeeding pharaohs wanted to be "reborn" into the starry vault, just as their illustrious predecessor had been. That is why the pyramids are built in the image of the stars: they are the pinnacle of the royal cycle of being born again. So, in essence, this is about a star religion which generated from the belief that the dead kings would become star souls. This religion would last more than 9,000 years!

Figure 11.
Osiris, Master of the Two Earths:
Aha-Men-Ptah and Ath-Ka-Ptah.

The pharaohs saw themselves as the followers of the reincarnated Horus, the Living One. When dead, they had to be reborn to be able to rise to the stars. All funerals took place on the west bank of the Nile, where the pyramid fields symbolized the area around Orion at the 'banks' of the Milky Way. The transportation of the dead body to the opposite bank of the Nile was a ritual symbolic passage of the soul to the other side of the celestial Nile (the Milky Way), where the heavenly paradise was located, and where Osiris wielded the scepter. Now every-

body can understand why: Orion (Osiris) was the first God-king to be resurrected. That is why the monument set up in his name is the greatest archaeo-astronomic monument of resurrection that ever existed!

The points of the compass were important in this ritual: the south marked the beginning of the cycle; the west, the start of the symbolic death the moment the star disappeared at the horizon; the east symbolized the rebirth of the star. All this in remembrance of the events of the day of the "Great Cataclysm." Aside from this, there are hundreds of things which could symbolize religion and facts being interwoven. For instance in Heracleopolis each day a bull was offered for its hide. In the temple of Dendera the bull's skin was pictured as of utmost holiness. The lost eye Horus can be found on the breast of every pharaoh, and so on. In Egypt you can also find the 'arks' of Atlantis.

4.

THE MANDJITS OF ATLANTIS

From the previous chapter, we know that the survivors of the catastrophe owed their lives to the Mandjits, which had the reputation of being unsinkable. Naturally, their descendants would include this joyous fact in their religion. The discovery of ships in the middle of the desert only provided insurmountable and inexplicable problems for the Egyptologists. In May 1954, the archaeologist Kamal-el-Mallakh found a well on the south side of the Great Pyramid—31.5 meters long and 23.5 meters deep. Two meters below that he found large blocks of limestone, some of which weighed more than fifteen tons. Below this stone roof lay a disassembled cedar boat. It took fourteen years to reconstruct the ship, but the result was worth it: a ship of 43 meters in length, of the same size as those which the Vikings used to cross the Atlantic. The discovery of this ship raised a lot of questions for the Egyptologists. If this ship was built by shipbuilders with knowledge of sailing on the open sea, then who were they? According to orthodox history the Egyptians were nomads for some centuries before the construction. Where in the desert could they have gained the knowledge to build sea-going vessels? Of course, it could be said that the Pharaohs only used them in rituals, but even then, where did they get the design? Questions, questions, and more questions. Of course we already know the only logical answer: from their ancestors who used similar vessels to escape from their country. In 1991 the mystery became even greater for the Egyptologists. In Abydos lies one of the oldest buildings in Egypt; the Oseirion. According to Professor Naville, who uncovered the structure in 1914, the enormous building was a large basin used for water storage when the Nile rose high. The nearby temple of Seti I was dedicated to Osiris. The pyramid texts say the following about him: "You died but will live again. Go to the lake and then follow the waterway to Abydos."

Once again we see a connection here with the events of nearly twelve thousand years ago. Osiris (Orion) lay in a bay and was transported across the sea. Thereafter he "awoke" in the sky. When you take a careful look at the star map you'll see that the Milky Way is situated next to the constellation of Orion. In Egypt the Nile was associated with the Milky Way (= sea of stars). The story is therefore correct in every detail. A reconstruction of these data gives us the following story. Orion, who is in the pyramid, has to go to the lake and from there to the Nile in the direction of Abydos. Naturally this can only be done by boat. And what do we find one kilometer northwest of the Oseirion? Exactly, twelve large ships. Why twelve? Probably to have a connection with the Zodiac. In *The Guardian* of 21 December 1991 we read the following in this regard: "A fleet of five thousand year old royal ships has been found 13 Kilometers from the Nile. Experts say that the boats, which vary in length from 15 to 18 meters, are Egypt's earliest royal ships. They belong to the oldest ships ever found." Hidden in their brick graves, the ships must originally have been situated above the desert sand. The layer of white chalk surrounding the graves must have made them sparkle from afar under the sun. The researchers also agreed that the ships were able to withstand the worst possible weather at sea. However, they were more than 500 years older than the pyramid ship. Even more of a mystery was that the same ships are depicted on mural paintings, which are 1,500 years older. The Egyptologists still can't figure it out. But we know better. The Atlanteans were a highly skilled seafaring nation, who had mapped the earth perfectly. They knew everything about the movement of the stars and planets. This knowledge was necessary to allow their sailors to navigate to other countries. In his book *The Path of the Pole*, professor Charles Hapgood writes:

The serious student should obtain a large modern map of Antarctica, either that produced by the National Geographic Society or the more elaborate and up-to-date map produced by the American Geographic Society. With the

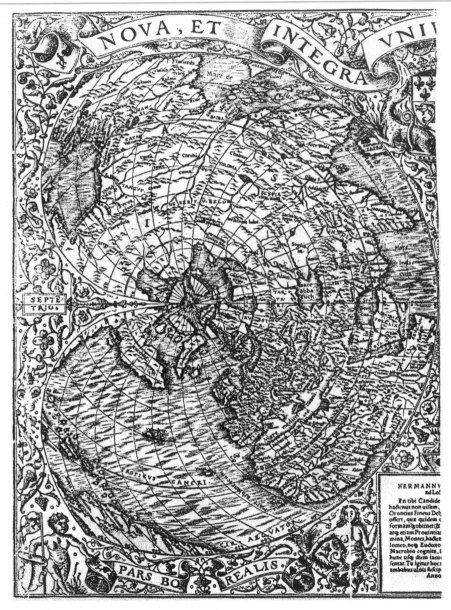

Figure 12.
The Oronteus Finaeus map of Antarctica.

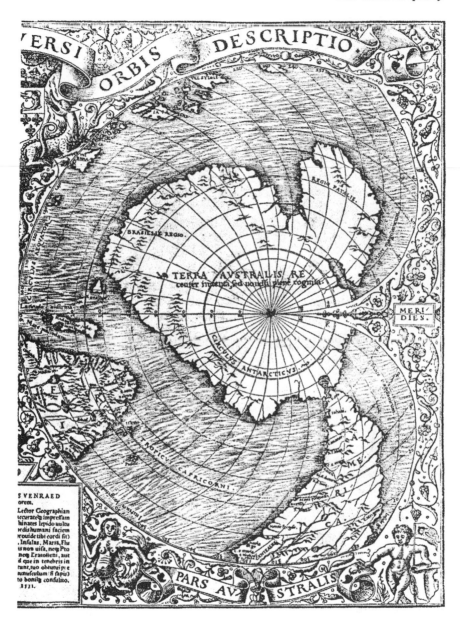

large map he should follow the coast, comparing it with the Oronteus Finaeus Map and this table. He will conclude, I am sure, that the agreement of the ancient and modern maps is entirely beyond the probabilities of coincidence. In final comment on this extraordinary evidence, I will say that though this map is proved to have existed as far back as 1531, no map of this accuracy could have been drawn in modern times until the invention of the chronometer in the reign of George III about the year 1780. This instrument first made possible the accurate determination of longitude. Conclusion: the map is evidence from a lost high civilization.

With this knowledge, and thanks to the Mandjits, the Atlanteans were able to escape the cataclysm. They owed their lives to it. That is why this exodus across the sea would still reverberate thousands of years later. It is for this reason that much later enormous vessels were to be built in stone and in the exact same proportions. Some of these have been discovered in Abusir and Saqqara, along the road to Giza, with their bows pointing westward.

The ship in Abusir measures about 30 meters and is a real monument. The name which has been chiseled into it in hieroglyphs is clear enough: "Father of Osiris," in other words, God! This Mandjit was built by order of Ni-Osiris-Ra, Pharaoh of the fifth dynasty whose name means "Descendant of Osiris and the sun." The ship's orientation is west-east, with the bow in westerly direction, where the sun is at present "keeping quiet." The mooring, as well as other various parts, have disappeared, but the ship has kept its super structure. The notable hull of the ship, able to withstand the wildest seas, shows an ingenious display of lines, just like the papyrus Mandjits.

The stone ship of Abusir is therefore just as important as the wooden ships. I hereby urgently call on all Egyptologists to address the high symbolic value of all these ships.

When you see this ship in front of you and you know the his-

Figure 13.
Replica of a small Mandjit.

tory of the exodus, then you can't help but daydream. The unforgettable spectacle of the thousands of Mandjits heading for the sea during the cataclysm will soon appear in your mind. Without these ships Egypt would never have existed as we know it now. Without these ships Isis, Horus, Nepthys, the high priest and his family and countless others could not have escaped. Since the present civilization is completely based on the Egyptian civilization, we would only be a primitive culture, not anywhere near the present one. I only want to make clear how important these Mandjits were. Their existence made it possible for the secrets of Atlantis to be revealed to us. Primordial to this is the fact that the priests were able to predict the day of the cataclysm with the aid of the "Mathematical Celestial Combinations." This day is approaching with rapid strides. Just like then, we will have to build a fleet of modern Mandjits to survive this catastrophe. The awareness of this will wake up the Egyptologists and they will give these boats their deserved place in history. In fact, all historians ought to do this. After all, I began and finished the first chapter pointing out that just after the last landslide, the one during which Atlantis was destroyed, agriculture sprouted at various upland planes in the world. The Russian botanist Nikolai Vavilov has dedicated himself to a thorough study of this. He located eight different agrarian centers where *the same* nursery plants were used.

The question I asked—how could the Atlanteans escape with nursery plants if their country was destroyed in one day—is hereby definitely solved: they knew beforehand that this would happen, built ships and took care of repopulating the world. It is for that reason that there are so many people on this earth at present and that we are facing the greatest cataclysm of all time! The ultimate question remains: how could they possibly have known that it would happen? This leads us to the next section.

PART II

ASTRONOMICAL EVIDENCE

5.
THE SHIFTING
OF THE ZODIAC

Everyone knows the Zodiac. The word Zodiac is Greek for 'Circle of Animals.' It consists of 12 star systems forming a circle around the earth. This is simply depicted in the illustration.

There are two ways in which the earth "appears" to move through the Zodiac. To understand that you will have to look at the hands of your watch or a clock: they turn from east to west. We can verify this by looking at the sun; it rises in the east and sets in the west. This is due to the earth's turning against the clock, from west to east. After 24 hours, or a day, it has completed a full turn. For the Zodiac this results in the following:

Figure 14.
The Zodiac.

- During one day, the Zodiac appears to turn around the earth, although of course it is the earth which turns around its axis. When you draw a circle around yourself, stand in it and then turn around, you will get the same effect. It is that simple.
- During one year the earth makes a full turn around the sun following a circle of 360 degrees. This means that the Zodiac seems to have completed a big circle around the earth in one year.
- If you look up from the earth to the sun and continue to follow this spot, then you will notice that you go through a sign

of the Zodiac after approximately thirty days (365 ÷ 12 = 30.4).

- Moreover, the astronomical circle of 360 degrees is divided in twelve signs of 30 degrees each (12 x 30 degrees = 360 degrees).

If you have trouble following this, don't panic. I will ask for some mental exertion, but in such a subtle way that it won't drive you mad: starting tomorrow, you will get up before dawn each day. What? I hear you yell, that really will drive me mad! I know that, dear reader, but let me finish my story. You install yourself on a roof and look through blackened binoculars (otherwise you could be blinded) or a telescope in the direction of the sunrise. Try to forget your stiffness and early morning blues and peer at the stars. In the east, there where the sun rises! And don't forget to blacken your binoculars, or you can go blind! Yes, yes, you grumble, and you point your binoculars at the star system which rises before the sun. I know, the science of the end of the world isn't easy. If you're lucky, you will see this same system rise before the sun for 30 days. After that another sign of the Zodiac will rise. It is not difficult to observe this, it only takes a lot of effort. Why should I be so bothered with this, you may wonder? My answer is: after the world's destruction in 2012 you can be bothered about thousands of other things. I guarantee it.

Okay, where was I with my story? Oh yes, each month you can observe one system of the Zodiac rise or awake before the sun. This is *one* part of the story. Another part are the four seasons. I know them! you may shout. And you sum up: summer, autumn, winter and spring. 10 out of 10, I'll say. But do you also know how this came to be? Your cheeks turn red ashamedly, but there is no need for that. I shall quickly tell you. The earth faces the sun at a slant. When the north is furthest away from the sun, it is winter in the northern hemisphere. In Australia, our antipodes in the southern hemisphere, it is summer at that time. And vice versa, of course. When the North Pole (i.e., the northern hemisphere which includes England, the Netherlands, Belgium, the United States, etc.) is turned towards the sun, the sun stands high above the horizon. It is warmer then because the sun's rays have

only a short distance to travel through the atmosphere. Why you suffer cold temperatures in winter is also easy to explain: the sun is in a low position and the rays need to travel a long way. They lose a lot of energy and you end up wearing a hat, waxing your skis and slaloming down snowy mountain slopes. Wow, you might well say, I feel like a true astronomer!

Congratulations, I reply, but that is not the end of my story.

Every year, on 21 June, summer starts in the northern regions. On that day the sun reaches the highest point in the sky. We all know this day as the longest day with the shortest night. For our antipodes the opposite applies: for them, it is the longest night, and winter begins. Over the course of one year, two other noticeable events take place: the moment when day and night are equal on both hemispheres, or the equinox. The spring equinox of one hemisphere is the autumn equinox of the other.

'I can understand all that,' I can hear you whisper nervously. 'Continue telling your story.' Whoa, take it easy, dear reader, because now I'm approaching the climax. The people of Atlantis and other old civilizations were clever guys. They employed astronomers who noted the positions of the Zodiac daily. After many years they suddenly discovered that something didn't tally. Slowly, very slowly, another star sign began to rise on the first day of spring (when day and night are of equal length). They were so impressed by this, that they gave the various star signs different names. The age of Pisces is coming to an end and during the spring equinox the sun will begin to rise against the new background of Aquarius. In the musical *Hair* they sing the praises of it in the song: "Age of Aquarius."

In the past decades this phenomenon has greatly influenced the popularity of the "new age." Loads of books and CDs have been published on the subject. However, one forgets that the "ancient wisdom" has created many myths around those occasions. They knew that the disorientation of the star systems did not last forever and held a disaster within. Therefore they wrapped many warnings in codes which disclosed the ultra-slow turning of the earth around the pole axis. To them the movement of the pole

Figure 15.
The Zodiac.

axis equaled the falling of the world tree at the end of an era. We saw the result of this in the dramatic events of Atlantis. That the Aquarian Age is disoriented is an irrefutable fact. Since approximately 100 BC the spring equinox has slowly moved through Pisces and is only now beginning its course through the second fish of this sign. Only in 2813 will it reach the same degree of longitude as the star of Bèta Piscium in the head of the fish; even if we are not too precise, we will not reach the border of Aquarius before the year 2300. Does this point to an imminent catastrophe?

In Egypt the Zodiac was "holy." Whenever a new age dawned, temples, gardens, statutes, sphinxes, etc., were rebuilt to make them fit in with the new age. The landscape architects (sons and daughters of Ptah, architect of heaven and earth) had to redraw everything to correspond with the radical changes of the "precession age." When the age of Taurus came to its end, architects and builders started work. Temples, sphinxes, statutes, etc., which were dedicated to Taurus, had to be taken down. After that everything had to be brought in agreement with the new age of Aries. For example, in Luxor whole lanes were constructed with sphinxes. They are still there, because when the age of Aries ended and the present age of Pisces began, the Egyptian civilization had disappeared. Therefore the pharaoh could not issue instructions to eradicate the remains of the previous age and to replace them by new ones. These interventions must not be underestimated. A temple made of thousands of stones, many weighing tons, is not readily pulled down. Hacking away rows of hieroglyphs and re-

liefs is not easily done. But the Egyptians didn't care about that. They were deeply religious and the Zodiac was highly thought of. Around the year 2100 BC the spring equinox moved into the sign of Aries. Historical sources reveal that the name "Mentoe," or Taurus, disappears and is replaced by the Ram of Amon (men). The Pharaohs add the name Amon to their names: Amenhotep, Amenophis, Tutankhamon. In one of the temple halls of Akh-Menor at Karnak, which is part of the Amon Temple, it is written: "retreat palace for the majestic Soul, High hall of Aries which travels through the sky." The reason the Egyptians considered the Zodiac so important can be found in the history of Aha-Men-Ptah, or Atlantis. From various tabloids and sacred texts Albert Slosman has been able to reconstruct the era of this country. It starts approximately 26,000 years before the arrival in Egypt! The first king is Ptah-Nou-Fi who wrote down the first "Mathematical Celestial Combinations" on leather rolls. In 864 years the sun had passed through 12 degrees of the Zodiac in the "belt" which spans the earth. The star sign which then disappeared he named Khi-Ath, or "Judge of the Hearts." He justified this name because the hearts of the people were weighed in that period to decide the difference between good and bad. Not long after that he gave this star sign the name of "The Scales" (Libra).

When I first read this, I did not pay attention to the numbers mentioned. Months later, having re-read it several times, something suddenly clicked. A circle is 360 degrees. Twelve degrees is one thirtieth of this: $360 \div 12 = 30$. Multiplying 864 by 30 results in 25,920. This is the duration of a whole Zodiac cycle! Also 12 equals the number of signs in the Zodiac. So these figures represented a certain code! It would still take months before I managed to crack the actually simple code. I explain it a few pages further on, as I will now continue with the history of Aha-Men-Ptah. As a new age had just started, Ptah-Nou-Fi named it after his mother who had given birth to him at a young "virgin" age. Seventy-one kings succeeded him during 2,592 years. During that time the civilization evolved and learned to live in harmony with the celestial rhythm. The 73rd descendant was still young when he was to be

crowned. At the very moment of his pompous consecration, a lion came to disrupt this traditional crowning. The young monarch dropped his crown and ran after the animal. It was a beautiful male specimen. He named it Er-Kaï, which means "strong as a lion." It should be noted that the Greeks renamed it Herakles, and we changed it to Hercules in our language. The centuries passed in this age of the Lion. After the sun arrived in the 32nd degree, the disaster took place. Land masses went down, sea levels rose catastrophically, the sun ran adrift in the sky and the earth revolved around its axis, after which she came to a halt in the same sign of Leo.

After this the movements of the sun, stars and planets were rigorously followed. The Lion not only became the symbol of strength but also of God and the Sun. After 1,440 years sign of Leo was left behind and the world returned to the sign of the Virgin. The queen of that time gave birth to a son, Ath-Aha-Ptah, who perfected the script in order to better note down the celestial commandments. The 2,592 years which the sun spent in this sign brought nothing but peace and justice, and many sciences as well as agriculture were brought to perfection. Then the age of Libra dawned, which this time served out its expected time of 1,872 years without problems. It was a golden time because everyone followed the celestial laws which provided that once per year the Master administered justice on existing disputes. Everyone went along with his verdicts, so hardly any contradictions existed. For this reason, the changeover to another age was viewed with great worry. This constellation did not yet have a name, which increased the feeling of uncertainty in the royal circles. As the date of the change came closer, the malaise increased. Changes in the light strength of some stars were seen as ill omens. In the 16th year of the New Age, the King was crushed to death when his palace collapsed; no one understood why it happened. His son had been staying in a different building and had survived. When the people wanted to inaugurate him the next day, he was found to have committed suicide. The priests, feeling the finger of God pointing at them, named this star sign after the scorpion, as this ani-

mal sometimes commits suicide. Thereafter, a cousin of the King ascended the throne; he reigned as a true tyrant. Sixty-one Kings succeeded him, all their reigns marked by injustice and continuous battles. The last King, the 64th, refused to marry even though he was surrounded by female beauties. He died without leaving behind any children. His succession was a bloody one. There were weeks of fighting. A distant relative managed to work his way up without mercy. Not only did he kill all other possible candidates, but also their parents, friends and family members. The priests administered the oath without protest. They called him Maka-Sati, or Archer. The college of the priests decided to also give this name to the new ruling constellation. This king organized a hunt in a forest northwest of the palace. In those days this was an extremely dangerous event, as they hunted mammoths. Normally such animals are peaceful, feeding only on plants, but when chased they become frightened and their enormous weight smashes whatever is in their way. Since the hunt involved an extraordinary species of giant animals, it is not surprising that it attracted many spectators. Only eight other hunters dared to accompany the new King. They did not bring anything but their bows and arrows. The invited audience viewed the spectacle from the terraces of the palace.

The monarch and the hunters approached the edge of the forest. Suddenly two mammoths charged in their direction they had been driven on by chasers who had reached the forest from the opposite side. The King pulled his bow as fast as lightning and shot four arrows within a few seconds. The first animal was hit in both eyes and fell down within a few feet of the monarch; the second mastodon went down in exactly the same way, but this one fell down against the King's horse. The other hunters had not even had the time to make a move! All the spectators watched this feat with admiration. There was no doubt that God had been in support of the King. From this day on they honored the King as the human-horse with the invisible arrows. For 16 generations he was succeeded by his descendants. The last, Maka-Aha-Sati, conducted a reign of terror as had never before been seen, and

dominated his people for 64 years. That is when the sun arrived in the 10th degree of Sagittarius. In the time span of one day a geological disaster took place, followed by a tidal wave. What had happened? Within a few hours the earth's axis had moved on 72 degrees, to the sign of Aquarius. This name was unanimously given to the new age, as the water had flooded everything! Only part of Aha-Men-Ptah remained after this cataclysm, the rest had disappeared under ice. This was all so shocking that the priests expanded their studies of the "Celestial Combinations" even further. The words of Dr. David D. Zink, author of *The Ancient Stones Speak* leapt into my mind: "Changes witnessed in the heavens and associated with these catastrophes led ancient man to precise observation of the skies...the beginning of astronomy was motivated by survival, not superstition."

Indeed it was. The temple of the "House of Life" was founded after this fatal day of 21 February 21,312 BC. The "experts of the numbers" were to study the celestial laws over 11,520 years. Two thousand years in advance they were to launch a warning about a coming catastrophe. In the year 10,000 BC the High Priest would launch the final plans for the forthcoming exodus of their beloved country. Within 208 years the inevitable was to happen. How clever they were we will see from their codes. You can find several in Figure 16.

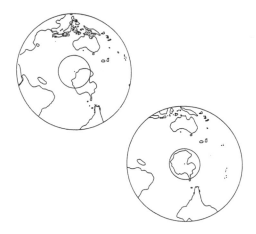

Figure 16.
Atlantis was partially destroyed after the cataclysm of 21 February 21,312 BC. The north was buried under the North Pole in existence at that time (the circle gives the polar region). The earth's poleshift of 27 July 9792 BC buried Atlantis (after the changes of the poles) completely under the South Pole!

6.
THE DURATION OF
THE ZODIACAL CYCLE

A code had been hidden in the description of Atlantis. What would the code look like? Simple: only a numeric message would be understood. Therefore, that's what it should be based on. Complicated calculations would be avoided. Thus, dividing, multiplying,subtraction and addition are the most logical choices. The codes were simple and had to lead swiftly to an easy-to-understand result. I learned from the book *Fingerprints of the Gods* that the decimal point could be ignored. That means that 2,592 is as correct as 25,920.

Like the original "Popol Vuh" (the holy manuscript of the Quiche tribe of the Maya), the story of Atlantis should contain clues to their prophecies of destruction. Those who wrote the story were "masters of the universe," which is also mentioned in the "Popol Vuh":

> They were endowed with intelligence; they saw and could see instantly far, they succeeded in seeing, they succeeded in knowing all that there is in the world. When they looked, instantly they saw all around them, and they contemplated in turn the arch of heaven and the round face of the Earth. The things hidden, they saw all, without first having to move; at once they saw the world, and so too, from where they were they saw it. Great was their wisdom.

With this in mind (hidden from the searcher and the thinker), I started to work. The Atlanteans had logical reasoning but also liked "playing" with numbers. So it is absolutely necessary to adopt their thinking pattern in order to find their way of reasoning. Their starting point is that only intelligent human beings are

*The Orion Prophecy*

allowed to break their code. The first indications of this are found in the history of their creation. And this stretches back tens of · thousands of years. When you're smart enough to find the first codes that are there, then you should be able to find all the other ones, because then their way of thinking will be familiar to you. This is at first a major adaptation. Try to understand the logic below, and you will already have managed quite a bit!

There are two numbers describing the "Creation" of Atlantis, 864 and 12. With these you can calculate several other numbers. If you continue using them in your calculations, you arrive at 25,920 years, the period of the entire zodiac. You have proven it before, but now you will do it differently, to learn to understand the Atlantean way of reasoning (people interested in mathematics: see Appendix).

But there is more. Their numbers inflamed my curiosity and through deduction I found code numbers of precessional astronomy. My findings prove that a hidden code exists packed full of clues and unmistakable clever math. It signals specific time-referents linking past to present and present to future. When decoded it pinpoints that a precessional cycle is about 25,920 years in the beginning. With this reasoning you can prove that they knew that when the precession changes to 25,776 years, the end of a cycle is near; which is now the case!

Further we will see that texts operate like "software" to real happenings and the monuments like "hardware." With that in mind we decoded the utmost important code of The Book of the Dead. The precession is very important in it. So don't underestimate these findings, because they all say the same: the end of a great cycle is very near! We have only a few years left!

In other words, they used their myths as vehicles for specific technical information and were capable of transmitting that information to us. What motivated them was logic: the survival of the human race. Almost everything of significance that they knew came from the stars. They were deeply concerned with astronomy and paid immense, steady and minute attention to the seasons, solstices and equinoxes. Those long-forgotten Newtons and

*80*

Einsteins were obsessed by measures, counting and numbers, and encoded them in their myths. They put it in powerful astronomical numbers and it is up to us to 'explain' their encoding of the precession of the equinoxes.

Our main findings are the following:

A full precessional cycle of 25,920 years never exists. Halfway through the cycle it is abruptly broken off. When a cycle reaches 25,776 years the precession will go the other way! East will become West and vice versa. This mechanism explains poleshifts, and the destruction of Atlantis. We will be destroyed by the same mechanism. To understand this decoding, look also at other chapters. It is the same math and as simple (see Chapter 23, The Dresden Codex Decoded).

Precession and the Magnetic Field

Scientists agree that precession affects our magnetic field. They are studying it intensely and many agree that magnetic field intensity waxes and wanes in a cycle. And we know that the precession changes in line with the magnetic field. During the last 2,000 years dipole field strength—hold your breath—has fallen 60%! This means that we are experiencing a precursor to a new reversal attempt. It could happen any moment. Normally, magnetic intensity falls gradually, but toward the end, it drops like a stone! Robert Coe found that the earth's magnetic field had reversed at the astonishingly rapid rate of eight degrees per day (or faster)—the same way as a light bulb glows dimmer as you turn a dimmer switch. Then, like a giant rheostat switched on, it glows again. But the North becomes the South, and vice versa. Between this, it fluctuates wildly. In *Nature*, Coe said: "Rapid fluctuations occurred many times during the reversal." He speculates further: "Enhanced external magnetic field activity... from the Sun might somehow cause the jumps." ("New Evidence for Extra-Ordinarily Rapid Change of the Geomagnetic Field During a Reversal", *Nature*, 20 April 1995).

With this in mind, it is good to know that this day is coming fast. Depending upon which way the earth is tilted, the world

floods, and most of the animals and people drown in a cataclysmic way. We read in the *Visud-dhi-Magga*, a book from ancient India, "... there are seven ages, each of which is separated from the previous one by a world catastrophe." Furthermore, we read that the book is written to preserve and pass down the wisdom of the antediluvian world.

The same is true of the Edfu Texts. Reymond confirms in her masterly study "Mythical Origin of the Egyptian Temple":

> The general tone of the record seems to convey the view that an ancient world was destroyed, and as a dead world it came to be the basis of a new period of creation which at first was the re-creation and resurrection of what once had existed in the past.

The Edfu Texts repeatedly state that the "Followers of Horus" had the knowledge—they knew the wisdom stemming from a previous epoch of the earth. It is this that we are decoding right now.

The Cycle of the Cataclysm

It is amazing and incredible that the Egyptians and the Atlanteans knew the number 25,776. Modern super-sophisticated astronomy has known about it only a few years! That alone makes clear how painstakingly accurate they were in their observations. And above that, they knew how to process their results brilliantly into simple series of numbers. These exist to warn us of the coming doom. The number proves that:

1) The astronomical knowledge of the Atlanteans is on the same level as the present computerized astronomy. It tells us that the end of a great cycle is near and that the cataclysm is going to happen any moment.

2) Their science was so advanced, that they knew much more than we think they knew.

3) These highly civilized people, super scientists in their time, had made large efforts to put their science into codes.

Figure 17.
The Zodiac!

The big question is now: why? Well, dear reader, you must know the answer by now. In the chapter on the big cataclysm that hit Atlantis, you read that the priests could predict this disaster. In the *Sing-li-ta-tsiurn-chow*, an ancient Chines encyclopedia, we find: "... in a general convulsion of nature, the sea is carried out of its bed, mountains spring out of the ground, rivers change their course, human beings and everything are ruined, and the ancient traces effaced."

That's what this science is all about! Fierce volcanic activity, destructive earthquakes, a giant tidal wave, the destruction of continents, and so on, are the result of events predicted by these numbers! The Egyptians described in their history several catastrophes and the periodic rebuilding of their world. So their myths are about catastrophes like the Flood. But the 'ages' that end in catastrophe and destroy a large part of mankind are due to the precession of the equinoxes. Obviously they attached great importance to it. Each civilization familiar with mathematics should be able to decode this message from ancient times. "Should," I'm clearly saying, because it is not always that simple. It took me months of racking my brains before finding these codes. And even then I stood only at the beginning of the story. And the snail's pace of the zodiacal precession is key! With certainty I could make the following conclusions:

•The zodiac describes the coming destruction of the earth.

• The zodiac still contains infinitely more codes to predict these events.

With these conclusions in mind, I started working. But where to look? I looked at the different durations of the zodiacal signs. Nowadays we count with equal periods for each age. But the Atlanteans didn't. To be precise, they should have taken 25,920 divided by 12 = 2,160 years. This was not the case for the Atlanteans. My intuition told me that that was where I had to look. The old scientists had put a "computer scheme" in their codes, I was sure of it. It was a question of finding it; that would bring me in direct contact with them. I managed to decipher a part of the incredibly long series of numbers, which describe the coming world chaos. You will read it in the next chapter. If you can divide, add, subtract and multiply, you will surely be able to follow my calculations. But don't forget I only found a part of it! Others will surely be able to find much more! I welcome them with open arms!

7.
THE DURATION OF
THE VARIOUS AGES

At present we calculate that an age remains for 2,148 years in its constellation. The Atlanteans calculated differently. They knew the star signs didn't all have the same sizes and therefore they used different periods. With help of the book *Le Grand Cataclysme,*I was able to find eight ages with their respective durations:

Leo	2,592
Virgo	2,592
Aries	2,304
Taurus	2,304
Pisces	2,016
Gemini	1,872
Cancer	1,872

The duration of the various ages was also different according to the Egyptians. The difference between the longest and shortest cycle was 720 years.

When looking at the zodiac, you'll notice that Aries and Taurus are next to one another. They have the same duration, 2,304 years. That is also true for Gemini and Cancer, as it is for Leo and Virgo. Since the sign of Aquarius is next to the sign Pisces, they have the same duration of 2,016 years. Do the same for Scorpio. It is next to Libra and you must count 1,872 years. The cumulative duration of the entire cycle is 25,920 years.

Virgo	= Leo	= 2,592
Aries	= Taurus	= 2,304
Capricorn	= Sagittarius	= 2,304
Pisces	= Aquarius	= 2,016
Scorpio	= Libra	= 1,872
Cancer	= Gemini	= 1,872

Total Duration = 25,920 years

Zodiacal Series of Numbers

The duration of the different eras can be put into a specific series of numbers: there is no other possibility!

I found this series after having subtracted the shortest period from the longest (2,592 – 1,872 = 720). That is ten times 72. After a bit of calculation, I noticed that other subtractions also brought me to multiples of 72. Putting them in order from high to low, following the multiples of 72, I then got:

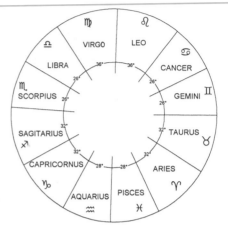

Figure 18.
The Zodiac of the Egyptians.

$$2,592 - 1,872 = 720 = 72 \times 10$$
$$2,592 - 2,016 = 576 = 72 \times 8$$
$$2,304 - 1,872 = 432 = 72 \times 6$$
$$2,304 - 2,016 = 288 = 72 \times 4$$
$$2,016 - 1,872 = 144 = 72 \times 2$$

The number 432 has a central position and equals 1/6 of the duration of the zodiac, 4,320 x 6 = 25,920. You have to multiply this by six because next to 432 you find the series 72 x 6.

Further conclusions: The signs with a period of 2,592 and 2,016 are in this series at the top and at the bottom, this means, in opposition, just as in the real zodiac. The signs with a duration of 2,304 and 1,872 are in the middle.

I discovered yet more series of numbers. In the above calculations you see next to the series of multiples of 72, the equivalent multiplications (for instance: 720 = 72 x 10). When multiplying the multiples with the equivalent numbers from the multiples, I arrived at the following series:

$$720 \times 10 = 7,200$$
$$576 \times 8 = 4,608$$

432 x 6 = 2,592
288 x 4 = 1,152
144 x 2 = 288

In this last series I subtracted from the highest number (7,200) the number just below it (4,608). That gave me the number 2,592, which is a very important one. Therefore I repeated this exercise a few times. A series of four numbers appeared. Another subtraction, following the same method, gave the answer 576 three times. A remarkable result, leading to the solution:

7,200 – 4,608 = 2,592 2,592 – 2,016 = 576
4,608 – 2,592 = 2,016 2,016 – 1,440 = 576
2,592 – 1,152 = 1,440 1,440 – 864 = 576
1,152 – 288 = 864

You see 576 three times, so you multiply it by three: 576 x 3 = 1,728. When dividing the first series of numbers by this number, you obtain:

7,200 ÷ 1,728 = 4.1666666
4,608 ÷ 1,728 = 2.,6666666
2,592 ÷ 1,728 = 1.5
1,152 ÷ 1,728 = 0.6666666
288 ÷ 1,728 = 0.1666666

When subtracting the found series twice from each other, as above, you arrive at:

4.1666666 – 2.666666 = 1.5
2.6666666 – 1.5 = 1.1666666
1.5 – 0.666666 = 0.8333333
0.6666666 – 0.1666666 = 0.5

1.5 – 1.1666666 = 0.333333
1.1666666 – 0.8333333 = 0.333333
0.833333 – 0.5 = 0.333333

The series are clear: something has to be divided by or multiplied by three!

After some searching, I found the link. The numbers 288 and 864 can be found in the above calculations at the bottom of the series where I found 576 three times as the end result; so, it is logical that these have to be multiplied by three.

288 x 3 = 864
864 x 3 = 2,592

Both numbers point at codes which I break in the next part.

864 ÷ 2,592 = 0.3333333

864 is the first period in a star progression of Atlantis. 2,592 is the second period. If you have to divide 864 by 2,592, then this means you have to follow the same procedure for all following periods!

The Secret Codes of the Zodiac of Atlantis

Duration	Age	Cumulative Duration	
864	Libra	864	864 ÷ 2,592 = 0.333333
2,592	Virgo	3,456	3,456 ÷ 2,592 = 1.333333
2,448	Leo Cataclysm*	5,904	5,904 ÷ 2,592 = 2.277777
1,440	Leo	7,344	7,344 ÷ 2,592 = 2.833333
2,592	Virgo	9,936	9,936 ÷ 2,592 = 3.833333
1,872	Libra	11,808	11,808 ÷ 2,592 = 4.555555
1,872	Scorpio	13,680	13,680 ÷ 2,592 = 5.277777
720	Sag. Cataclysm*	14,400	14,400 ÷ 2,592 = 5.555555
576	Aquarius	14,976	14,976 ÷ 2,592 = 5.777777
2,016	Pisces	16,992	16,992 ÷ 2,592 = 6.555555
2,304	Aries	19,296	19,296 ÷ 2,592 = 7.444444
2,304	Taurus	21,600	21,600 ÷ 2,592 = 8.333333
1,872	Gemini	23,472	23,472 ÷ 2,592 = 9.055555
1,872	Cancer	25,344	25,344 ÷ 2,592 = 9.777777
576	Leo Cataclysm*	25,920	25,920 ÷ 2,592 = 10.0!

*In these years, a cataclysm took place during which the earth was subject to major changes.

In the last year of this cycle, we notice the number 10. That year Atlantis was completely destroyed!

After the discovery of these series of numbers, I grew silent for a moment. I had to contemplate it. Their calculations showed clearly enough, that the earth could never travel a full cycle of the zodiac! Every so many thousand years, something disastrous happened, which reversed the movement through the zodiac; but how they were able to predict the end of the world remained a mystery to me! Here and there I see a ray of hope to continue unraveling their codes. When, for instance, you're studying the movement through the zodiac before and after each cataclysm, then you notice that sometimes there have been drastic shifts. Before the first cataclysm, the zodiac went from the star sign Libra to Leo (Libra ➡ Virgo ➡ Leo). In Leo, the earth's surface changed drastically, land parts sank below the sea, new islands arose, volcanoes erupted, and so on. After everything had gone quiet again, it seemed that a large turnabout in the precession of the zodiac had taken place: it now went the other way around!

In other words, a certain mechanism, an event in the interior of the earth, had turned upside-down. That made the movement go as follows: Leo ➡ Virgo ➡ Libra. A couple of weeks before, I had read an article about the reversal of the earth's magnetic field. A good thing that I had kept it. I read it again with full attention. Soon I was convinced that it contained an important key to the solution of the mystery. I will summarize it here for you: The fiery part of the earth, "the magma," weighs about 15 billion tons. In its center, a core rotates at a speed just a little bit higher than the surrounding masses. The solid inner core of the earth has a radius of 1,200 kilometers and "floats" in the fluid syrupy outer core, which has a radius of 3,500 kilometers. Both consist largely of iron. The temperature of the inner core is higher than that of the outer core, so you would expect that the inner core would also be fluid. But, because the pressure is higher than that in the outer core, the iron can't melt. Through the transfer of warmth, convection currents appear in the outer core. These currents generate a magnetic field, which enforces itself. The outer core can be

considered a self-enforcing dynamo, just like the dynamo of a bike. Instead of light, it generates magnetism. This can be assessed with a compass, which points to the lines of force. Really important is what follows from the discovery that the inner core rotates 1.1 degree further than the earth's mantle. This means that the inner core is 0.8 seconds faster per day, and that at the border of the inner and outer core, there is a shift of about seventy meters each day.

I was thinking,'That could be the explanation for the precession of the zodiac! Because if the rotation of the mantle of the earth is slower than the inner core, then there must be an effect, however small this would be.'

To be precise, the earth "turns" in the zodiac in 25,920 years. This matches a rotation of the earth about its axis of 360 degrees. Since the earth rotates about its axis in one day, this means we fall 24 hours behind. That made a bell ring! Twenty-four hours matches a specific number of seconds. There are sixty seconds in one minute, and in one hour $60 \times 60 = 3,600$. Multiply this by 24 and you get 86,400.

"How is it possible," I was saying out loud, "the Atlanteans have manipulated time to such an extend that it can be used to calculate the code of the precession of the zodiac!"

It is not really that difficult. The only thing you have to do is divide. If the earth falls 86,400 seconds behind in 25,920 years, then this implicates a yearly change of $86,400 \div 25,920 = 3.33333333$ seconds, exactly the series of numbers I had already found in the zodiac! I was really stunned. Those darn Atlanteans were not only at the cradle of our mathematics, but also of our time! And all this is an indication to us that the change in rotation time of the earth turns on a mechanism, which can only end in a catastrophe. That was their way to describe the mysterious behavior of the magnetic field of the earth.

Let's now take a look at the other cataclysms. Before the second one, the earth moved from the sign Scorpio to Sagittarius. In one blow, the earth was then catapulted to the age of Aquarius. The movement didn't reverse there. As we have seen above, this

movement has its origin in the self-willed behavior of the earth's core. Since there was only a sudden shift of ages, this proves that the earth's core kept turning in the same direction. If it had reversed, then the ages should have gone in the opposite direction, as before and after the first cataclysm.

Finally we get to the third cataclysm, the one which destroyed Atlantis completely. The day of the destruction as well as the magnitude of the catastrophe has been predicted correctly, based on the previous data. It is something I still don't understand, though I have made desperate attempts. What I have been able to deduce, is that the zodiac went from Cancer to Leo and then stopped abruptly. The magnetic field of the earth changed, the inner core went in the other direction and the zodiac was traveled through, in the opposite direction. That's the movement we're still following now. How will this end?

To be able to calculate this, we have to adopt the way of thinking of the Atlanteans and Egyptians. Their supposition was that there was a force R coming out of the universe. With, as a starting point, the postulation that each action is followed by a reaction, R is the result of the interaction of the elements—the thinking of the human beings and their reflected image in the mirror. It is from this duality of Good and Evil, from the human being and his reflected image, that the priests were able to calculate the "Mathematical Celestial Combinations." Based on this and on the diverse combinations of radiation from the enormous suns of the zodiacal signs, they were able to obtain absolute numbers which could predict Good and Evil. It probably sounds somewhat complicated, but, as I demonstrated before, sequences of simple series of numbers are behind all this: a mere question of finding the code. The same strategy needs to be followed for further unraveling of the secrets of Atlantis. It was their point of view that later generations, because of the events, would not be able to read their holy texts. Only a numeric message would be understood and decoded. The "Mathematical Combinations" I have already discovered prove this. They only have to be inserted into a giant plan, of which they are a part, a blueprint of a millennia-

old computer plan. In order to accomplish this, we probably need to have a whole lot more data than we have now. They can only be found through further excavations or by putting all astronomical data we possess through new scrutiny. Both possibilities need to be studied urgently, because at the transition from the age of Pisces to the age of Aquarius, the earth will be destroyed. The old scriptures prove that:

1) The Atlanteans were able to determine the exact day of the destruction of their world, based on the "Mathematical Celestial Combinations."

2) These "Combinations" are connected with the passage of the different signs of the zodiac.

3) The planets are of significance in the determination of the "end-date" of an era. The planet Venus is especially important to the Maya.

Based on these data, it has to be possible to break the code of the Master Plan which is behind this all. I have an urgent request to everybody—astronomers, mathematicians, physicists and so on, to try to unravel it. If we don't succeed in time, then the world will be destroyed, without having had a serious warning. But we may also find this knowledge in the monuments left by our predecessors.

8.
THE LABYRINTH: SUPERBUILDING OF THE OLD EGYPTIANS

After reading about the events in Atlantis, I was baffled. How on earth was it possible that the Atlanteans could determine the destruction of their country? A couple of times they mentioned the "Mathematical Celestial Combinations" on which the prediction was based. I remembered reading something about it in Slosman's previous book. After having looked for it for quite a while, I found it. According to the annals, the survivors had made a construction in Egypt immediately after their arrival there: a temple in honor of the creator to express their gratitude for arriving in their second fatherland. Their second immediate action was to build an observatory where one could study the "Mathematical Celestial Combinations." It was built alongside the Nile, the hieroglyph for which corresponds with the Milky Way. When putting the map of the Nile alongside the map of the Milky Way there clearly is a visual resemblance. Several important stars from the Milky Way correspond with places where temples have been built.

As mentioned before, the survivors of the catastrophe had built a primary observation post right after their arrival in their new realm; this observatory does not exist anymore. There they kept the positions of stars and planets. Together, these data formed specific geometrical combinations of which the major harmonic laws were deduced. Diodorus Siculus of Sicily confirms this search for living in harmony on earth with the consent of the heavens. The following is written in chapter 89 of his first book: "Nowhere else can be found such an exact observation of the positions and the movements of stars and planets as with the Egyptians. They possess all observations, which they made year after year, going

back to incredibly ancient times!

This confirms the high priests being "Masters of Mathematics and Numbers," and this from time immemorial. With these astronomical data and based on their "Mathematical Celestial Combinations," they were able to make predictions on planetary movement, their rotation time and many other stellar phenomena, and all this without effort. I gasped for breath after reading this. If we possessed this knowledge, then we would be able to fight successfully all opposition to the fact of the coming cataclysm! We would surely find enough indications for the incontestable evidential value of their findings. But where to look? Calmly I reread the rest, which I had already read a couple of weeks ago. This told us that the followers of Seth and Horus had continued dividing the country for thousands of years. Exhausted from a war which had lasted for millennia it was decided to unite the followers of Seth and Horus. It was then that it was decided to built an astronomical center, identical to the one in Atlantis. The year was 4608 BC, when the era of the Bull began. The enormous work was completed 365 years later. On the day that God had predestined for this event, Athothis (Thoth) would officially declare the unification of Egypt. Some research tells us that the first day of Thoth was 19 July 4243 BC. From then on, the Sothic era began, and with it, the classical Egyptian calendar.

Undoubtedly there was a deeper significance in all this. This was not only the celebration of the unification, but also of certain cycles of the sun, moon and stars. Egyptian agriculturists needed a special calendar to make their predictions of the annual flooding of the Nile more accurately. For the Sothic Calendar the Egyptians used a year based on 365 days. It was divided into twelve months of thirty days, and an additional five divine days. After four years this calendar was not correct anymore and one whole day was added to one year to synchronize it. Of course the Egyptians knew a year existed of 365.25 days, but they refused to count this way because their holy calendar contained the numbers on which the predicted end of the world was based. With the use of the new calendar the farmers gained more insight into the cyclic

flooding of the Nile, and didn't always have to get the advice of the high priests.

In addition to these two calendars they also used a moon calendar, counting alternately 29 and 30 days, and fitting in a cycle of precisely 25 years of 365 days. The French researcher Schwaller de Lubicz noted that this time span matched 309 moon-periods. He calculated:

25 x 365 = 9,125 days

9,125 ÷ 309 = 29.5307 days per moon period

This is an extremely accurate result. Modern astronomy uses a moon period of 29.53059 days, a difference of only one second! This Egyptian calendar can be considered—and rightly so—as a wonder of precision.

Let's return now to the unification of Egypt. At the bank of the Nile a public worship ceremony took place. Two high priests addressed the Nile and spoke: "Your Heavenly sources enable us to live, because they allow our lands to be flooded every year."

To the public they said: "From now on you will live in harmony with God's laws and orders, because they will grant you life on earth as well as in heaven. Fertilize the earth for your work and in turn it will provide you with cereals!"

To the heads of both factions they swore: "Your authority remains the symbol of all your actions because the way you govern will determine the happiness of your people."

With their hands raised to heaven, they spoke to God: "Oh Lord of eternity, You who knows everything! May Your law and orders rule from this day on and may our lives be trouble-free. May our children follow our example, conform to Your harmony, without a new catastrophe happening! May Your heavenly wisdom, which You offered us by means of the Mathematical Celestial Combinations, fill us all and inspire us to restrain from evil actions which could provoke your anger."

It was after this memorable day that the construction of a large astronomic center began. Its name was "Circle of Gold" and it contained two temples: "The Double House of Life" and "The

Temple of the Lady from Heaven: Isis." Two different schools were in it: those studying the nightly firmament and reproducing it on earth; and others preferring a more mathematical study, where everything was theoretical, without watching the sky. This given, they possessed an incredible amount of possible combinations in relation to the sun, planets and stars of the zodiac. Because the Egyptians divided each of the twelve constellations of the zodiac into three, this gives us thirty-six possibilities. When multiplying the planets with this number it gives $7 \times 36 = 252$. Once more multiplied with twelve it gives $252 \times 12 = 3{,}024$. That's how many chambers the building had!

The Description of Herodotus

Herodotus had seen a part of it and written about it in a book. To get to know more about it, I had to find Herodotus's description. I searched a number of libraries, but in vain. I did find several references, but no clues. I decided to let it rest for a while. Then the catalog of a Dutch book club arrived in my mailbox. As always, I browsed through it with curiosity, and there it was! The title jumped right out at me: *Herodotus: The Report of My Research*. It proved to be a unique Dutch translation. A few days later I bought the book; it contained more than 700 pages. I started reading immediately once I got home. It began: "Herodotus is my name, I am from Halikarnassos and am now telling the world about the research I did to keep the memory of the past alive and to immortalize the great, impressive works of the Greeks and other people."

That could really count as opening words. I was highly interested and could have read the book in one sitting. Luckily, my common sense told me to stop. It would take me several days and I didn't have that time now. Rapidly, I looked through the index and opened the book to the page about the labyrinth. It said:

As a token of their unanimity they decided to leave a memorial and that led to the building of the labyrinth, which

Figure 19.
Impression of the labyrinth.

is situated not far from the southern bank of the Moeris lake, in the neighborhood of a place called Crocodilopolis. I have been there and it is beyond all description. If you would make a survey of all city walls and public buildings in Greece, you will see that all together they did not require so much effort nor money as this labyrinth. And the temples in Efesse and Samos aren't exactly small works, either! It is true, the pyramids leave you speechless and each and every one of them equals many of our Greek buildings, but they cannot stand comparison with the labyrinth.

I was overwhelmed by these words. The Giza pyramids are considered the most impressive buildings from ancient times. And yet, according to Herodotus, who also gave an elaborate description of the pyramids, the labyrinth surpassed them all! Realizing this excited me terribly. Eagerly I went on reading his report: "To start, it has a dozen indoor gardens of which six are in a row at the northern side and six at the southern side. They are built in such a manner that their portals are face to face. An exterior wall without openings surrounds the entire complex. The building itself is a two-storied one and has 3,000 chambers of which half of these are underground and the other 15,000 are on the ground floor."

Again I had to stop reading. Three-thousand rooms with indoor gardens and one single ring wall encircling the building. A more gigantic building than this would not be possible! Half of the rooms were above ground and the other half below. Imagine rooms with a length of only two meters, and the total length would be three kilometers! That gave me dizzy spells. This had to be the largest building ever! No doubt about it. Why wasn't it known better? Could it have vanished from the earth? It was still there in 448 BC. Has it been taken apart since then and used for other buildings?

I called Gino. "Gino, this is Patrick. I have a few questions. Do you know whether any large, new buildings were built in Egypt after 450 BC? I mean, before the modern era."

"Why do you ask?"

"I have read the description of the labyrinth in the histories of Herodotus. It must be unbelievably large! Something like that can only disappear if it were pulled down!"

"Let me think. No, I know nothing of any large monuments being built after that date. Pyramids weren't built anymore and temples were mainly only maintained; there wasn't really much building."

"Not even by the Romans?"

"Not that I know of. But of course it could have been used to build houses."

"Have you ever read anything about that?"

"No, never. If it is really that big, then at least something had to be written about it."

After this short conversation I was sure: the largest building ever built still existed! It lay hidden somewhere under tons of desert sand. Where was I with my text? Oh, yes, here! Intrigued, I continued reading. Said Herodotus:

> I visited and looked at the fifteen-hundred ground-floor chambers myself, so I speak from personal experience, but for the underground chambers I have to rely on the authority of others, because the Egyptians refused to let me in. There, the tombs can be found of the kings that originally built the labyrinth, and of the holy crocodiles. So I have not been there and everything I know about it, I know from hearsay. The rooms on top of them have indeed been shown to me. You would not believe they were built by human hands. The passages interconnecting the chambers and the winding paths from court to court were breathtaking in their colorful variety, as I walked in full admiration from the courtyard to the chambers, from the chambers to the colonnades, from the colonnades to again other chambers and from there into still more courtyards. The ceiling of all these places where made of stone, just as the walls which are covered with relief-figures. Each courtyard is surrounded with a row of white marble, seamless columns.

"Good God," I groaned. What luxury! And nowhere is it mentioned that it had been plundered or demolished! But then, where was this monumental labyrinth, with the tombs of the twelve kings? Undoubtedly, there must be the biggest treasures ever to be found in Egypt! Tutankhamun's treasury is nothing compared to this. That is something you can be sure of. I became more and more excited. If the upper rooms were gone, then at least the underground rooms would still be there. Just a question of finding a trace of the gigantic wall and the fundament of the colonnades. Once those were found, one would easily be able to reach the 1,500 chambers where messages from ancient times lay waiting to be deciphered. This possibility fascinated me utterly. It would be impossible to make a more sensational discovery! The whole world would be extremely excited when this still-unknown wonder of the world was opened up. Yet, to find it, I first had to discover a link to the place where I had to look. With burning head, I read on: "Right by the corner where the labyrinth stops, stands a pyramid of at least seventy-five meters high and decorated with a relief of large animal figures. It can be reached through an underground passage."

Aha! That was a serious clue! A pyramid with animal figures! I called Gino again: "Gino, have you ever heard of a pyramid with animal figures on it?"

"What do you mean?"

"According to Herodotus, close to the labyrinth, there should be a pyramid 75 meters high, and with large animal figures cut out in relief."

There was silence for a while at the other end of the line. I was hoping for a breakthrough, but Gino's words were a blow for my unbridled enthusiasm: "To be honest, I have never heard of such a thing. But that doesn't mean anything, because the Giza pyramids were covered in white limestone. After Cairo was demolished by an earthquake, they were dismantled and the limestone was used for the reconstruction of citadels and other works of art. Those blocks were covered with countless drawings and hieroglyphs, which are all lost. The same thing could have hap-

pened with this pyramid. In that case, the only thing that's left is a pyramid with blocks made of rocks!"

I was so miserable, I felt like cursing. Every lead seemed to go down a blind alley. But come on, let's get going again. Maybe I can find another indication in Herodotus' work. Sometimes you don't need very much; a pyramid or building 75 meters high and with animal figures on it is sufficient. But where was it located and does it still exist? Unhappy, I shook my head and went on reading in the report written almost 2,500 years ago. Herodotus continued:

> But, however spectacular this labyrinth is, the lake Moeris, right next to it, makes one really gasp. Its perimeter is 3,600 stadiums or sixty schoinoi—666 kilometers—as long as the entire Egyptian coastline. This long, drawn-out lake has a north-south orientation and its depth is more than ninety meters at its deepest. It is probably man-made because in the middle are two pyramids, each reaching ninety meters above the water, while their base is equally far under water.

Here I had to quit. Pyramids of a height of 180 meters? That was difficult to believe. Probably Herodotus meant buildings or colossi. Besides, a footnote said that Herodotus possibly meant the colossi of Biahmu; further indications were lacking. It didn't make things easier. It was painful. I sighed and read on:

> On top of each of the buildings is a statue representing a man on a throne. If you would calculate the complete height, you would come to nineteen meters, because a hundred fathom equals one stadium of six-hundred feet—a fathom counts six feet or four ell and a foot equals four palms, so an ell is six palms (a foot is 29.6 cm, a fathom is 178 cm, an ell 44.4 and a palm about 7.2 cm).

With this I had a new lead. Those statues in stone of men on a throne—yes, there could be something in it. If, after the probable silting up of the lake they were not moved too far away, then it might get us somewhere. It was a track worth following. Later on, I would try to give it the necessary attention. In the mean-

time, I kept on reading:

> The lake is not getting water from natural sources, that
> would be impossible because the surrounding country is
> bone-dry; no, a canal is its connection to the Nile. Through
> the canal the water flows into the lake during half a year
> and the other six months it flows back into the river again.
> The profit for the royal treasury during this period is at least
> one silver talent per day because of the fish that are caught
> there.

All right, I thought, the location has to be found in the desert.
There are no natural sources, which means that if there is no longer
a connection with the Nile the lake dries out completely. How-
ever hard you would look for it today you would not find any
water! Herodotus continued: "The inhabitants of that region told
me there was a tunnel from the lake to the Sirte in Libya, and, this
way, getting far inland via the west side of a mountain region
south from Memphis." Another clue. There had to be a mountain
region not far from Memphis in the direction of the interior of the
country. That might possibly be helpful in finding the location of
the lake. But it wouldn't be easy. Of that, I could be sure. But,
nothing ventured, nothing gained. It was probably a question of
working the data. I wrote everything down in an orderly fashion
and mailed it to Gino. A couple of weeks later, on a Sunday, he
called me.

"I think I know the location of the labyrinth," he said.

"How did you manage that?" I asked, surprised.

"The construction started in the age of Taurus. The Hyades
are a labyrinth of stars. I calculated their position on earth with
the pyramids (representing Orion) and Dendera (representing the
star Deneb) as points of reference. That's all I have for the mo-
ment. Can you come over and have a look at it?"

"How about tomorrow night?"

"Fine, I'll be expecting you."

The next evening we were studying the maps. With pride Gino
showed me the place Haouara. "That's were it must be," he said,
self-assured. I looked at the location and nodded my head. It

Figure 20.
The location of the labyrinth.

seemed possible. Only a thorough analysis on the location itself would give us a definite answer. But something was still bothering me. The name Haouara strongly resembled another name I had read somewhere. I let it rest as Gino explained further: "According to the tradition, the pharaoh—after his death—had to pass through a labyrinth before ascending to the stars. Nowadays the astronomers call the Hyades "the labyrinth" because the stars seem to form an inextricable knot. That had to be the same to the ancient Egyptians. Hence my theory that it has to be there."

There is no flaw in that argument. For now, that is. The minute I got home I dove into an encyclopedia about Egypt. Soon enough I found Hawara. This was the English word for the French Haouara! I was stupefied because it seemed the labyrinth described by Herodotus would indeed be there! I was stunned! Was this the end of my search?

Amazed, I started reading:

Most Egyptologists are of the opinion the labyrinth was discovered in 1843 by the famous German archaeologist Richard Lepsius (who died at the age of 34). It was about Lepsius's discovery of the burial pyramid with surrounding ruins of pharaoh Amenemhet III (1844-1797 BC), not far from the oasis El Fayum. Lepsius wrote about this: the positioning of the whole is in such a way that three large groups of buildings with a width of three-hundred feet enclose a rectangular place six-hundred feet long and five-hundred

feet wide. The fourth side, one of the smaller sides, is bordered by the pyramid lying behind it; this pyramid measures three-hundred square feet and thus does not completely reach the wing of the buildings!

After having studied the map that came with it, I strongly doubted this would be the labyrinth.

The description disagrees completely with the earlier indications of Herodotus. In Hawara the pyramid follows the same axis as the temple ruins. According to Herodotus the pyramid was in a corner. And there isn't any mention of walls filled with reliefs, gigantic construction, an underground part of 1,500 chambers, marble columns and so on. And where, by all archaeologists, are the graves of the mythical pharaohs? Lepsius found no trace of those! Then what exactly did he discover? Hundreds of rooms next to and on top of each other, of which some are small and others smaller. So that couldn't be the labyrinth! I decided to leave it and go to bed. The next evening I called Gino: "Gino, I have to congratulate you, and disappoint you!"

"Why is that?"

"Well, the place you calculated is the exact place where a labyrinth has been found. But—and here comes a big "but"—the description of the complex does not match at all what Herodotus says about it. Don't you have an encyclopedia on Egypt where we might find something more?"

"But of course! I completely forgot about it!" An hour later Gino called back: "You're right, Patrick. On pages 513 and 514 it is clearly stated that the excavations that were carried out there don't match history."

"Could you make a copy for me by Saturday?"

"No problem!"

The next Saturday Gino brought me not only copies on the labyrinth, but also on an old Egyptian manuscript that was mentioned in a book about the pyramids. He told me it was something really special. But that was for later, because first we looked at the movement of the zodiac above the pyramids. That night we didn't discover anything new, and the next day I read the text

on the labyrinth. Partly it was Herodotus' description, but it also mentioned that Strabo had written about it. The Greek geographer Strabo reports in the seventeenth part of his *Geographica* in chapter 37: "A colonnade surrounds a series of adjacent palace chambers, all in one row and all following one wall. In front of the entrances are a large number of low, covered passages with many twists and curves, so that without a guide, it is impossible to find a specific palace room or even the way out."

This set me dreaming for a while. It was not surprising they called it the labyrinth. If we found it, we would probably get lost! I read on: "The ceiling of each of these chambers consists of one piece of stone. Also the walls of the covered passages are finished with extraordinary large stones. Nowhere there has been used wood or other building material."

I was as much impressed by the construction as Strabo must have been. Whatever happened to this legendary complex? In the year 25 BC, when Strabo visited it, it was still there. As he described it, enormous monoliths were used to construct it. Such gigantic stones could not have been used to build other things with. I was very sure now; the astronomic observatory was still in its place! But where? That was the question that would not leave me until I found it! Alas, I didn't have much time left. Sixteen years and four days from now the greatest catastrophe in history would take place. This complex has to be found before that date and preferably years before. Otherwise it will not only be destroyed but it will also be too late to warn mankind about the oncoming catastrophe...

I also read the following in the copies:

The situation in the Middle Kingdom was such that the construction is a realistic possibility because it could have been dedicated to the unification of the country—both administrative and practical. It could symbolize a monumental construction expressing unity. Furthermore, it could have had an important administrative function in the new unified state. But this solution is not the complete explanation of the riddle. This complex architectonic building, accord-

ing to Strabo and Herodotus, has such gigantic dimensions that it had no equal in Egypt. The question is, has it been able to withstand time, because there have been no restoration works in a very long time. To solve this problem once and for all, new excavations based on all known historical and archaeological knowledge are necessary.

I could do nothing but agree with this conclusion. It is a question of first looking at the matter in a theoretical way and then doing the necessary assessments on location. It must be possible! I am completely convinced of that!

Facts About the Labyrinth

- Largest man-made building ever.
- The construction took 365 years (from 4608—4243 BC).
- Diameter from East to West: 48,000 Egyptian elbows (one Egyptian elbow = 0.524 meter). 48,000 x 0.524 =8.384 km!
- Contains 'Circle of Gold,' legendary chamber, alluded to in The Book of the Dead. It is made of granite and sheathed in gold filled with a technological legacy left by a lost civilization far older than Egypt itself.
- The astronomical knowledge of the Egyptians is written on large walls. All their astronomical findings can be read from the hieroglyphs. All the star constellations are on one gigantic zodiac!
- Many walls can move. This makes it a real labyrinth! Ancient texts talk about people that lost their way and died. They also speak of secret chambers located in the labyrinth filled with artifacts and documents from a civilization that flourished on a global scale thousands of years ago.
- Contains rooms with documents on the history of Egypt and their astronomical knowledge.
- How they calculated the last polar reversal is written on 36 super-large hieroglyphs. This is the knowledge we have urgently to find! Also the calculations to the year 2012 can be found there.

9.
STAR SIGNS

The main reason for our journey to Egypt—which included a search for the labyrinth—was Gino's discovery of a connection between the Milky Way and several pyramids and temples of Egypt. He had noticed this while putting a map of Egypt next to one of the Milky Way. He immediately saw that the temple of Dendera had to correspond with the star Deneb in the constellation Cygnus. One of the turns in the Nile in the area of Dendera even corresponds exactly with the Milky Way. It is almost as if it was constructed. Such a similarity could not possibly be a coincidence. This finding implies that the Egyptians could accurately determine positions with a distance of 800 kilometers between them, an extremely difficult matter which can be matched only with the most modern equipment. If, of course, the theory is correct. So we decided to buy a Global Positioning System (GPS) an instrument which—via satellites—can determine a position exactly from a certain location.

Dendera is the Star Deneb
Dendera, Egypt, Tuesday 25 March 1997. The trip from our hotel to Dendera was an adventure in itself. Just prior to our visit, dozens of people had died under terrorist attacks. Only under special police protection were we allowed to travel to the temple. We passed one control post after another, and many, many soldiers. It was as if a war had been declared. At the entrance of the temple, Gino met Mohammed Aldawy Barbary, archaeologist and chief of security. He stayed with us for hours and made it possible for us to stay there the whole day. That was really good fortune. He confirmed to us that Dendera had been associated with the star Deneb, as we had postulated.

With our first steps into the temple an overwhelming feeling hit us. Everything radiated grandeur and power. The day before

we had visited The Valley of the Kings, but it couldn't compare with Dendera.

Here, everything was more mysterious, more enigmatic, more complex. As if a hidden power was behind it. An unfathomable and deep source of knowledge—and it was up to us to try to unravel it. We looked with astonishment at the wonderful columns and the exquisite ceilings. A guide came to us. He showed us subterranean arches and told us that many items in the temple were based on the number 12: 12 signs of the zodiac, 12 columns, 12 poles in the sundial, etc. He showed us a specific place in the middle of the temple where they used to sing. Mirjam and Brigit, who traveled with us, were standing there, face to face in that small space. Their singing sounded unearthly beautiful, and shivers of pleasure traveled through my body. It seemed as if the whole building quivered and vibrated with them. I imagined being a pharaoh. Tradition tells us this ritual was performed at sunrise and sundown. If it had been up to me, it would have lasted forever. After they finished singing, we continued studying the temple. Up on the roof we took the important coordinates with our GPS. Then we admired the copy of the zodiacal table. The original is in the Louvre in Paris, but its condition is worse. It was here that Gino noticed a first deviation in the concept. According to his measurements the zodiac was directed to the north, with a deviation of five degrees in an eastern direction. Since it was a copy it could be a coincidence. So he decided to measure the south-north axis of the temple. To his astonishment it also showed a deviation of five degrees in the eastern direction.

I thought this through and found a possible explanation: A circle has 360 degrees. Divide 360 by 5 and you get 72.

Multiply this by 360 and you find the number indicating the precession of the zodiac: $360 \times 72 = 25{,}920 =$ precession. Since the temple was dedicated to the zodiac, it could be a good explanation. Later on, another plausible hypothesis came forward.

After measuring the position, we spent a large part of the rest of the day admiring the building. The entire complex was so impressive it left us breathless. I could write a whole book about it. You have to see it to believe it. The construction forces you to

learn. Then you start realizing how advanced it is, the secrets that are behind it. That what happened almost 12,000 years ago is about to happen now. That's the power of the temple of Dendera. It will stay with me the rest of my life.

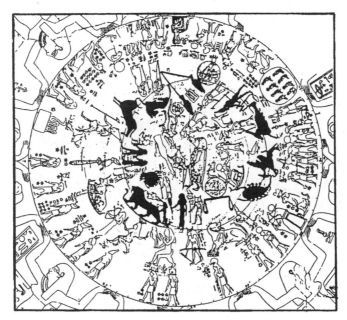

Figure 21.
The round zodiacal table of Dendera

Esna is the Star Altair

Esna, Egypt, Wednesday 26 March 1997. The first assessment we made was that the temple's level is below the Nile level. The archaeologist on duty explained that only on that depth was there solid ground to build on. Because of its low level it suffered from subsoil water intrusion, and that was bad for the conservation of the hieroglyphs.

Since the Egyptians were so keen to keep everything in as perfect a condition as possible, we concluded there must have been a special reason to build the temple right here—a reason much more important than the degree of difficulty of building it there. Soon enough Gino found the sign of Altair (in the eagle-constellation

Aquila) which again reinforced our theory. Furthermore, we saw
columns similar to the Dendera ones; the temple was built in the
same era, hence the similarities. Other elements of correspond-
ence are the zodiacal signs and the pattern of the ceilings. Both
also have a draw-well, but Dendera also has a mini-oasis. After
measuring it, the temple proved to be directed to the north with a
deviation of five degrees to the east. Two such striking deviations
could not be a coincidence!

The Pyramids are the Orion Constellation

Giza, Egypt, Monday 31 March 1997. We were walking towards
the pyramids; it was less than a kilometer from our hotel. I had
read an elaborate description in the book *Fingerprints of the Gods*.
The previous day I had already had a first taste of it through the
view from our room: grand, mysterious, mystic and an infinite
number of other adjectives could be ascribed to it.

"I bet the pyramids also have a deviation of five degrees," I
challenged Gino.

"I won't gamble on this one, 'cause I already know the an-
swer!"

That made us burst into laughter. A few minutes later we stood
in front of the largest building on earth. You have to see it to be-
lieve it. It beats every description I ever read. I was overwhelmed
by its grandeur, and found it mysterious because of its hidden
secrets, mystic because of its esoteric character. For minutes we
let its impression work on us; after that, we started working. With
the GPS, Gino measured the corners from the pyramid. When
walking from one corner to the other he also assessed the direc-
tion of the pyramid. The result was no longer a surprise to us: a
deviation of five degrees to the east. We had noted the same de-
viation for the two other pyramids.

The South-North Axis

During our careful study of the surroundings we stumbled
upon an arrow made in red Aswan granite. When you're facing
the entrance, you can find it at the left-hand-side of the south-
north axis of the Chephren pyramid. To our surprise, the arrow is

oriented precisely north. That made us conclude that the deviation of five degrees was indeed made for a specific reason, especially since we had encountered this angle several times already:
- In Esna and Dendera.
- At the junction of two passages in the temple of Karnak.
- At the slanting wall in Karnak (slanting walls are exceptional).
- In the sarcophagus in the temple of Karnak (sloping chambers).
- When studying the Celts.

As already mentioned, the angle can be explained through the precession or movement of the zodiac. This was how the Egyptians wanted to point out to later civilizations that it needed to be studied thoroughly. For that matter, when unraveling the construction of the great pyramid, you find several angles of 72 degrees, which are connected to the angle of five degrees: 360 ÷ 5 = 72. When multiplying 360 by 72 you find the precession: 72 x 360 = 25,920.

In Egypt, a year took 36 weeks of 10 days = 360 days. The last five days were dedicated to the gods. With the angle of five degrees, the Egyptians also wanted to tell us they measured hours and minutes of a day (24 x 60 = 1,440 minutes).

Multiply this by five and you get 7,200, a multiple of 72. Again this points to a code of the precession.

The enigmatic deviance of five degrees of the temples and pyramids forces us to the following conclusions:
- The pyramids are built to point out to us that the constellation Orion is crucial. If through the precession it becomes the center of interest, a disaster will occur on earth.
- At this moment Orion is almost at its highest cycle. It is the most visible constellation in the entire sky. That tells us the disaster is approaching.
- The shape of the pyramids is similar to the appearance of Orion in 2012 and in 9792 BC.

Do not underestimate these findings, because they are based on the enormous astronomic knowledge of the Egyptians. The similarities between temples, pyramids and their celestial images is incontestable proof. To be able to carry out such a grand and

difficult task you have to know an awful lot about astronomy, geology, geodesy, map projection, etc.

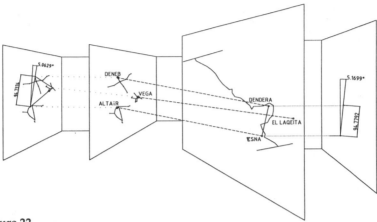

Figure 22.
An astronomical hidden code exists within the placement of pyramids and temples. Here you see a three-dimensional view of the relationship between the stars Deneb, Vega and Altair and the positioning of temples in Egypt.

Research on Location

Hawara, Egypt, Wednesday 2 April 1997, 11 a.m. At high speed, the taxi driver hurried his car through the desert. The sun was burning my eyes. At a distance I could see the Hawara pyramid appearing. I was moving restlessly back and forth. Gino pointed at the building and nodded—that was it. We were rapidly nearing our journey's objective.

We arrived; the landscape was desolate, and not one tourist could be seen. Three guides and a ticket salesman welcomed us with open arms. Not one of them spoke English. Luckily our driver could facilitate communication between us all. The entrance fee was 16 Egyptian pounds, quite a lot for a pyramid made of clay, but we paid gladly. Two guides accompanied us. Gino and I put on our hats against the burning sun and we followed the graveled path. I was surprised to see the pyramid had collapsed in the middle; the clay stones had become a shapeless pile. In the valley of the kings and in Dendera I had seen several clay constructions.

Because it only rains one day per year in these regions they can remain in a rather good condition for thousands of years. This was clearly not the case here, though there probably wasn't more rainfall here than anywhere else. Soon enough we would solve this riddle.

One of our guides made wild gestures. He pointed to a bright white pillar, hardly visible above the sand. The figures of two crocodiles were chiseled on it. This clearly was a clue that this was the right site. Indeed, Herodotus mentioned that the labyrinth was located close to the crocodile city. Our guides kneeled down right in front of the entrance. They made a drawing of a pyramid in the sand; they distinguished three layers on it. Then they pointed to the lower layer and to a stone made of red granite from Aswan. The use of this type of very hard stone indicated that the pyramid must have been important. You don't tool this type of stone without good reason. On top of this layer, the same type of stone was used, as for the Giza pyramids. And the last layer was made of clay stones, as we already noticed.

"That red granite was used to protect the upper layers from water," Gino said, herewith confirming what I already suspected. I nodded and we went to the entrance. After only a few meters we were stopped by water that flooded the entire burial chamber. Gino used his lamp, but it couldn't penetrate the darkness in front of us. There was water everywhere. Then he shined his lamp on the walls. They were covered with salt crystals. My heart sank into my boots. The labyrinth was much deeper than the pyramid, and there was already groundwater here. This also explained the poor condition of the clay pyramid: the groundwater had dissolved the clay layers and thus the pyramid had partly collapsed. Cold shivers came over me in the intense afternoon heat: if the labyrinth was flooded, then it must contain billions of liters of water! Not to speak of the damage! That really tempered my excitement. We looked at each other in doubt. Then I climbed an earth wall which was right next to the pyramid. Some twenty meters away, about eight meters deep, I saw the canal running as Herodotus described it. The pyramid stood much higher and yet it was flooded completely! I couldn't understand it. Later, Gino

would explain to me that the earth had soaked up the water like a sponge. That was a good explanation for the groundwater, but didn't solve the problem. Anyhow, I was staring into the distance and saw nothing but a green oasis in front of me. I could easily imagine there used to be a lake with beaches. Indeed, far off to the right, the oasis changed into desert sand, which hardly differs from sea sand. Many geologists are convinced that deserts used to be seas, but were pushed upwards by the working of the earth. While I was daydreaming, I kept on looking around. Quite soon I was filled with the feeling that we were in the right place. During my research I had had a similar feeling several times, and every time it proved to be right. This time would not be different. My intuition was too strong for that. The labyrinth was right here! You could bet on it!

While we went around the pyramid, Gino stopped to measure its position. He had calculated it theoretically beforehand and to our satisfaction his results matched the measured values! Again a confirmation of what I suspected. At the north side of the pyramid, which pointed directly toward Giza, was a moonscape. The ruins of graves were lying there. In different places they had collapsed and there were yawning openings. With many gestures, the guides pointed out that it was dangerous here and that you could sink. We took note, and continued our search. There was not much to discover here, except for one peculiar fact. Close to the pyramid, Gino discovered two stones, positioned in a right angle, with a hole underneath. Gino almost went crazy when he saw this. On our trip to the airport he had told me about his mother-in-law's dream: if we discovered two stones and a hole, that was where the labyrinth was, according to her prediction. He had also said that many of her dreams had come true. And now we were standing there at that small hole in the ground. It made things stranger and even more exciting. We tried to widen the gap with our hands, but didn't succeed very well. Then Gino took several pictures with his lens in the opening, but there was only a dark-black result. The riddle of the prognostication therefore still exists. Since I have no experience with such matters as predictions, I merely wanted to mention it, for its peculiarity.

After this aside, we went to the other end of the site. It was here that Lepsius had done excavations during the previous century. Here, too, it seemed like a moonscape. Rather soon I noticed that Lepsius's excavations hadn't gone very deep, at the most a couple of meters, was all I could see. This was not deep enough to uncover the labyrinth, which was probably another five meters deeper. Seeing this gave me a new feeling of certainty that it was here, right beneath my feet. We continued our search and stumbled upon the upper parts of some columns. These could have stood on top of the labyrinth in earlier times. For more than an hour we searched the plain following a crisscross pattern, but, apart from many potsherds, it brought us no results. Anyway, we knew enough.

Following, I list again the main evidence as to why the labyrinth must be located in this place:

1. There is a canal in front of the pyramid, a branch of the Bahr Jussuf canal. According to Herodotus there used to be a canal connected to the lake which was in front of the pyramid.

2. Behind the canal is a dip: the oasis of the Fayum. This is where the lake must have been.

3. The position of the pyramid matches the star Aldebaran of the constellation Taurus. Such a similarity points towards the importance of the position.

4. Several tops of columns that are sticking above the sand indicate that there is more hidden under the surface. These, probably stood on the roof of the labyrinth.

5. The temple was built in the early days of the age of Taurus. When looking closely at the star sign Taurus, one sees its similarity to the Pleiades and the Hyades. The region which correlates with the Pleiades is located too high, so that possibility is no longer open. This leaves us with the Hyades. And that's where the labyrinth is!

6. The Hyades contain twelve bright stars and also a large number of others. The number twelve matches the zodiac. Astronomers call the Hyades a labyrinth of stars. A further indication is that the Hyades cover five degrees of the sky, the same number as the deviation measured of temples and pyramids in

115

relation to the north-south axis.

7. Red Aswan granite was used for the fundament of the pyramid. This points to the importance of the place as well as to the fact that it protected the clay stone construction from the water.

8. Two chiseled crocodiles are a sign for Crocodilopolis, which was not far from here.

9. Lepsius did not dig very deep, not deep enough to find the labyrinth.

10. And the strongest argument of all: Egyptologists from the whole world say the labyrinth must be there! What are we waiting for?

Our conclusion: it is absolutely necessary to start new excavations here. Only in this way can the enigma of the lost labyrinth be solved.

World-Wide Consequences

The search for the labyrinth needs to start super-urgently. If not, then mankind will be in great danger. More than 12,000 years ago, a highly developed civilization prevailed. They mastered astronomy, geology, mathematics, geography, sailed the oceans, had incredibly accurate calendars, and so on. The evidence for it is piled up in the labyrinth. Merely unlocking this knowledge will change the history of the earth for good. Besides, we will then have proof of where they got the knowledge and wisdom to be able to predict the destruction of the earth. Realizing that our civilization is about to be wiped away by a gigantic geological catastrophe will in the first instance cause a tremendous panic reaction. Then, world-wide actions will be taken rapidly to preserve the most precarious knowledge and pass it on to the survivors of the catastrophe.

During my research I have been astonished several times at the high-quality science of these antique geniuses. On many fronts their science was more advanced than ours. They were able to calculate the exact orbits of planets, 4,000 years in advance—something that we have just discovered how to do. Out of innumerable data they then deduced the final day of the destruction of the earth. They knew this to be a cyclic, recurrent event and based

their entire religion on it. If I hadn't unveiled these secrets, the catastrophe would hit without any serious warning, with disastrous consequences for mankind.

Hopefully everybody will now realize that the excavation of this astronomical center is of absolute and utmost urgency. Otherwise, the mission of the ancients, to warn later generations about this catastrophe, threatens to be lost forever. As I have stressed several times in my book, this world-wide disaster could mean the end of humanity if we don't succeed in shutting down the nuclear power stations in time. I hope there are enough intelligent people around to finish this search successfully. Otherwise, the largest catastrophe ever threatens to erase all traces of humanity for good.

Determination of the Position

That the astronomic knowledge of the Egyptians was impressive was something Gino could positively prove once we were back home. Using the positions of the pyramids and temples, he tried to calculate mathematically how they had done it. After an intense search he came to the conclusion they must have known the exact circumference of the earth, and they must have been able to calculate the distance to the stars! This is how he handled the problem: how do I project the position of a star on earth?

Solution: Freeze the heavens in a certain moment in time: 27th July 9792 BC, the day of the previous catastrophe. Calculate the distance between the stars and record them in specified units (for instance: royal ell, etc.). Take the center of the earth and project the star on it. Take into account a certain scale while making the projection, so everything can be remeasured accordingly. The projection is three-dimensional, which complicates the work considerably. And on top of that you have to take into account the angle between the stars. In order to do this you have to know space-math and possess the necessary knowledge to project a point on a three-dimensional landscape. Only the finest mathematicians and astronomers can do this nowadays. Place the temple on the junction with the earth.

Figure 23.
Three-dimensional view of the relationship between the pyramids, the Orion constellation and the Hyades (labyrinth of stars). When decoded, this information pinpoints the location of the labyrinth that is believed to contain artifacts and documents from the previous world-wide flood.

Our measurements prove they were able to accomplish this and demonstrate clearly that the Egyptians were incredibly far advanced and could match today's science!

Further analysis of these data show that the angle between Esna and Dendera is five degrees, exactly that of their corresponding stars Altair and Deneb. This gives a new interpretation for the deviation of the south-north axis. Probably there are more candidates for this angle: the angle between Sirius and Aldebaran is also five degrees.

Ophiuchus

After the discovery of the relation between the mentioned stars and their places on earth, Gino saw the constellation Ophiuchus.

If his theory is correct, the constellation Ophiuchus dominates almost all of Egypt. A plausible explanation for this can be found in the events during the destruction of Atlantis. When Scorpio appears on the eastern horizon, Orion dies in the west and then disappears. According to mythology, Ophiuchus cured the hunter Orion by crushing Scorpio under its foot. In astronomical language: Orion reappears in the east above the horizon, while Ophiuchus pushes Scorpio under the ground in the west. A story worthy of being studied in depth.

118

PART III

HOW DID THEY CALCULATE THE END DATE?

10.
THE ORION MYSTERY
DECODED

Monday 25 November 1996. Gino and I looked again through all the data we had on the zodiac. It didn't get us very far. We decided to continue our search on the computer. Gino composed data on the star constellations of 2012. Sometimes it took quite a long time, because it was quite a job to program it. But he was a genius and the result was always excellent. I was desperately looking for a connection between all the information I possessed, but didn't get far that night. Dozens of images of planet positions, star constellations and complicated internal patterns passed my eyes. More or less dizzy, but excited, I went home. Something was brewing within me, I could feel it. But what?

We'd see each other again the next evening. We would mainly search the Internet. That was a revelation for me; it was the first time I had worked on it. We decided to look for data on the zodiac. It seemed there were piles of publications on it that would provide us with work for days. That's why Gino changed his search to include both the words "zodiac" and "Egypt." Then there were only three articles found. One of them seemed to be terribly important. Some highlights are paraphrased as follows:

"Secret of the Great Pyramid Revealed" By J.P.E.

For millennia they have caused wonderment. Why were they built? Who built them?

A recent discovery has been made that proves the Great Pyramid design was based upon the most complex astrological measurement we know of.

The 25,920 year measurement of precession turns out to be the major measurement incorporated into the design of the Great Pyramid and the true reason the Great Pyramid

was built. Sort of a shrine to the Great daddy measurement of the movement of the Zodiac.

The shafts of the Great Pyramid have been shown to align perfectly with key stars of the Zodiac at major changes of the various houses of the Zodiac.

Can it be that the Great Pyramid is a monumental time clock?

It measures precession and other various changes of the dekans of the zodiac.

Immediately after reading this article it became clear to me. The pyramid was indeed a giant time clock and it was ticking! Sixteen years from now the ticking would stop, because then the largest catastrophe in the history of mankind would happen. That's why the pyramid had been made with such grand precision! To warn us, the builders had to use superior construction. The least deviation in its construction would withhold later civilizations from the ultimate message: Pay attention! World-wide destruction will happen when the clock stops ticking! What brilliant reasoning! And it is only now that we discover it! Now that it is almost too late to take the necessary precautions!

Researchers had already asked themselves why the shafts had been built with such an incredible degree of precision: there are no deviations and the whole must have demanded enormous manpower. The building of the four shafts is comparable to the design of several large temples! This architectonic vision has puzzled thousands of visitors. Up till now. It was becoming more and more clear to me by the minute. To make everything even more transparent, Gino would have to make quite a lot of calculations. That would take him several weeks. Satisfied with this plan, I asked to see the stars of 2012 again. I had this feeling I would find something new. Soon enough the star constellation with the codes of the destruction of the world appeared on the screen.

"Can you show a different view?" I suddenly asked, following my intuition.

Gino's hands flashed over the keyboard and then an image appeared I had seen before without paying attention. Through the screen ran a straight line.

It fascinated me; I stared at it and whispered, "What is that line?"

"That's the equator, the line dividing the earth precisely in two," Gino answered.

I felt there was more behind this. But what? Damn, what? Again I stared at the screen. Next to the line there was another one, indicating a wave-like movement. It rose from the base line, reached a summit and then lowered down below its starting point. A perfect wave. Maybe the explanation seems somewhat difficult, but the picture below will make it clear. This is what I saw:

Figure 24.
The undulatory motion of the zodiac.

That's all very well, you will say, but what are you getting at? That's exactly what I was asking myself. I couldn't get this image out of my head, and yet I couldn't find a solution for it. It was already after midnight and I decided to go to bed because I had to go to work the next morning. Wednesday, Thursday and Friday I couldn't think of anything else. Where was the link? There

was one, of that I was pretty sure. Then something occurred to me. I had seen it before, on the inside cover of *The Atlas of the Universe* by Patrick Moore. When I got home I hurried to my book-case and took the star atlas from the shelf. Yes, indeed! The exact same lines were in there. Almost obsessed, I stared at it. Then I gasped. I had it! The wavy line pointed at stars in the zodiac! And the equator of the earth went right through it!

I jumped in the air from sheer pleasure after discovering this. How was it possible I hadn't noticed it before? In fact, it is elementary astronomy, just as is the existence of the seasons. Everybody is familiar with the steady progression of the seasons. It occurs because the earth has a slantwise position in relation to the sun.

This angle causes the existence of seasons and is responsible for the North Pole and the northern hemisphere being turned away from the sun six months a year. When it is summer in the north, it is wintertime down under. Everybody knows that. If you put this reasoning into simple mathematics, you get a wave-like movement. Summer is positive and is at the highest point above the diameter. Winter then, corresponds with the lowest point under the diameter. To get the wavy line you simply start measuring. You start in summer. The closer you get to fall, the closer you get to the diameter. When reaching the fall you cross the diameter and continue descending towards winter. Once past winter you start rising again. A perfect wave; identical to the one of the zodiac. Because there are also seasons in the zodiac. In the northern hemisphere (Europe and USA) it is impossible to see the star signs Gemini or Orion in June. Let's put it this way: this wave-like motion tells us whether a star sign of the zodiac is visible for us or not. Summer is positive: the constellation is visible; and the other way around: it is invisible in wintertime. Of course it also depends on the part of the world you're in. In June, Orion is not visible in England, but it is in South America. Once you've determined which parts are visible, it is easy to locate them in the sky.

I could feel I was close to solving the Orion mystery. In less

than four days I had managed to get the information that the shafts follow the signs of the zodiac, and furthermore found that the zodiac is represented by a wave-like motion. Of course there was a connection here! How could there not be! The astronomers and mathematicians of thousands of years ago had reached an incredibly high level. They had gone at least as far as we have now. And as for their obsession with the end of the world, they had gone much further. They had already unraveled codes which we are only starting to understand. This is absolutely brilliant! But let's go on. I still hadn't managed to unravel the meaning of the star sign Orion. Then something began to dawn on me. I saw a sparkle of light. In the book *Le Grand Cataclysme* I had read that Osiris (Orion) after his birth had been associated with a certain star sign in Atlantis. His mother had seen this star sign and named her son after it. This gave me a clue. Atlantis was situated close to the North Pole. After the downfall, the poles switched and the land disappeared under the ice of the South Pole. So, Orion was a star sign in our southern hemisphere! Furthermore it must have had a special meaning, otherwise the last king of Atlantis wouldn't have been named after it! Excited, I started looking in my atlas for a possible connection. I found it on page 217! I was astounded when I saw the projection of the southern and northern hemispheres. But what really struck me dumb was the position of

Figure 25.
At this moment, Orion dominates the northern and southern starry skies.
This means the cataclysm is very near.

Orion! I had to look several times before I could believe it. Orion was positioned as the most clearly distinguishable star sign at the edge of the southern hemisphere. This cannot be true, I thought. But the map was very clear indeed: Orion stood as the only constellation on the outer edge of both south and north! Purely astronomically this means that Orion is the only constellation recognized as a clear marker in both the southern and northern skies!

A few pages further I read the following: Orion is traversed by the equator of heaven and is thus visible from every place on earth. The Belt points in one direction to Aldebaran and in the other to Sirius, while Procyon, Castor and Pollux and Capella are also easy to find. Its characteristic shape and its high clarity make Orion particularly suitable as starting-point for the identification of stars. All main members of this star sign (except for Betelgeuse) belong to the "early" spectral types and are very hot, bright and white.

Figure 26.
Actually Orion stands against the central line which goes through the undulatory motion of the zodiac. Astronomically seen, Orion is "Master of the Sky" and "Master of the Zodiac."

Master of Heaven in 2012 and 21,312 BC

With this, my star guide had solved a centuries-old riddle. Be-

cause the Atlanteans sailed the oceans of the world they needed a recognizable beacon in the sky. Along with the zodiac, they also had Orion as a point of reference! Immediately after the catastrophe of 21 February 21,312 BC, Orion stood in practically the identical position as now! Then Orion must be the master of heaven, simply because it is in the middle of the two starry skies. No other constellation that is close to it can equal its brightness! Therefore the Atlanteans chose Orion as their marker in the sky. In view of their ambiguous thinking this had to match an earthly construction: the pyramids of Cheops. The Orion mystery was unveiled! My heart pounded with joy and I was glowing with excitement. When Bauval pointed out that the pyramids had been placed in accordance with the constellation Orion, he had left an open question as to why this had been done. I now had an answered to that question. (Coincidentally, Bauval is Belgian, as am I. The bravest amongst the Gauls, as the Roman emperor Caesar had put it, had done it again!)

But, I still had another problem. Now Orion touches the diameter that runs through the wave-like line of the zodiac.

Figure 27.
In 3000 BC, Orion stood far from the central line that goes through the Zodiac. The importance of Orion to the Egyptians and his actual astronomical position point to the end of a great cycle.

Immediately I thought of the article I had read on the Internet. If the shafts of the pyramid indeed point to the corresponding positions of the zodiac, then what I had found here was its cosmic counterpart! The codes of the destruction became more and more clear to me. In 2012 Orion not only dominates the northern and southern starry skies, but also the zodiac. It is at that crucial moment in time that the destruction of the world will happen! Old scriptures confirm this. During the fall of Atlantis, high priests had managed to escape. They taught their knowledge to their followers. Zoroaster was one of them. The following quotation from him comes from *Cosmos* by Carl Sagan:

All good fortune and misfortune that befalls man and other creatures, come forth from the seven and the twelve. The twelve signs of the zodiac are, as the holy command teaches us, the twelve rulers at the side of the light; and from the seven planets it is said that they are the seven rulers of darkness. The seven planets suppress all creation and deliver it to the death and to all the ways of the evil: because twelve signs of the zodiac and seven planets control the destiny of the world.

When we put the Mayan date for the end of the "fifth sun" into our computer program, we saw a special order of planets appearing on the screen. Astronomers claim this configuration only happens once every 45,200 years. With all the former in mind, the alarm should go off. Zoroaster knew what he was talking about, because he mastered the secret knowledge of Atlantis. Realizing this made me gasp for air. More than ever, I now was convinced of the nearing disaster and I found more clues in our program.

11.
THE COMPUTER PROGRAM
OF THE
END OF THE WORLD

Sunday 2 February 1997. I walked around like a wounded dog. Last night I had sat in front of the computer with Gino. Result: zero. In addition, an expected amount of money wasn't remitted. Without that money I wouldn't be able to go to Egypt to continue my work and solve the mystery. That would be a disaster. You can imagine how I felt! Nothing was going the way it had to!

All of a sudden I had this brilliant idea to divide the number of years between the catastrophes by known numbers. A few hours later I had pages filled with calculations. I seemed to be getting somewhere. At that time, however, I hadn't realized yet that I had made a mistake. Only some days later this would become obvious.

But my mistake did help get me closer to solving the riddle. At first, I simply added together the numbers of the years from the previous catastrophe to the next. After the cataclysm, the year 9792 BC still had five months to go, so I had to start counting from a year later: 9,791 + 2,012 + 5 months + 11 months (the catastrophe happens in December 2012) = 11,804. With this number I started further calculations and had found several series of numbers. Three days later I realized my mistake. I had counted one year too many. The year zero does not exist because it cannot be divided! The first century started in year 1 and ended after 100. Our calendar jumped from 1 BC to 1 after Christ. Nobody could have counted the year zero, simply because it is uncountable. So, in reality, 11,803 years must have passed between the previous destruction and the one that has been predicted. But in fact that didn't make a difference. The Maya as well as the Egyptians worked with "holy" numbers, which gave them an end result

that was too large, and then they subtracted a certain value, after which they had the correct result. Here the same thing had happened. Accidentally I had worked with a number that was too large, and by this had brought the riddle closer to its solution. To start with, I divided 11,804 by 117, because this number was known and used by the Maya to obtain large numbers (see *The Mayan Prophecies*). 11,804 ÷ 117 = 100.8888888888. I liked this series of numbers which looked like it would fit into the thinking pattern of the Atlanteans. Further I was 100% sure that this meant something, because the number series 888888888 was 'holy' in Egypt (Albert Slosman translated this from the hieroglyphs). Therefore I continued dividing. Some of the following numbers were 52 and 36, because they were known by the Maya and Old Egyptians. There was an interesting correlation between these and the first number I had found:

11,804 ÷ 36 = 327.88888888
11,804 ÷ 52 = 227
327.88888888 − 100.888888888 = 227

This was too nice to be true. So, filled with courage, I started to multiply by the number of days in a year, following the two calendars:

11,804 × 365.25 = 4,311,411
11,804 × 365 = 4,308,460
11,804 × 360 = 4,249,440

In the previous calculations I had found the number 227. When dividing the above "super-numbers" by 227, I suddenly came upon the "holy" numbers of the Maya! I couldn't believe my eyes when I saw this. You can easily reproduce the calculations:

4,311,411 ÷ 227 = 18,993
4,308,460 ÷ 227 = 18,980
4,249,440 ÷ 227 = 18,720

The numbers 18,980 and 18,720 are holy for the Maya, but 18,993 is not. That seemed strange to me. I scratched my head,

sucked on my pencil and again look to my Hewlett-Packard calculator. The Atlanteans could only subtract, add, divide and multiply, so it had to be simple. Slowly I put the number 18,993 into the calculator. Without knowing why, I subtracted the number 18,980: 18,993 – 18,980 = 13. Thirteen is bad luck, it is said. It has to be true because it was present in my scheme of calculations of the end of the world. Of course I had to do something with this number. But what?

A little bit nervous I re-entered the unholy number in my calculator. Then I divided it by thirteen. Imagine my amazement, when all of a sudden the holy number of the Egyptians appeared! If you don't believe me, see for yourself: 18,993 ÷ 13 = 1,461.

This last number points to the Sothic cycle in Egypt. Everybody is familiar with a leap year. It means that every four years we add a day, to synchronize the orbit of the earth around the sun. In fact we should add a quarter of a day each year, but since this isn't very practical, we add one day every four years. If we didn't do this, it would take 1,461 years (365.25 x 4 = 1,461) before the calendar was on the right track again. The day on which both years coincided marked the beginning of what the Egyptians called the "New Year." Herewith I had most clearly proved that there is a connection between the Maya and the Egyptians.

Further calculations gave the numbers 1,460 and 1,440.

18,980 ÷ 13 = 1,460
18,720 ÷ 13 = 1,440.

1,440 gives us four periods of 365 days. According to Egyptologist Schwaller de Lubicz this was important. Furthermore, we know that 1,440 is the number of minutes in a day. And this completed the evidence.

Yes indeed, the "Masters of the Numbers" from Atlantis had again done a fine job. This probably happened before the demolition of their country. Then they must have calculated how long the next cycle would be. They divided it into 227 periods of 52 years, together: 11,804. The Maya knew that the destruction could only take place every 52 years. If nothing happened then, they

would be safe for another 52 years. Dividing the super-number 4,308,460 by a random number from the Mayan cycle and multiplying this by the number of rounds, we always find 227. That is logical because 11,804 is divisible by fifty-two and the calendar rounds of the Maya consist of exactly the same number of years. If you don't understand it, it'll become clear in a moment.

The Maya had a calendar cycle of 52 years. 52 years times 365 days gives us 18,980 days. The double of this, 104 gives us 37,960 days, etc.

Some examples:

Calendar Cycles	Days	Years of 365 Days	
1	18,980	52	
2	37,960	104	
40	759,200	2,080	
80	1,518,400	4,160	
227	4,30,8460	11,804	(=destruction)

At the end of each cycle of fifty-two years or 18,980 days, the Aztec (the Aztec overtook the Maya) were scared to death. In the last night of the old cycle they went into the hills because they were afraid the world would come to an end and the sun would not rise anymore at the horizon. There they studied the sky and waited until the Pleiades reached the southern meridian. If the cluster of stars continued its movement, they celebrated, because then they knew it would not be the end of the world. A new fire would be lit and torches would be sent to all parts of the kingdom to celebrate the new cycle, offered to them by the sun god Tonatiuh.

If this story is mathematically correct, then the Mayan calendar has to be such that the last day of a calendar cycle matches the day of destruction. After all, their "holy" years were too short to permit a correct calculation. Every 52 years their calendar is 52 x 0.25 = 13 days out of pace. Therefore, their calculations must be

based on the last day.

According to Diego de Landa (*The Mayan Prophecies*) this celebration was held for the last time in 1507. This date does not match the countdown to 2012. To calculate it you have to add ten cycles of fifty-two years to 1507 (10 x 52 + 1,507 = 2,027). This gives us roughly fifteen years too many. If the Aztec really had their big celebration on that day, then that was wrongly so. The count didn't start on 12 August 3114 BC, because there would be a difference of about five years. Nor did it start in 9792 BC, because then there is a difference of eight years. Thus the question remains: why did the Aztec have their celebration that year? Or was it another celebration altogether?

However, the tradition of celebrating every fifty-two years is correct. The interval between two catastrophes covers 227 periods of fifty-two years. Probably the Aztec copied these data but didn't succeed in interpreting them correctly. I decided to continue my search and to try to solve the riddle. In order to do this I worked with the super-numbers I had found and divided them by the Egyptian "holy" numbers. The result:

$$4,311,411 \div 1,461 = 2,951$$
$$4,308,460 \div 1,460 = 2,951$$
$$4,249,440 \div 1,440 = 2,951$$

When I saw this it immediately made me think of the code of the zodiac. There, I had obtained three times the number 576. Adding them and continuing to work with them gave me the result that the precession of the zodiac is caused by the slower turning of the earth. Practically speaking: each year the earth is 3.33333 seconds behind, compared with the year before. I discovered this through the series of numbers 0.33333333. I probably had to use it again. But first I added the number 2,951 three times in a row: 2,951 + 2,951 + 2,951 = 8,853. That was easy. But now the more difficult work began. What should I do with this number? Purely out of curiosity I divided it by 117. The result: 75.6666666. This number had no specific meaning to me. It didn't get me anywhere. I racked my brains, but didn't get any closer, until I got

help from the number of the precession of the zodiac. Then the following magical result flashed on the screen:

$75.6666666 \div 0.3333333 = 227!$

Again I could hardly believe my eyes, but, the message of the ancient scientists was more than clear: the numbers 117 and 227 are correct because they both are interrelated and can be calculated through the use of the precession of the zodiac! So the 11,804 years had to be correct also! Hereafter it was easy to continue:

$8,853 \div 227 = 39$

$39 \div 0.33333333 = 117!$

The computer scheme for the calculation of the end of the world proved to be more than true. But, being already familiar with the way of thinking of the Atlanteans, this would not be the only thing to be true. That is why I multiplied the quotients with each other and saw it was right: $39 \times 75.66666 = 2,951$.

Once I had found this, it was easy to find twenty other ways to calculate and find interrelations between the numbers. Everybody who knows how to calculate can do the same thing.

While the song "Noach" (Dutch for Noah) from the CD by Lisbeth List was playing, I continued thinking. Unconsciously, I was singing along with the words:

> Tonight the Flood is going to start
> Just like that in the park
> They are building an ark
> The vessel is almost finished
> We are watching on TV
> How the waters are rising
> And now that's where everybody wants to be
> Noah

Melancholically, I kept humming along. The end was near and I couldn't disentangle the computer scheme completely. Nobody would believe me and the waters would rise to catastrophical heights.

Noah Noah, why does it have to be like this?

My conclusion: Starting with the period between the two catastrophes, we obtain the "holy" numbers of the Maya as well as those of the Egyptians. The evidence for this is overly-clear. Furthermore, we find indications that the Mayan celebration every 52 years has its origin in the countdown of the end-date, because they exist of 227 periods of the same time span. All these numbers I found are worrying. They clearly point in the direction of the existence of a "master plan," devised by the scientists of Atlantis to warn their descendants—and us—of the nearing catastrophe. I'm begging you on hands and knees to review my calculations and maybe find other connections. The end date is closer every day. Nobody can afford to ignore the knowledge of these super scientists. They built pyramids of which we are even now in awe. Their calendars are incredibly correct. That alone says enough about their scientific knowledge. Everybody should realize this. Then the necessary measures can be taken to try to save humanity. If nothing is done, this could mean the end of everything.

The Master Plan Decoded

Finally, in October 2000, I was able to decode the number series. With my calculations you can mathematically prove that starting from 27 July 9792 BC, the cataclysm will happen on 21-22 December 2012. However, it is so complicated that I need several more months to explain it in easy language. It will be published in my next book. How we were able to break other super-important codes, you can read in the next chapter.

12.
THE ORION CODE DISCLOSED

From the previous chapters, we know that the Maya as well as the Egyptians predicted the same day as the end of the world. In their scripts are secret codes on the star sign Orion and the passage of Venus through the sky. When these codes meet specific criteria, something happening on the sun will have a demolishing effect on earth. For months now, I had been pushing Gino to get me the ultimate answer to my burning question: what is that code? But he couldn't give me the answer because it was impossible to get it from the program "Skyglobe." It could not reconstruct the sky of 9792 BC. Luckily, he had seen another program in an astronomy magazine which could do it—"Loadstar." Around Christmas-time, he received it. But when he wanted to try it, his computer crashed. He called a friend and the two of them took apart the entire personal computer and then put it back together again. That took several weeks. He called me: "My computer is repaired!"

Immediately I began sweating. "You know what to do! Look for a link between Venus and Orion! And look also in 9791 BC and 9793 BC."

"I will find it!"

With fresh courage, he began the search. After having worked on the computer every night for a whole week till well after midnight, he called me: "Patrick, I think I have found a clue."

My heart jumped and I cried out, "Tell me, I can't wait any longer!"

"After three days of working, I encountered the phenomenon of Venus making a planetary retrograde loop behind Gemini and above Orion at the end of 9792 BC! After that, I studied it systematically. From that time until the present, this has happened sev-

eral times. It also happens in 2012!"

All excited, I yelled through the phone: "I'm coming immedi-
ately!"

On my way to Gino's, it was almost as though I was having
dizzy spins. If what he had told me was indeed correct, we would
be close to a solution. Then nobody could doubt what is waiting
for us anymore.

Gino welcomed me with a broad smile and showed me the
printouts he had made. The first was from 9792 BC. And indeed,
at that time, Venus turned behind Gemini and partially above
Orion, as you can see in the picture on page 143. After staring at it
for minutes, I looked at the turning of Venus in 2012. Because of
the long time span, I thought the Orion constellation would be
differently composed. But it wasn't. Therefore, it looked very simi-
lar, but the movement of Venus was more to the right. It could be
the code, but I was starting to doubt it: "Doesn't Venus make that
movement in other years?"

"About every 250 years."

"That is a rare code!"

"Absolutely. But the main thing is that the precession in al-
most 11,000 thousand years is not the same. Only in 9792 BC and
2012 is the precession the same!"

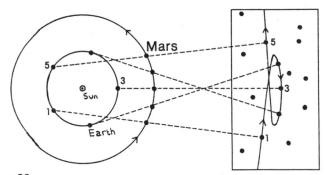

Figure 28.
What is a retrograde planetary loop? The Earth moves slower around the
sun than Venus. It is like you get a retrograde planetary loop against the
stars. In other words, Venus makes a circle in the sky. The same principle
works for the other planets. Here you see a Mars loop.

We were stuck. We had a unique event, but couldn't verify it to obtain absolute proof. The year of the predicted end of the world matched the date from the astronomical code. It would take us several weeks or months of brain-racking. Of that, I was sure. Why were the Egyptians making it so immensely difficult for us? It drove me crazy!

A week had passed while Gino had been staring at his computer and I had been thinking and thinking about the difference in data. Then suddenly a thought came to me. The code would be described in the Egyptian Book of the Dead! I grabbed the copies Gino had made for me from Slosman's book. Very quickly, I went through the pages. My eyes flew over the French text. Damn! There it was! I could have hit myself that I hadn't thought of this before!

But it can't really be held against me. The holy scripture of the Egyptians was written in such a puzzling way, that you have to be familiar with the astronomical codes to be able to find them in there. So that you can follow my reasoning, I will give you the translation of the relevant passages of the Egyptian Book of the Dead (*Le livre de l'au-delà de la vie*). Read it slowly and attentively, and try to adopt the ancient way of thinking, and you'll succeed:

The dismay after the incredible horror of the catastrophical disaster

is making it impossible for the terrorized population to escape! That is what heavenly words tell after the Two Brothers had killed each other!

Explanation: Life began again after that, under the course of the new Sun; and the young ones found their souls again.

𝕀𝕀•𝕀...𝕀▭𝕀⚡𝕀•𝕀𝕀𝕀•𝕀⚡𝕀𝕀•𝕀↦𝟡↦𝕀𝕀◀𝕀❘❘❘❘

and their lives, under the high protection of the sons
of Isis and Nepthys tookup their celestial images again,

so the new generations would exist for ever. Thus the survivors of the
catastrophe coming from heaven are purified, in order to accomplish the Orders.

originally passed on by Osiris (Orion).

You're already familiar with the story you're reading: the destruction has happened. Isis, Nepthys, Horus and some hundreds survivors escaped to the new fatherland, a "second heart of God" (Ath-Ka-Ptah, changed into Aeguyptos in Greek and into Egypt in English). The last sentence of this verse especially draws our attention. As you can see in the text, it is literally said that the survivors have to carry out the orders of Orion meticulously. After this follows the—for us—most important passage from the Book of the Dead.

The text is almost entirely written in red to stress its importance. It was in this text that I found the codes of the coming destruction. Without Gino's discovery, I wouldn't have been able to do it. Read this text attentively, because it decides the life and death of billions of people.

Thus living under the starry vault, under the rules of the
Mathematical Combinations, generated by the heavenly verse,

and its important orders, The Twins, descendants from the
Two Brothers thanks to Osiris (Orion). Variant: The starry
vault and its important Combinations, under the sky to

be passed down the important orders by The Twins, the Lives of the
Descendants, the sons of the Two Brothers, are grouping under one
same willing attention. Other variant: the Two Sons of the Two Earths

born on the Second Earth: Thus the starry vault is the
reflection of the higher Important Orders, wanted by the
Heavenly Word. And the descendants of the Two Brothers,

in the presence of the importance of the Orders they become Twins of
Osiris (Orion). That is why, after the destruction wanted by the Celestial
Combinations to get permission to the Place, the Old Lion turned around,

following the order of the Word to turn around!

If you are confused, don't be ashamed. First let us recount what
Albert Slosman wrote about his translation (*Le livre de l'au-delà de
la vie*, page 199):

This is undoubted the most important explanation con-
cerning the changing of the star-world in the sky. And this
comes after a paragraph almost entirely written in red to
stress its importance. The code is hidden in the end of the
paragraph, so the full significance of the effects blows you
in the face!

This Great Cataclysm happened on the 27th of July, 9792 BC. This was the age of the Lion and the earth turned on its axis. And as Herodotus wrote, "The Sun fell into the sea." This is because the earth started turning the other way around, which she still does to this today."

Still, it meant nothing to me before I got Gino's clues. I had read it a hundred times without learning a thing. But once you know the astronomical code, you can get it without too much effort. Let's start at the beginning. In the first line, the importance of the mathematical combinations and of the important orders which are worked into the verse, is stipulated. More specifically it is about THE TWINS, descendants of the two brothers of Orion. When looking at the celestial events of 9792 BC, it becomes clear quickly. In the computer simulation you see Orion. Above it, at an angle, is the star sign of The Twins (Gemini). In that year, Venus made a three-month retrograde planetary loop behind the star sign of The Twins; this is at the left above Orion.

When you see this happening, you suddenly understand the code. Read the last sentence attentively! It says that the Old Lion turned around, FOLLOWING THE ORDER OF THE WORD TO TURN AROUND! This says the magnetic field has reversed!

It is this turning that is referred to in the verse. There is no doubt about that. The Twins are connected up to five times with the super-important codes they give. After realizing this, I was astonished.

I called Gino.

"We found the code!" I almost shouted through the phone.

"What do you mean?"

"Venus makes a loop behind The Twins! Look at *Le livre de l'au-delà de la vie*,on page 197. It literally says there what you have found!"

Françoise, Gino's wife, heard my excited voice and got the book. She looked up the right page. There was silence for over a minute. Then I heard Gino whistle through his lips: "You are right. The pattern I found is described here! But the way they did it!

Figure 29.
Venus made a retrograde loop at the left above Orion, starting on 25 November 9792 BC. It stood still in Gemini on 25 December 9792 BC and then turned back to Orion.

More complicated than this is impossible!" Gino sighed, and I could hear him read everything again.

He paused to take a breath and I asked, "Would there be any more codes hidden in this book?"

"I'll bet there are. Now that I know this, we definitely have to find other codes! But, if they are all as difficult as this one, we will have years of study before us to find them!"

"That's exactly what I would like to do. Mind you, we only have fifteen years before everything will be destroyed. We absolutely have to find them."

"If our book becomes a best-seller then we can spend all the time we want on this task."

"Oh well, let's just dream about it for now."

Gino laughed, and in the meantime, I glanced at the verse in which the nearing destruction is described. Then I suddenly understood something. Again I had found an important code. "There is another code in there! Read the last sentence carefully! There it says that the Old Lion turned around!"

For a while there was silence, then Gino said, "That's right, but I don't see the code."

"It says the magnetic field has reversed! As you know, the

zodiac moved from Gemini to Cancer and Leo before the destruction. In the age of Leo the catastrophe took place. After this, the zodiac followed the opposite route from Leo to Gemini to the age of Pisces in which we are now living, and which is coming to an end."

Zodiac before the catastrophe: Gemini → Cancer → Leo

Zodiac after the catastrophe: Leo → Cancer → Gemini → Pisces

I saw that my reasoning was correct, and continued: "If you take a look at the movement of Venus, you will see that it makes a 360-degree turn! In the Atlantean religion, this meant that from that day on, everything had to happen in the opposite direction, as it said in the holy scripture. Translated to our language, it means the magnetic field of the earth had shifted. The North Pole became the South Pole. That made the inside of the earth rotate. This is responsible for the precession through the zodiac. And from that day on, the precession went in the opposite direction! That is what they meant!

The correct interpretation of the symbol of the two lions is then as follows: When the sun rose again at the horizon, it was at a new horizon. The Egyptians symbolized this by attaching a braided cross, the symbol for eternal life in Egypt. This sun would

Figure 30.
The loop of Venus proverbially means that the magnetic field of the earth turned around. In Atlantic language: "The Old Lion turned around, following the order of the Word to turn around"!

stay at its horizon until the day of the next cataclysm, after which a new cycle of doom and arising can start.

Surprised by this new twist, Gino exclaimed with enthusiasm, "Of course! That I didn't think of that myself ... you're even better than I thought!"

Dryly, I answered, "This is about the continued existence of humanity. If we don't find enough evidence, nobody will believe us! Everything in me is working at full capacity for the moment!"

Laughing, Gino answered, "Same with me. I go to bed with it, and it is still there when I wake up in the morning!"

Here our conversation stopped for a moment, then I continued: "Have you looked at the next page yet?"

I could hear him turn the page. Then I heard a soft murmur. This is what he read:

The importance of the Words dominate the people of the land. This Importance of the Verse guarantees a long period of Life and has to be used to find the End beforehand!

So writes Ani, Writer coming forth from the Priests, servants of the Eldest, under the order of the Will of the Highest of All.

"Well, that's clear enough." Gino answered "The code indicates that the next catastrophe happens in 2012. It will be the end of our civilization. Probably for good, if the nuclear power plants melt down!"

With a sigh, I had to agree with this. "That is becoming my biggest worry. I fear the worst."

Then our conversation returned to the subject at hand. I said, "The following verse mentions that there were codes in heaven, by which they were able to reach their second fatherland. Up till

Figure 31.
Venus will make a retrograde planetary loop at the right above Orion in the spring and summer of 2012. This is the *OPPOSITE* astronomical code from the previous one. It points to a catastrophic change in the magnetic field of the sun and the earth.

now I haven't found them. Can you see something?"

For two entire minutes it was silent on the phone, after which Gino said: "No, for the moment I don't see it. I will make a note of it. Maybe in time, something will come up."

"In Albert Slosman's comments it is stated that we have to follow the Heavenly Law and its orders. If we don't, then a disaster will follow, bigger than the one before. But, we've already agreed on that one."

"Yes, indeed," was Gino's short and gloomy answer. For a while we were silent. My brain was working, though. It then occurred to me that there was more, much more. The previous catastrophe had been predicted, based on earlier events! Would Venus at that time also have made a turn above Orion?

"Gino, do you remember I told you that their prediction was based on a previous catastrophe?"

"Of course, only I forgot the date."

"On 21 February 21312 BC, a part of Atlantis vanished under what was then the North Pole (the South Pole now). This was accompanied by a tidal wave. Further, it is written in the annals that 8,496 years before that catastrophe, another one happened.

So, that must have happened in 29808 BC. With the Celestial Mathematical Combinations, they predicted the correct day of the end of Atlantis. That same code had to be present then. Would you be able to find it, do you think?"

"This program can only go back in time to 10000 BC. I can't go any further."

"You're not going to tell me that they knew more then than we can find now?"

"That's exactly what it looks like. They were much more sophisticated and developed than what we thought could be possible. I have to admit, I was quite surprised."

"Can't you crack the program and enlarge it any further?"

"I might be able to do that, but I doubt that the outcome will be correct. I'm afraid we have to wait for more data, after which they can write a program that can go further back in time."

"Damn," I was swearing in silence. We are stuck right now!

Absolute Super-Sensational Decoding

The ancient Egyptians codified in their religious and rebirth texts the previous and coming polar reversals. They inherited this knowledge from their predecessors and wrote it down in an esoteric language. We discovered this wisdom of momentous importance—something that shatters our knowledge of history.

Our research has persuaded us that a scientific language of precessional time and high-tech astronomy was deliberately expressed in the The Book of the Dead. This language will shed a new light on the enigmatic civilization of Egypt. The celestial coordinates are so rare that no astronomer in the world can doubt them. Throughout this investigation we have tried to stick to the facts. Nobody will believe us that the next polar reversal will happen in 2012, if this code isn't true!

It is only in the last years that computer technology has made it possible for us to reconstruct the ancient skies and see the patterns that unfolded in our research. The Giza monuments and The Book of the Dead are a legacy for mankind, and they reveal the most important secret of mankind: the end of our world. Af-

ter completing our archaeo-astronomical investigation, we are left with an enhanced sense of the tremendous mysteries of ancient Egypt and the story of Atlantis—a sense that its true story has only just begun to be told. Looking at the precision of the movement of Venus behind Gemini and above Orion we feel that the purpose of the ancient astronomers was sublime.

They found a way to tell us—thousands of years in their future—that the end is near, by making use of the universal language of the stars and planets: a circle at the left, and one at the right, above Orion. Their message across the ages in a star-planet code is so simple and self-explanatory that you don't need words to describe the things that will happen.

Herewith we report the facts:

1. The codes we have are the right ones: Venus made and will make a retrograde planetary loop above Orion. This is also behind the star sign Gemini.

2. Only in 9792 BC and in 2012 is the precession the same. Due to the precession, the other movements over almost 12,000 years are not identical!

Our findings make clear the need for serious work to be done by today's astronomers. We VERY STRONGLY claim that the retrograde loop of Venus above Orion is the right code. Astronomers can check our findings with the latest programs. They will find it is unique! And it fits perfectly with the translation of Albert Slosman!

Just the Facts

Albert Slosman made his translation in 1979. Following, you will find the original translation from his book. Everybody is invited to check it. He didn't have a computer program to look for the astronomical code! Anyone who can prove that we have incorrectly translated Slosman's work can have our royalties from this book. After studying his translation, read on.

LE LIVRE DE L'AU-DELA DE LA VIE

161 — AINSI VECURENT SOUS LA VOUTE CELESTE, DANS L'OBSERVANCE DES COMBINAISONS MATHEMATIQUES, ENGENDREES PAR LE VERBE DIVIN

162 — ET SES IMPORTANTS COMMANDEMENTS, LES JUMEAUX, CES DESCENDANTS DES DEUX-FRERES GRACE A OUSIR. AUTRE VARIANTE : Ainsi, la voûte céleste et ses Combinaisons importantes, pour devenir sous le ciel

163 — les importants commandements transmis par les Jumeaux, groupèrent les Vies des Descendants, ces fils des Deux-Frères, sous une même attention bienveillante. AUTRE VARIANTE des Deux-Fils des Deux-Terres

164 — nés sur la Deuxième-Terre : Ainsi, LA VOUTE CELESTE FUT LE REFLET DES IMPORTANTES COMBINAISONS D'EN-HAUT, VOULUES PAR LA PAROLE DIVINE. ET LES CADETS DES DEUX-FRERES, AINSI,

165 — devant l'importance des Commandements ils se firent Jumeaux pour Ousir. C'est pourquoi après l'Anéantissement voulu par les Combinaisons Divines pour permettre l'accession à la Demeure, l'Ancien Lion

166 — se retourna, la Parole ordonnant à son avant d'être derrière ! »

149

166 — L'importance des Paroles commande aux habitants du Pays. Cette IMPORTANCE du Verbe perpétue la Vie et ce qui lui est propre pour prédéterminer la Fin !

167 — Ainsi écrit Ani, le Scribe descendant des Prêtres serviteurs de l'Aîné, aux ordres de la Volonté de l'Un-Primordial. »

Revenons plutôt à l'explication de ce verset très important qui mérite que l'on s'y arrête du point de vue astronomique avec la Constellation du Lion. Car manifestement il s'agit d'une explication concernant le plus important changement dans les configurations astrales de notre ciel. Et elle vient après un paragraphe écrit presqu'entièrement en rouge qui montre l'extrême importance du texte, tout en cachant la fin de l'alinéa non pas pour en amoindrir la portée, mais plutôt par une crainte instinctive d'en décrire les effets !

Lors du Grand Cataclysme, survenu le 27 juillet 9792 avant Christ, donc dans ce que nous appelons pour les natifs « en Lion » où le Soleil durant son périple annuel y séjourne 30 jours environ. Mais le Soleil avançait aussi précessionnellement (durant plus de 2 000 ans) devant la constellation du Lion, la Terre bascule sur son axe. Et, comme l'écrivait Hérodote « le Soleil tomba dans la mer ». Ceci n'étant qu'une apparence puisque notre astre du jour est « fixe ». Ce fut donc notre globe qui se retourna sur lui-même et fit apparaître depuis ce jour mémorable le Soleil reculant dans l'Espace. Ce qu'il continue de faire encore aujourd'hui.

13.
THE CODE OF THE IMMINENT WORLD CATASTROPHE

The Final Decoding

Given the above findings, we are certain we have the right year. But there is more. In 9792 BC, Venus made its circle above Orion *AFTER* the cataclysm. In 2012, Venus will make it *BEFORE* the cataclysm. These are the *OPPOSITES* of EACH other! Further I found that to decode the Dresden Codex, I had to make an incredible amount of OPPOSITE calculations. Also astronomers found that the pyramids from Giza are an OPPOSITE reflection of the Orion constellation. The earth also starts turning in the OPPOSITE direction after a polar reversal. So we began studying the loops from Venus above Orion. In 2012, Venus will turn to the right above Orion, and in 9792 BC it turned to the left above Orion. These are the *OPPOSITES* of each other!

More specifically: in 2012, Venus will reach its furthest point at the 30th of June and then turn back to Orion. At that moment, Venus will be between Orion and the Pleiades. In 9792 BC, Venus reached its furthest point at the 25th of December and then turned back toward Orion.

The program we used is "Skychart Pro 5." We re-checked our findings in September 2000.

Our conclusions regarding this research are the following:
- The Venus code above Orion gives the right year.
- The OPPOSITE turnings are very close to the days of the cataclysm!
- The translation of Albert Slosman must be right. He decoded the right year! This is unbelievably accurate.
- The story of Atlantis (as translated by Albert Slosman) must

be true (see Chapter 3, "The Great Cataclysm").

• There was a polar reversal in 29808 BC and a very rapid turning into the zodiac in 21312 BC. This must also be true, because Albert Slosman translated them in the same way as he translated the date of 9792 BC. Starting from this point, you can find why the Maya used the Venus-numbers and the Egyptians the Sothic cycle (see further)!

The Right Date

With our retrograde loop of Venus above Orion, we have the right year. The loop also suggests that the right day must be around December. Other astronomers found a connection between Venus and the Pleiades and the end day of the Mayan calendar. The Pleiades were strongly associated with the greatest of Mayan sky gods, known as Itzamna. He ruled the heavens and was also the god of the all-important axis of the earth. As we now know, the earth will soon shift from its axis. The Maya believed that there had been great death and destruction at the end of each of the previous worlds. We know that this is true and that it will happen again in 2012. This date is alarmingly soon. It translates into our Gregorian calendar as just before sunset, Central American time, 21-22 December 2012. At that moment Venus sinks below the western horizon, and at the same time the Pleiades will rise above the horizon in the east. Symbolically speaking, we will see the death of Venus and the birth of the Pleiades. At the moment the sun really sinks, Orion rises. Symbolically speaking, this gives us a new precessional cycle.

But will this really happen? No! When the earth starts turning the other way, and east becomes west, the Pleiades and Orion will sink and Venus will rise again in the east (the west before the cataclysm) and start an new cycle! After one day, the Pleiades and Orion will rise again in the west (the previous east)! A new precession cycle begins.

More Codes of the Pleiades

A huge carved stone statue of a skull that had a strangely two-

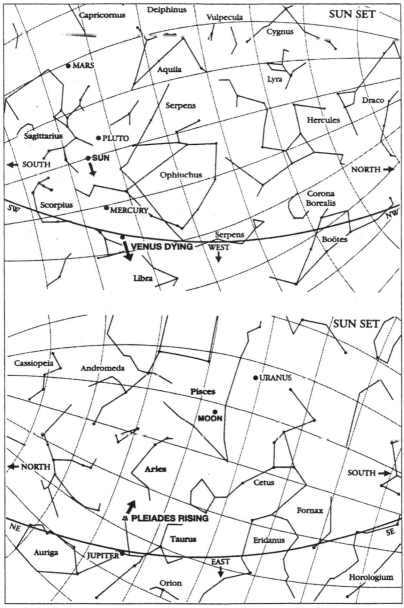

Figure 32.
The sky at sunset in Central America on 21-22 December 2012, showing the death of Venus and the birth of the Pleiades.

153

dimensional appearance had been found at the bottom of the western face of the Pyramid of the Sun in Teotihuacán. It had been discovered in the center, along the edge of the Avenue of the Dead, pointing to a particular spot on the western horizon. The archaeo-astronomer Anthony Aveni of Colgate University observed that on the days when the sun passes directly overhead, the Pleiades make their first annual predawn appearance. He also discovered that this massive stone skull was aligned with the precise spot where the Pleiades disappear beneath the horizon. On the night of 12 August, the sun also sets at this point on the horizon. This is precisely the anniversary of the start of the last Great Cycle of the Maya which started on 12 August 3114 BC.

Another study, published in *The Ancient Kingdoms of Mexico*, Penguin, London, 1990, found that the great Avenue of the Dead was built to face the setting of the Pleiades at the time Teotihuacán was constructed. So, the whole layout of Teotihuacán was like a huge clock-face. It pointed, like one hand of a clock, at where the Pleiades would have set on the southern horizon on 12 August 3114 BC, whilst the other hand of the clock, the skull, pointed at the place where the Pleiades sets today. And when you study the three pyramids of Teotihuacán, on which of one the skull is attached, you'll find that they also represent the three stars of Orion's belt. And this ticking clock from Orion and the Pleiades has only a few years left.

Egypt: the Same Code

For the Maya, the sun, Orion, the Pleiades and Venus were of exceptional importance. They have built several temples in order to follow the paths of all of these heavenly bodies with extreme precision. But what about the Egyptians? After studying this in depth, I found the shocking answer: They had the same code! Herewith, I give my findings:

1. The Egyptians incorporated Venus into the code of the zodiac and used it, as did the Maya, to find the year of the Great Catastrophe. Furthermore, the sun, Orion and the Pleiades are considered as very important. The Pleiades are associated with

Seth, who inflicted the deadly blow to Orion.

2. In the Holy Book it is clearly written that Osiris (Orion) and Seth (the Pleiades) are each others' opponents in their fight for the empire. In astronomical language, this means being in opposition. Furthermore, Orion is linked with the sun. In 2012, at the end of times, Orion and the sun are in opposition with the Pleiades and Venus.

3. In 2012, at the end of the Mayan calendar, Venus will be between Scorpio, the Serpent and Ophiuchus. According to mythology, Ophiuchus saved the hunter Orion by crushing Scorpio under his foot. A plausible explanation for this can be found in the events during the perishing of Atlantis. When Scorpio appeared on the western horizon, Orion died in the east and then disappeared. In words: Scorpio gave Orion a deadly bite, then the cataclysm happened; east became west and vice versa. In astronomical language: Orion reappeared in the west above the horizon, while Ophiuchus pushed Scorpio under the ground in the east. In 2012, after the next cataclysm, the opposite will happen.

Conclusion: The Maya, as well as the Egyptians, calculated the same end date. Considering the large difference in the time of their hegemony and their different calendars, this is extremely remarkable! That leads us to another code from the Egyptians.

Stargate

In ancient Egypt the constellation of Orion was depicted by the figure of a walking man, often shown with his hand upraised, either clutching a braided cross (symbol for eternal life in Egypt) or a star. According to the late E.A. Wallis Budge, an esteemed Egyptologist, the star symbol has a secondary meaning as 'door.' Sahu, the Egyptian Orion, is, therefore (in accordance with the ancient philosophy) secretly indicating that at this place, above his outstretched arm, lies a 'stargate' to heaven. According to our findings, the Orion Gateway will be opened a few months before the end of time. Symbolically, this will happen during the circle of Venus above Orion in the spring and summer of 2012.

What Will Happen?

The earth's spin will decrease rapidly. Then it will go the opposite way. As it is now going from west to east, so will it be going fromeaest to west. In other words, the rotational spin of the axis will be in the rotation as it is presently. This means that the earth will have to be slowed down and be spun up again in the opposite direction. This will take place in less then a day, with tremendous earth changes, cataclysmic events, billions of death and great destruction. And then all things will normalize again, except that climatic changes will have taken place, because of the pole shift.

Now you can ask me: are you sure of what you are saying?

That is a logical question, which I shall try to answer. The date 27 July 9792 BC has been decoded by Albert Slosman from the hieroglyphs. The end of the world as predicted by the Maya is on 21-22 December 2012. The scriptures of the Egyptians point to Venus being in a specific code position in the year when Atlantis was demolished. Venus is also important for the Maya. You only have to read *The Mayan Prophecies* to realize this. Venus's code has been incorporated in their scriptures and buildings. A prediction I made, and for which I have found the mathematical evidence to prove, is that similar codes can be found in the Egyptian scriptures. In Egypt there existed an underground complex which Herodotus called "The Large Labyrinth" which contained more than 3,000 chambers. That is where the astronomic calculations were done! They were copies of the ones that used to be in Atlantis. They were kept because, and I was amazed when reading it, the Atlanteans knew the exact date of the destruction of their land 2,000 years in advance! Here, I'm asking for your mind. I want you to understand that they *CALCULATED* the end of Atlantis— now buried under the South Pole. Again, they *CALCULATED* an even more violent end for us. Put magnetic reversals and precession together, and you've found the colossal cataclysm that they were talking about. That there is a link between 2012 and 9792 BC is undeniable. If we keep ignoring these findings, we will all die. All alarm bells should be ringing around the world!

Keeper of a Forgotten Time-Capsule

We urgently have to look for the labyrinth, the super large complex that is even larger than the pyramids, according to Herodotus' description. It will provide us with the correct data with which the Egyptians and the Atlanteans made their predictions of this world-wide cataclysm. All the data of the elitist, 'scientific' priests of The Large Labyrinth will be found there. Also other mysteries from an archaic and elite academy lay there waiting for us. It has long been known that they carefully studied the cycle of the sun in its perceived yearly circuit along the zodiacal path. And more recently, compelling evidence has emerged from the researcher Maurice Cotterell—which I confirm totally—that they knew the sunspot cycle theory, a theory that modern astronomers don't even know about! To observe and accurately measure the sunspot cycle theory is a feat that could only have been achieved by scientifically highly advanced people—technological and mathematical supermen. They were astronomers par excellence who had been following and recording the explosions on the sun for thousands and thousands of years, and found that when there is a big change in the magnetic field of the sun, the earth will turn upside down. A great catastrophe blueprint was the result. Their enigmatic findings vibrated through Egypt with the rigor of a messianic cult. They took steps to mobilize the people of Egypt and harness their energies to the fulfillment of a gigantic warning: the Great Pyramids. Thanks to this enormous work, I was able to decode their warnings.

I don't doubt we will find in The Large Labyrinth a connection between the reversal in the sun's magnetism, the earth's polar reversal and the destruction of Atlantis. Furthermore, research on the reversal of the sun's magnetism around the twentieth December 2012 has to be carried out urgently. I myself have no doubt after having made these discoveries. The only question that is keeping me busy for years now is: how can I possibly survive this? And, is it possible to shut down the oil wells and nuclear power plants in time?

Figure 33.
The three stars of Orion's belt (in opposition to the real one) and the three great pyramids of Egypt and Mexico.

World-Shocking Message

Right now we have a gigantic problem. For thousands of years the Egyptians were the possessors of a super-secret that they wished to hide—something of unprecedented significance for mankind. We found that it was their goal to warn their descendants of a giant cataclysm. With that knowledge they could escape in time—and save their civilization. Nobody else would. This

decoding is the proof of their great knowledge. It is irrefutable, and the first proof in the history of modern science that a high civilization mapped the sky. Not only did they map the sky, they also followed the movement of the planet Venus and linked it to the polar reversal that destroyed their homeland Aha-Men-Ptah. This code tells us that the Maya and Egyptians were master-astronomers. But this is stated much too lightly—in fact, they were better than our astronomers! So they were super-high-tech stargazers. The time has come to listen to their clear alarm signal that beckons to us out of prehistory. The codes point to an imminent catastrophe. We can do two things: continue on as if we don't know a thing, or start taking measures to survive the blow.

Without exception, this will be the largest challenge in human history. The destruction caused by wars is peanuts compared to what is coming at us now. The blow will be comparable to the explosion of ten thousand atomic bombs. Entire parts of our world will be destroyed. Billions of people will die. The suffering will be extreme. Unless we take world-wide precautions to arm us against this destruction. Not everybody will be saved, I realize that. But if you don't do anything, then the loss of life will be even larger.

My message is clear: if humanity does not recognize the implications of this date quickly, it will endanger itself greatly. This centuries-old manuscript proves the following:

1. The codes the Maya and the Egyptians used in their calculations are the same.

2. Independently from the Maya, the Egyptians determined the date of the end of the world with great precision.

3. The Egyptians and the Maya must have had superior calendars to make their calculations.

From the above facts, which are all incontestable, we can decide that the Maya are descendants of Atlantis, or based their knowledge on the tradition of the survivors of the cataclysm. As for Egypt, we already know that with absolute certainty. This way we can explain the world cataclysm of 2012 in a logical way. Furthermore, this knowledge proves that for both civilizations it not

only originated from the same essential source, but also that they could verify it themselves. That completes the picture and confronts us with the largest challenge ever for humanity: the imminent cataclysm. This gigantic geological disaster can wipe out our civilization. We can react with resignation, panic, despair, denial, etc. But in the few years we have left, the warning will hopefully be picked up by enough people to take the necessary precautions. These can enable the most precious knowledge to be transferred to future generations. Let us remember the following words from professor Frank C. Hibben in *The Lost Americans*:

> One of the most interesting of the theories of the Pleistocene end is that which explains this ancient tragedy by world-wide, earthshaking volcanic eruptions of catastrophic violence. This bizarre idea, queerly enough, has considerable support, especially in the Alaskan an Siberian regions. Interspersed in the muck depths and sometimes through the very piles of bones and tusks themselves are layers of volcanic ash. There is no doubt that coincidental with the end of the Pleistocene animals, at least in Alaska, there were volcanic eruptions of tremendous proportions. It stands to reason that animals whose flesh is still preserved must have been killed and buried quickly to be preserved at all. Bodies that die and lie on the surface soon disintegrate and the bones are scattered. A volcanic eruption would explain the end of the Alaskan animals all at one time, and in a manner that would satisfy the evidences there as we know them. The herds would be killed in their tracks either by heat or suffocation, or, indirectly, by volcanic gases. Toxic clouds of gas from volcanic upheavals could well cause the death on a gigantic scale. ...
>
> Storms, too, accompany volcanic disturbances of the proportions indicated here. Differences in temperature and the influence of the cubic miles of ash and pumice thrown into the air by eruptions of this sort might well produce winds and blasts of inconceivable violence. If this is the explana-

tion of the end of all this animal life, the Pleistocene period
was terminated by a very exciting time indeed.

Re-read these words and remember them forever. Due to them
we urgently have to restore the knowledge of ancient Atlantis in
regard to the day of the next cataclysm. Without this essence, the
later civilization will, 12,000 years from now, suddenly be plunged
into the Stone Age. Whether we have to build gigantic pyramids
to accomplish this, I don't know. I do know that these buildings
were an essential element in my research, bringing me to the point
where I could shout "eureka." On purely mathematical grounds,
as a researcher, you can deduce from these buildings enormous
quantities of data and knowledge on the cataclysm. This wisdom
from ancient times teaches us the following:

1. Our computer-dependent civilization will be demolished by
the reversal of the sun's magnetism, which will send a cloud of
electromagnetic loaded particles into space. Thereupon the poles
will crash, a slide of the earth's crust will occur and this will be
followed by a gigantic tidal wave.

2. The sunstorm and the reversal of the poles will destroy all
electronic equipment. This will result in the complete loss of
99.9999999% of our knowledge in just a few hours' time.

3. The geological slide of the earth's crust and the tidal wave
will demolish libraries and books for good.

To meet this super challenge, we have to, as has been proved,
be prepared for the worst. Survivors must have the basic knowl-
edge of all natural sciences at their disposal, for they have to start
from scratch. Nothing of any importance whatsoever will still
function or remain. It will depend on the few survivors whether
our history will be handed down or not.

Of course, I realize that much can be improved in our society.
That is exactly why we have to make sure that the essential is
passed on. For instance:

•The next civilization that will arise after the cataclysm has to
 show an immense respect for nature. Pesticides, herbicides,
 fertilizers, and so on have to be barred completely. They have

to be replaced by biological agriculture.

- Forests and woods have to have a central place in and around the future cities. The cities themselves have to remain small.
- To prevent pollution the world population has to remain limited. In the beginning, right after the catastrophe, priority can be given to repopulation.
- Nuclear power plants should never be built anymore. During the slides of the earth's crust with its titanic quakes, quite a lot of radioactivity will be released from the hundreds of nuclear power plants on the planet. The amount of radioactivity flung into the world is probably sufficient to terminate mankind. It is my largest fear that this will indeed happen, and that we can't do anything about it!
- Unnatural nutrition, destructive for our health and requiring loads of energy to produce, should be forbidden by law. Amongst these foods I would include candy, chocolate, potato chips, white sugar, and so on.
- A fruit and vegetable diet has to be promoted. It is not only healthy but also prevents some 30,000 diseases. Because medical care such as surgery will be practically impossible right after the catastrophe, everybody will understand the benefit of staying healthy. Only a fruit and vegetable diet can have this effect and is essential to staying healthy.
- Meditation and fasting have to have a central place in the fight against infectious diseases and other diseases. Together with the above, they will be the basis of the new way of living.

These "holy commandments" will enable us to create a much happier society than we have now. Profit will not be the central issue, but the mental and physical health of all earthlings. Hopefully as many people as possible will realize this after the shock of the cataclysm, so the mistakes of the actual consumer society will never be made again. These are the teachings we have to pass on. An infinitely better world will be the result. And if you have still doubts about our findings, read on.

14.
THE STORY OF ATLANTIS AS TRANSLATED BY ALBERT SLOSMAN

I've read the book *Le Grand Cataclysme* (The Great Cataclysm) by Albert Slosman a dozen times. It intrigued me tremendously. After a year I started to study the cataclysms more intensely.

Answers, I was looking for answers. I studied the time lapses between the previous cataclysms, and asked myself: why the Orion code with Venus? Why Venus at all? It is a planet and it has nothing to do with the cataclysm. Months and months went by. I thought and thought. Then a light started to shine. Had it something to do with the sun, I asked myself? That was it! The sun! I was astonished that I didn't think of that earlier! Let us look at the happenings in 9792 BC. When comparing data from the holy scriptures with data from other books I read, an awful lot becomes clear:

Solar flares will light up the atmosphere of Venus, just like polar light. It will become as visible as the moon—or even more so. A part of the atmosphere of Venus will be blown into space.

The Maya described these events: Venus was like a second sun and had a tail. For these reasons, the Atlanteans, Maya and Egyptians took Venus as the most important marker in the sky.

The important conclusion to be drawn from this is that the Maya as well as the Egyptians followed Venus precisely, because they knew it would light up again in the sky when the next cataclysm happened! Therefore the Venus-Orion code! In my decoding of the Dresden Codex (see below), you will see that important numbers from Venus led to the decoding of this Codex! And what do you find? The sunspot cycle theory (see below and also *The Mayan Prophecies*). Venus is nothing more then a marker to find the right year of the previous and next cataclysm! It has no

influence on the cataclysm whatsoever!

Above I explained how we were able to break the Venus-Orion code by following secret instructions in the Egyptian Book of the Dead. The code can be broken only by using high-tech astronomy programs. It shows an incredible story of their traditions, history and a cataclysm that wiped out their home country Aha-Men-Ptah. This was one of the many codes I was able to break. They tell us the stories of a secret science, which explains how the sun affects life on earth. Here I had to do something similar.

Albert Slosman translated that the previous catastrophe had been predicted, based on earlier events. In that year, Atlantis partially vanished under what was then the North Pole (the South Pole now). This was accompanied by a tidal wave. Would Venus at that time also have made a turn above Orion? We were able to answer this question in September 2000, because this happened in 21,312 BC and the latest astronomical programs go back to 100,000 BC. We researched 21,312 BC and the surrounding years and, according to our findings, Venus didn't make a turn above Orion.

We also have the date of 29,808 BC. In that year a polar reversal occurred. And again Venus didn't make a turn above Orion.

So I had to look somewhere else for the Venus code. But where? My starting point was that the previous cataclysm of 9792 BC was predicted. Could I find more codes from Venus in the previous happenings? I started to study them meticulously (see next page).

I started looking at these tables. What game were the Egyptians playing with these cycles? Was it a game of numbers? Were the numbers concealing a hidden message? Could I find the numbers of Venus in it? Had I to follow secret instructions? Questions, questions and still more questions, but no answers!

The Encoded Numbers of Venus

The Egyptians and the Maya used the observations of the planet Venus to find a connection between the cataclysms. What's the number of Venus? That's easy to answer: 584. This is the synodic

		Cum. Duration
Duration	Age	of the Cycles

35,712 BC: founding of Atlantis

864	Libra	864
2,592	Virgo	3,456
2,448	Leo	5,904

Cataclysm. The year: 29,808 BC. First polar reversal! The earth started turning the other way! East became West and vice versa!

1,440	Leo	1,440
2,592	Virgo	4,032
1,872	Libra	5,904
1,872	Scorpio	7,776
720	Sagittarius	8,496

Cataclysm. The year: 21,312 BC. The earth turned 72 degrees in the Zodiac in half an hour! This is unbelievably fast!
Remark: No polar reversal, just a rapid turning in the same direction!

576	Aquarius	576
2,016	Pisces	2,592
2,304	Aries	4,896
2,304	Taurus	7,200
1,872	Gemini	9,072
1,872	Cancer	10,944
576	Leo	11,520

Cataclysm. The year: 9792 BC. Second polar reversal!
Total years since the beginning: 5,904 + 8,496 + 11,520 = 25,920 = time of one precession = end of Atlantis!

1,440	Leo	1,440
1,872	Cancer	3,312
1,872	Gemini	5,184
2,304	Taurus	7,488
2,304	Aries	9,792
2,012	Pisces	11,803

2012: NEXT CATACLYSM

Figure 34.
The changes in the movement of the earth, after the previous cataclysms.

cycle of Venus in days. The synodical cycles of the planet Venus around the earth show marginal fluctuations in duration between 581 and 587 days. Whilst these fluctuations in themselves were known by the Maya, they were actually far more interested in the reason behind these small variations, shifts in the relationship between the plane of rotation of Venus and the rotational axis of the earth itself. Yes, I thought to myself, this could be the answer: a relation between Venus and the rotational axis of the earth itself! Until very recently our own astronomers had not even noticed this, but the Maya were absolutely obsessed with this cycle,

which they tracked back into history well before their own time!

As the observatory at Chichen Itzá had indicated, the ancient Maya were experts in astronomy, mathematics, calendrics, cycles, etc. They had a very complex idea of their place in the universe, filled with great and terrifying gods. But they were also incredibly scientific in their stargazing, with highly precise calendrics, predominantly based on the planet Venus.

The ancient Maya were very obsessed with numbers and timekeeping in general. Indeed, the Maya' expertise in mathematics was such that they are now widely credited with having invented the concept of zero. This enabled them to handle large numbers with ease.

Numbers were not just abstract concepts used for their calendars, astronomy and architecture. No, the ancient Maya thought that each number possessed a spirit of its own. To the Maya, numbers were manifestations of the energies of the universe.

Their calendrical system was far more complex and accurate than our own. Based on the movements of the planets, it could not only predict solar eclipses that the Maya could actually see, but also eclipses happening on the other side of the world—or far in the future. The calendar was so sophisticated that it even accurately predicted eclipses that have happened recently. The Maya considered their calendar a gift from the earliest people, a gift from the gods, people who could see everything. Modern astronomers are only just beginning to 'discover' the basics of the Mayan calendar.

For the Maya time and space were inextricably linked. It helps us to understand the cyclical nature of Mayan calendrics and how they calculated the end of the world. Thinking about this I started to look at the time between the previous cataclysms. It turned out to be a truly remarkable adventure in time. Imagine my amazement when I learned that there is a connection between the codes of Venus and the Sothic cycle from Egypt (see: Appendix, Further Decodings). These discoveries were hidden in the time between the cataclysm of 21,312 BC and 9792 BC. If you subtract them you'll find it is 11,520 years. Furthermore in 21,312 BC the earth

turned 72 degrees into the zodiac. The number 72 is not an arbitrary number. It is an essential number from the precession cycle (72 x 360 = 25,920)! As we know, the Egyptians understood complex astronomical relationships, aligning temples to meet the precessional cycle, changing the identity from Apis the bull to Aries the ram, reflecting the precession of the heavens on earth. And the number 72 is essential in these bursts of creative accomplishments, miraculous achievements of technologically and artistically super humans. So I thought that they also encoded the number 72 in the 11,520 years between the cataclysms. I multiplied 11,520 by the days in a year according to the Maya and the Egyptians (365 and 360, respectively) and divided them by 72. To my astonishment I found the encoded numbers 584 and 576 of Venus from the Maya! And that was not the only thing I found.

The Sothic Cycle of Egypt

By the same method you can find the encoded numbers 1,460 and 1,461 of the Sothic cycle (see: Appendix) of Egypt! It is indisputable, and I was struck by the clever math. I marveled at their intelligence; I witnessed their skill and wondered, how did they know? It is just unbelievable, and I asked myself: what god-like minds encoded all of this information into one single number? The number represented a language of symbolism that describes events in the real world. It describes history, astronomy, and more—without the use of a dedicated language—to future peoples like ourselves.

They had knowledge of cataclysmic mechanisms that affect the earth periodically, and were able to calculate them. It seems reasonable to suggest that they would wish to convey this knowledge to us. But how could any civilization communicate with another which would emerge thousands of years later? Books would have been burned through ideological succession, languages lost, ideas wiped out. How could the decoding instructions be conveyed to another race of an alien language and an altogether different method of writing? There are only two constants which are common denominators of advanced civilizations:

numbers and astronomy.

To accommodate this, the Atlanteans and their descendants used the simplest numbers possible. By adding or subtracting a 'holy number' they found other numbers that made further decoding possible. If you now put yourself in their position, you are able to decode it! Your chances of survival increase dramatically! You also need to remember that the method of encoding depends upon the importance of the message, more concrete methods being used for more important messages, increasing greatly the chances of their message getting through. It was considerations such as these that persuaded the Egyptians to encode their messages into their astronomy, time calculations, architecture and numbering system. Some of them would stand the ravages of time, increasing the certainty of decoding and delivery. So I turned my attention to the decoding of their numbers. That was one part of the story. Even then, not content with the success of this decoding, I progressed even further, decoding astronomical messages left in their writings. These support each other, providing an overwhelming response to the non-believers. They all say the same: polar reversals are a fact of life. Every 12,000 years they happen again. Only you had to understand the numbers.

Not surprisingly, the choice of the Sothic cycle and its traditions has confounded and perplexed scholars for several centuries. Why, they ask? Well, this is because it is a very important number that leads to the solution! By studying the decoding, you will see how they developed an incredibly clever system of clues, enabling a duplication of the same message in their calendars, architecture, astronomy, etc., and the evidence that I found is crushing! What this shows is that the Egyptians did not wish the meaning of their cycles to be revealed except to the researcher who understood the astronomical importance of the numbers 1,460-1,461 of the Sothic cycle of the star Sirius.

The Egyptians started their year on the night of 19-20 June. On that day, the dog star Sirius rose just before the sun and it continued to rise at that day, in defiance of the precession of the equinoxes. Why? Because Sirius is, relatively speaking, very close to

earth. It has a considerable 'proper motion,' which enables it to defy precession, while all other stars are affected. There you have it! The Sothic cycle is a precession code—another amazing secret of the past. It reflects their super knowledge of astronomy. The zodiac of Dendera shows clearly the astronomical constellations depicted by the astrological characters of the zodiac. Inscriptions in the pyramid of Unas document the myth of Osiris and take the mythological story one stage further: ' ...Oh king, you are the companion of Orion ... and may you go to the place where Orion is ...' this was intended to escort the dead king to the constellation of Orion, to become a star after death. In his book *The Orion Mystery*, Bauval reconstructed the skies, and discovered that the southern 'ventilation shaft' from the Great Pyramid of Cheops, at Giza, pointed directly at Orion's belt, while the similar shaft out of the Queen's Chamber below it pointed at the star Sirius. A double code—precession and Orion. What is the meaning of this? We already know: the precession in 9792 BC is the same as in 2012 AD. Furthermore, the pyramids are an opposite reflection of the Orion constellation. The meaning is very clear: at the end of a great cycle, the world will be turned upside down, and the code of Sirius is important in it. With that in mind, I was able to find one after the other decoding with the number of the Sothic cycle.

Here I give another one: the ancient Egyptians used a calendar which had only 365 days in the year. Sounds silly for such fine astronomers, but it isn't, because this slight inaccuracy again enabled Sirius apparently to defy precession. The Maya also used 365 days. Did they use a legacy from a high civilization, I asked myself? Was it a code for something? The correct length for a solar year is 365.2422 days, but the Maya estimated it at 365.242. This is only 17.28 seconds from the real value. Intrigued, I started looking at the numbers, and after a few hours their code numbers blew right into my face! What had I found? That their astronomy showed sophistication comparable to our own! They knew a solar year is 365.2422 days! Again a world-shocking decoding! This is .08 seconds from the real value! A fault of 0.000000003%! I will reveal in the Appendix how I decoded it.

You'll find a lot more decodings with the Sothic cycle in my next book. They all prove the validity of my decoding method.

My conclusions are the following:

1. My starting point was that there is a connection between Venus and the time between the previous cataclysms. In my calculations I found similarities between the Sothic cycle of Egypt and the Venus cycle. I can prove this is unquestionably true through deduction.

2. The connection between the Mayan super numbers and the Sothic numbers will be proven extensively in my next book. Various Mayan numbers are the Sothic numbers multiplied by code numbers. By using these code numbers I was able to decode the Mayan calendars (see my next book) and the Dresden Codex (see Chapter 22). And I promise you will be almost shocked to death when I reveal the final decoding from the duration of a solar year, according to the Maya and Egyptians. So unbelievably accurate!

3. The way the Maya and the Egyptians calculate is without any doubt based on the same series of numbers. That is why the Maya and Egyptians must have the same source.

4. The Maya as well as the Egyptians knew exact astronomical numbers (see: Appendix, Further Decodings). This is the most shocking of all. By this knowledge they were able to make precise predictions of planet tracks thousands of years before they happened. Not only that, but they were also able to perform the calculation of the end date with incredible precision! This is why their warnings should be taken extremely seriously! And I mean *extremely!*

5. Anybody who still claims the proof is not watertight, does not understand their way of thinking. Try again. In their world of thought numbers were the most important starting point because they are universally accepted. If you start from this premise, it will eventually become clear. What we are doing is using the same way of calculating that the Maya did. Every four years we adjust our calendar by an extra day. This adjustment is slightly too high. After 128 years we do not count an extra day and there is no leap year! When you think about this, it is easy to understand their

way of thinking. It is this way of calculating they have used in all their calculations. In case of a leap year it concerns one day. If you calculate this over thousands of years, it becomes a large number of days. They make their other calculations in the exact same way. After a period of time, for instance, they came up with thousands or millions of days. To make this match with other calendars they subtracted x days or added y days until the similarity was there again. With this knowledge they were able to find a theory of crucial importance to civilization as we approach the year 2012.

Figure 35.
Chapter XVII from the Book of the Dead is the only one without glyphs. It describes The Great Cataclysm. I will reveal the decoding in my next book.

15.
THE SUNSPOT
CYCLE THEORY

The Maya as well as the Egyptians were sun worshippers. Their entire culture was based on the sun. They had every reason for this, as the sun not only gives life but also death. It is exactly this duality that made them worship our golden circle.

We too know and realize that the sun is important. To name but a simple example: a cloudy sky can seriously ruin our summer holiday. This is a relatively innocent example, because scorching heat can cause catastrophic droughts and failed crops. Astronomers are only now starting to realize that the cycles of the sunspots could be at the root of this. Our knowledge of the correlation between the eleven-year sun cycle and the average temperature on earth has increased over the past years. It now seems certain that the climate on earth is related to the number of sunspots. One of the most dramatic examples is the period from 1650 to 1710, when there were virtually no sunspots to be seen. Astronomers call this period the Maunder-minimum. In that same period it was colder than normal in our region. Meteorologists also call this period the Small Ice Age.

Sunspots are remarkable. They form relatively cool areas on the surface and only look dark because the rest of the sun's surface is even hotter and brighter than the spots. Inside a spot, the temperature is slightly below 4,000 degrees; very hot indeed, but enough cooler to make the spot seemingly darker due to the contrast with the environment.

The lower temperature is caused by its strong magnetic field, which appears to be 10,000 times stronger than the magnetic field at the poles of the earth. This magnetism stops the upward moving motions that, on other parts of the sun, transport energy to the surface. This results in less energy reaching the surface where

the spot lies and the spot having a lower temperature.

A solar spot is a temporary phenomenon. The smallest spots only exist from a few hours to a few days. Bigger ones can last weeks to months. Some of them are even big enough to be seen by the eye. Sun spots appear and disappear according to a certain rhythm. At the start of the cycle, spots appear in the vicinity of the "poles" of the sun. During the cycle they appear closer to the "equator." After that, usually right before the end of the cycle, more appear around the poles. But the cycle does not happen regularly. There are ups and downs. Between 1954 and 1965 for example, there were a lot of spots to be seen.

Spots appear in pairs. Both components have an opposite magnetic field, as if a gigantic "horseshoe magnet" appears on the sun's surface. Obviously this is not the case. There are strong electric currents in the sun's interior causing the magnetic fields.

A group of spots and their environment are called an activity area because there is much more happening behind the appearance of the spots. Countless gas bows ravage the surface of the sun. These bows, or loops, get their characteristic form from their strong magnetic field, caused by electric currents, that have a strength of tens of billions of amperes. The loops are external signs of these gigantic streams moving through the sunspots.

Sunspot Activity

Sun activity is a more or less periodical phenomenon. Through centuries of study, people discovered that the sun reaches a minimum and a maximum over a period of 11 years. This period is called the sun cycle. Around 1840 astronomer Wolf managed to quantitatively describe the sunspots and their groups. The graph below shows the evolution of the solar spot activity since 1680. Keep in mind that in 1610 Galileo was the first person to use a telescope for astronomical studies. He saw that it was spots and not planets revolving around the sun, because as opposed to Mercury and Venus who pass the sun from time to time, they were not constant but changing all the time, in number as well as in location on the solar surface. After this discovery people had

fairly reliable data on the number of sunspots. The above-mentioned Maunder minimum from 1650 to 1710, and the strong variation over the centuries is remarkable. A comparison with the change in average temperature of the earth shows a striking resemblance between the highs and lows.

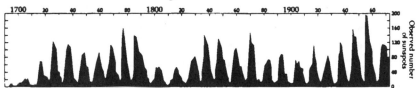

The (approximate) 11½-year sunspot cycle, from observation since 1680.

Figure 36
Number of sunspots since 1680.

The graph shows that the sun's activity exhibits variations of the eleven-year cycle. There are short and long cycles; the longest time between two peaks was 17.1 years (1788-1805), the shortest 7.3 years (1829-1837). Also there are cycles with a large and a small top intensity. For example, in 1952 and 1989 the sun showed heavy activity with violent eruptions. On the other hand, in 1962 almost nothing was to be seen on the sun. It was that quiet. The biggest surprise for the solar experts came in 1996. According to the theory this should have been a calm period, in between two cycles. But nature decided otherwise. In the spring of that year the satellite known as Anik E-1 became unusable. The reason for this was storm damage. Huge solar flames had sent millions of tons of particles into space. These crashed on earth's atmosphere which partially bounced them back into space. But because it was such an incredibly large mass, trillions of particles managed to get through. The result was disastrous for the extremely expensive satellite. This was totally unexpected by the astronomers. They thought the sun only showed this type of behavior at the maximum of its cycle. Obviously this was not the case: the sun could also be vicious during calm periods. This is a very important point. If you apply the eleven-year cycle, it should be declining sharply at the end of 2012. Experts say there is no way there would be a superstorm then that would reverse the earth's magnetic field.

Seeing what has happened, this theory cannot be relied upon now. Also, the cycle of the sunspots could become longer or shorter, which would result in the "maximum" matching the date predicted by the Maya and the old Egyptians. This is enough proof to not just dismiss the ancient wisdom of these super scientists. We know a lot less about the sunspot cycle than the Atlanteans. For thousands of years they studied it, applying a theory that no modern-day sun expert knows! Based on that theory they could accurately predict the behavior of the sun. As you can see in this book, the Maya and the old Egyptians had extremely accurate numbers regarding the time it takes the earth to make a revolution around the sun. If you possess such incredible accuracy, you will have no trouble calculating the revolving time of the sun's magnetic fields. Once you know that, you can, after a long search, unravel the cycle of the sunspots. That is how they did it, and that is how we will have to do it again. The problem is we only have a limited amount of data. There is a possibility this will not be enough to acquire the necessary theoretical knowledge to recalculate the predicted end date. In any case, I will start by showing how the Atlanteans got their knowledge.

Earthshaking Theory

Astronomers and physicists still have no explanation for the sunspot cycle, but the priests who studied the "Mathematical Celestial Combinations" discovered a few phenomena. After very long periods of observation, they noticed that the sunspots moved across the equator with an average time of 26 days. Up to the poles the average time becomes longer. Also, they discovered that the time required by the sunspots to move from one point to another varies together with the sunspot cycle. When a sunspot minimum occurs, the spots are moving slower over the sun. In contrast, at a maximum, the spots are moving faster. Out of all those observations they distilled a theory. The main code was rediscovered in 1989 by the investigator Maurice Cotterell. He made use of rounded numbers for the magnetic fields of the sun, 26 days for the equatorial and 37 days for the polar field. Starting

from these numbers, he found a sunspot cycle of 68,302 days. This is described thoroughly in his book *The Mayan Prophecies*. He used differentials and a computer program which he called 'rotational differentiation.' To simplify this matter, he used a comparison, which was based on a random indication of the magnetic fields of the sun and the earth with an intermediate period of 87.4545 days. This was chosen because the polar and equatorial fields of the sun finish a common cycle every 87.4545 days, and return to the starting point. He equated one cycle with one bit. The result was sensational: there was a clear rhythmical cycle in the long computer printout. Cotterell saw that this appeared similar to the known sunspot cycle. With this he had found a relation between theory and reality. It is necessary to emphasize here that none of the astronomers know this theory! That is why nobody on earth is aware of the catastrophic effects of a complete swing-over of the magnetic field of the sun. I repeat: none of the official scientists know this theory! That is why the warning of the Maya and the Egyptians have to be taken very seriously! The fact that the Maya were even aware of this theory is earthshaking!

"Why?" you may ask. Well, there is no simple mathematical solution to calculate this cycle. I am aware, thanks to papyruses more than 5,000 years old, that the Egyptians were capable of calculating extremely difficult mathematical problems. The Maya should have had the same capabilities.

Just to give an example of a difficult problem the Egyptians could solve: calculate the volume and the surface area of a half sphere. This problem is found in the papyrus of Rhind, which can be found in Moscow. The age of this is estimated to be 5,000 years, and was copied from older documents. When I looked at the problem, I lost my breath. It was not that simple! I needed my book of spatial mathematics to solve the problem. I even needed two hours to refresh my memory to understand the calculation once I read it!

This is further proof that the Egyptians knew a lot more than the Egyptologists want to admit. Furthermore, thanks to the breaking of the Dresden Codex and the Egyptian astronomical zodiac,

I found the evidence that both civilizations knew the sunspot cycle. This is clear evidence that they could do the job, and unconditional proof that the Maya and Egyptians are from the same origin, and that they were brilliant mathematicians and astronomers exceeding the scientists of today! An example of this is the fact that the polar field of the sun is invisible from the earth. Only satellites in orbit around the sun are able to see this polar field! The great mystery is how the Maya found the speed of this field? And I have many similar questions!

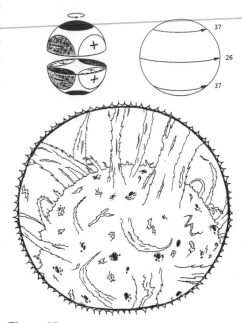

Figure 37.
The speed of the magnetic fields of the sun: 26 days at the equator and 37 at the poles.

For both peoples the sunspot cycle was a central item in their way of life. This is not hard to believe when you realize that a giant solar storm, coming from a culminating point in the sunspot cycle, will swing the polar fields of the earth. The catastrophe that is coupled with this will kill billions of people, probably all of mankind, because of the destruction of nuclear power plants by enormous earthquakes. Earth will become one giant radioactive ball, inhospitable to man. These thoughts alone should make us aware and understand the urgency to dig up the labyrinth, where all knowledge is buried.

Lost Knowledge and Rediscovered Codes

Many problems will find a solution in the secret rooms of the labyrinth. Calculating the sunspot cycle requires a serious knowledge of mathematics and is not easily done. Specific knowledge

about the movement of the earth around the sun, spatial mathematics, exact time measurement, integral mathematics, are all necessary. The strange fact is that they possessed all these skills, but it had to be kept secret. Only the priests initiated in the sacred texts had the knowledge. For others, everything was shrouded in mystery. This does not facilitate our work. A certain code is hidden behind each number or character. The meaning of this and how to interpret it requires extreme patience and tenacity. Without those qualities, there is no deciphering their important encoded messages. Interesting to know, is that they always worked with the same holy numbers. 'Keep on trying' is the message. It is the only way to find the answers, as long as we do not possess the data from the labyrinth. If you calculate back and perform "other thinking mathematical calculations" on the sunspot cycle, you will find many interesting encoded messages. Divide the Cotterell theoretical sunspot cycle by the turning periods of the magnetic fields of the sun. In that manner you find the number of cycles the magnetic fields go trough in one cycle of 68,302 days or 187 years:

$$68,302 \div 26 = 2,627$$
$$68,302 \div 37 = 1,846$$

When subtracting these numbers, the number of times the equatorial field catches up with the polar field is found: 2,627 - 1,846 = 781. This leads to different connections. To calculate when the one field catches up to the other, make the following easy calculation:

$$2,627 \div 781 = 3.36363636$$
$$1,846 \div 781 = 2.36363636$$

Explanation: when the polar field has traveled 2.3636 of a circle, the equatorial field catches up. The equatorial field has traveled one circle more, or 360 degrees. This is exactly after 87.4545 days, and is in accordance with the calculated cycle of Cotterell. Amazing is that in both fields, the infinite number 0.36363636 occurs. Here lies the origin of 360 degrees:

1. When I learned mathematics I did not understand why a circle consists of 360 degrees and not 100. When staring at these

numbers it became clear: its origin is in the calculation of the sun-spot cycle!

2. Another decoding explained that the Egyptians and Maya calculated the difference of degrees which the fields traveled (360) and used it in the precession cycle, which lasted 25,920 year (25,920 = 72 x 360). This proves without a doubt the origin of 360 degrees!

3. After a cycle of 87.4545 days, occurs a difference of 360 degrees. Eight of these cycles form a mini cycle in the calculations of Cotterell. This results in the next number of degrees: 360 x 8 = 2,880. This number appears in different calculations. It is an essential part. Here you find the origin of this number. Using the times between previous cataclysms makes it possible to calculate the Sothic cycle with the assistance of the number 2,880!

4. Later on, the infinite series 0.36363636 appears several times in the Dresden Codex and will become a crucial code of Venus. And it becomes even more complex. Code numbers, multiplied by 36, give new combinations that lead to more revelations of the Dresden Codex and the Egyptian Zodiac.

$25,000 REWARD

The situation is deadly serious. The Maya knew a theory that the modern astronomers don't know! Nobody will believe me if I weren't very sure of this. Therefore, I offer a reward of $25,000 to the first person who can prove that the sunspot cycle theory of Maurice Cotterell (see: *The Mayan Prophecies*) is known by astronomers. To collect his or her money, he or she must send the scientific astronomical magazine in which this theory was publicized by official astronomers to my publisher. Only scientific papers from before July 2001 are permitted. All publications outside the official astronomical scientific papers are excluded.

I hope you believe that I am serious after this offer!

16.
CATASTROPHIES, SUNSTORMS AND THE PRECESSION OF THE ZODIAC

This chapter is extremely important. It shows an indisputable mathematical link between the sunspot cycle and the precession (shifting) of the zodiac. Where this leads us, you will read in a moment. But first you have to look at some small mathematical calculations. Nothing hard. I have made these calculations numerous times. They did not give me a mental breakdown, so you do not have to panic. Just as I did, you will face several remarkable numbers, which you cannot ignore. Let us start right away.

First you need to remember that each magnetic field from the sun has a different orbital speed. The rotation at the poles is slower than at the equator. The equatorial field rotates around its axis in 26 days, the polar field in 37 days. After 87.4545 days the faster field of the equator catches up the polar field. In that period the equatorial field has traveled 3.363636 part of a circle and the polar field 2.363636. The difference is exactly one circle or 360 degrees.

'Not so hard,' I hear you think. Fine, then I can continue my story. If you have read the chapter concerning the breaking of the code of the zodiac, then you should know that the earth shifts 3.33333 seconds in the zodiac each year. Now I ask you to multiply that number by itself: 3.33333 x 3.33333 = 11.11111. This is the average time of a sunspot cycle. Every 11 years the sunspot cycle goes up and down, from a high point to a low. Again, this is no coincidence. In later calculations I succeeded in breaking several codes with this number, which proved that my search was going well. If this significant number is multiplied by the number of

rotation cycles of the magnetic fields of the sun, I found the following astonishing results, and I mean really astonishing:

$3.363636 \times 11.11111 = 37.37373737$

$2.363636 \times 11.11111 = 26.26262626$

Indeed, once again appear the periods of the rotations, but in reverse compared to the number of traveled circles. Two infinite series of 37 and 26 are found. Smart readers will notice the following: this means that if you know the period of the magnetic field of the equator, you can calculate the speed of the polar field with use of the square of the precession number! And of course you can do the same the other way around.

Well, I am speechless. I am not able to express it more accurately. It is an extraordinary mathematical connection, where coincidence is totally—I repeat—totally out of the question. It is a part of a 'Master Plan,' a very sophisticated computer program, which defeats the most modern software in its beauty and complexity. You cannot ignore it. Just try to make something like this. This is your starting point: incorporate the two magnetic fields of the sun, which are the building stones of the sunspot cycle, with their average period. If you would ask this of an astronomer, he would look at you desperately and not answer the question. It is even worse. He would not be able to give a mathematical model, because he does not know the formulas the Maya and Egyptians knew! These series of complex astronomical data are world-shocking. They prove unconditionally the intelligence of those who created these theories. Just as the discovery of the Rosetta stone induced the start of Egyptology, this way of decoding will cause a revolution in the knowledge of antiquity. It is a crucial link to the existence of our civilization. In a certain way these numbers have an esoteric numerology. As you can see yourselves, these are essential numbers which can be processed to basic components. When those are processed, in turn, they lead to the same numbers! A mixture of combinations of the highest order, resulting in a source of information for the insiders, the numbers experts.

The relevant numbers are a determined metaphor for the catastrophic disaster which is going to ravage the earth. They are the

intriguing climax of a search into the reasons for pole shifts, the falling down of skies, the destruction of land, animals and people. In their simplicity is hidden an immense complexity of mythology and religion, of science and mathematics, brought together in an essential symbolic.

It does not stop here. Apparently, the discovery that the equatorial field of the sun rotates in 26 days was easy to make. The rotation of the polar field was much harder due to the invisibility from the earth. That is why they hid in the precession number the secret code of the polar field. The proof is as follows:

11.11111 x 3.3333 = 37.037037037037

An infinite series of 37 is found here. So much coincidence is not possible. Once again, more connections between the shift of the zodiac and solar magnetism should be found. The proof for the predicted and actual events in Atlantis is given if we find those. At the same time, we are sure of what is going to happen in 2012. The Atlanteans knew that a gigantic shortcut in the sun causes enormous eruptions.

Figure 38.
Effect of the Differentially Rotating Magnetic Fields.

The electromagnetic shock wave is so powerful that the earth's magnetic field is blown away. After that event the earth will move in the opposite direction in the zodiac! To describe this, the Atlanteans searched for a mathematical relation between these two phenomena.

Together we can reveal this. We use the time of the magnetic fields of the sun: 26 and 37 days. Then we calculate the number of degrees each field travels in one day. Dividing the number of degrees of a circle by these numbers results in the following:

$360 \div 26 = 13.84615385$

$360 \div 37 = 9.729729730$

Divide the precession cycle by these numbers:

$25,920 \div 13.84615385 = 1,872$

$25,920 \div 9.729729730 = 2,664$

Take a closer look at these numbers. Already the first one is significant. For the Maya 18,720 is a very important number. But 1,872 is also the shortest period in the zodiac of the Egyptians! Besides, I encountered those several times in calculations. The accuracy of this simple calculation clears all remaining doubt. This is still not everything. Later on, the number 2,664 will be indicated as an essential code number in the Dresden Codex. In other words, you can retrieve two Mayan code numbers by making a simple calculation with the Egyptian zodiac! This indicates that they must have the same origin. By digging deeper into these findings, I was able to decode more important data. The omnipresence of the symbolic numbers is no coincidence. They form a strange but understandable similarity. They are the synthesis of a super-civilization that was confronted with the end of time—gods who have incorporated their myths and knowledge into one big idea. A source of knowledge where disturbing exact scientific research was incorporated. I gasped for breath. What further discoveries were ahead of me? Finding the precession requires the knowledge of two points in a year where day and night are equal in time. Those would be 20 March and 22 September. Research indicates the Maya and Egyptians had this knowledge, due to the fact several temples were built at that point where at the be-

ginning of the Spring the sun rose above horizon.

And there lies the solution of the riddle I am trying to reveal. The precession cycle is a majestic machine of extraordinary complexity. I almost swooned. Their knowledge of the cosmos had to be enormous, their math phenomenal. According to them it takes 72 years before the sun shifts one degree over the ecliptic. This is a remarkably precise calculation according to the astronomers of today. Only science of a mathematically and astronomically high standard can produce such an accuracy.

I asked myself, is it possible that secret codes were hidden behind this number? Did they initiate this encoding in the numbers I found above? Was their heritage so brilliantly encoded that somebody with a scientific perspective could reduce their complex mathematical information to a more understandable model? Full of respect, I started my calculations and soon it seemed that my hunch was correct:

1,872 = 72 circles of 26 days

2,664 = 72 circles of 37 days

I am quite sure that you were astonished looking at the number 72. When it is multiplied by the period of the solar magnetic fields, it results in the stated numbers. These numbers appear so frequently that they cannot be ignored. We stumble here upon the essence. Without a single doubt, it is clear that the Egyptians purposely incorporated these numbers in their way of calculation. Why, I was wondering? A thorough study of the text of Albert Slosman about the previous catastrophe gave me the answer to this burning question: Aha-Men-Ptah was shifted 72 degrees in the zodiac after the catastrophe!

This connection of important basic numbers in the sunspot cycle and the zodiac are created with a purpose. They are the mathematical answer to apocalyptic visions of volcanic eruptions, enormous earthquakes, ice ages, and a gigantic tidal wave—and therefore frighteningly realistic. What a brilliant solution, what an unearthly logic, I whispered to myself. I really could not get enough of it. Was this a telepathic message through the mistiness of time? Something told me that this was indeed the case. There

was a lot more to find behind these numbers of the far past. Could I be able to recall those memories? Could I break the forgotten encoding more extensively? I looked at the numbers with renewed interest, and I was successful after a short intensive study (readers interested in mathematics can find the evidence in the Appendix). Subtract the number of the sunspot cycle (see previous chapter) from the calculated values:

1,872 - 1,846 = 26

2,664 - 2,627 = 37

What did you find? A direct connection between solar magnetism and the shifting of the zodiac. Such science is extremely progressive. It exceeds the science we know today. Behind all this is a helping hand, which wants to warn us. Incredibly smart scientists were responsible for this. The reason for this is that this connection is not random. There is a direct connection between dramatic time periods on earth. The precession cycle is closely connected with the beginning and the end of the ice ages. This has been known since the 1970s. The earlier mentioned discoveries are the evidence that the Atlanteans had a higher level of knowledge, and this more than 12,000 year ago! They also discovered, just as the scientists of today, that there were several causes for the ice ages. They were confronted with this on 2 February 21,312 BC. The earth turned 72 degrees and the subtropical Aha-Men-Ptah (First Heart of God) became in a few hours partially covered with the then North Pole. This tragedy was followed by a tidal wave. The survivors grouped and decided to create an astronomical center: the Circle of Gold. For thousands of years their best scientists studied the heavens. Finally they concluded the following:

1. The spring point is shifting very slowly. This means that it appears after a certain time in a different constellation. They encoded the solar magnetism, the period of Venus and other important numbers in the periods of the different cycles: 1,872, 2,016, 2,304 and 2,592 years. Names were given to these constellations, based on historical facts, which are used almost unchanged to this day.

2. During the shifting of the zodiac a second phenomenon takes place: the earth's axis is shifting slightly. It becomes a little more or less inclined. Scientist call this the inclination in relation to the ecliptic (this means the angle between the equator and the ecliptic). The Atlanteans must have discovered the same as the scientists of today: it fluctuates with a difference of 2.4 degrees. The axis is the most upright at 22.1 and the most inclined at 24.5 degrees.

3. The fluctuation of the earth's axis has an influence on the speed of the zodiac. It fluctuates century by century. It was 25,920 years. Today it is 25,776 years. Most disturbing is that the Atlanteans had hidden in their genesis a secret code that I was able to break. According to this, a disaster took place in Atlantis when the precession changed to 25,776 years. Today we have reached the same period! A more alarming correlation does not exist. It proves that a catastrophic event can take place any moment now.

Scientists proved that the beginning and the end of ice ages in Europe and the Americas could be predicted by these discoveries. These alarming events take place when the poles of the earth axis are straighter up than normal. Also, the precession causes a change in the rotation of the earth that causes a shift of summers. This means that if a summer is relatively cold, a part of the ice formed in the winter does not melt. The next winter a new layer of ice is formed and a chain reaction of glacial circumstances is the consequence.

So the existence of a new zodiacal age can be a crucial initiator for the beginning of ice ages. This is not the whole story. Over the last two million years, the earth has encountered ten long and forty short periods of ice ages. The average time of an ice age is 80,000 to 100,000 years. These ice ages were alternated with warmer, interglacial periods that lasted for about 10,000 years. In the last 330,000 years Europe has known three warmer periods, followed by colder periods that lasted 100,000 years. Ten thousand years ago, the warmer period started in which we are today. The end of it is definitively coming closer. An unknown disaster

is waiting for us. Ice caps hundreds of meters thick will bury Europe and destroy everything below it. Of course the Atlanteans knew this. And, I am sure, even more. They must have made the following correlations:

1. Solar spots and the strength of winters: low sunspot activity produces strong winters, and the reverse is also true. An easily made conclusion. Everybody agrees about this topic, particularly when their knowledge of the sunspot cycle is taken into account.

2. The deceleration or acceleration of the precession cycle: the astronomers of today presume that the sun causes the precession, but they do not know how. We all know that the solar wind produces electrical particles, which can penetrate the earthly atmosphere through the poles and produce the well-known auroras, australis and borealis. A portion of the particles can reach the inner core and create an electrical loading, responsible for a change in rotational speed.

3. The shift of the magnetic field and solar storms: after a period of more than 1,300,000 days the magnetic field of the sun turns around (see: *The Mayan Prophecies*). This phenomenon comes with enormous solar explosions, which are responsible for multiple effects. The magnetic field of the earth is heavily hit, the auroras are visible almost globally, and lighting is widespread. This is more than enough to attract attention and lead to the necessary conclusions.

4. In 10,000 BC the Atlanteans were so certain of a correlation between the magnetic field of the sun and a catastrophical happening on earth that they decided to orchestrate an exodus. For 208 years, preparations were made for this. The Maya and Egyptians, as descendants of the legendary Atlanteans, predict a similar, but even more violent catastrophe on 21-22 December 2012. What did they calculate? After almost 12,000 years, there is a gigantic reversal of the magnetic field of the sun! When that happens, unbelievable super sun flares escape from the sun. Trillions of particles will reach the earth's poles and put them "into flames." Because of the continuous stream of electromagnetism, the magnetic field of the earth will get overcharged. Unknown electrical

forces will be generated. When the poles are filled with auroras from the falling particles, the inevitable will happen: the earth's inner electromagnetic field will get overcharged and will crash. Then, wham! The earth's magnetic field reverses and the earth starts spinning the other way! Just like a dynamo that starts turning the other way, the north pole becomes the south pole and vice versa! And our entire civilization will be destroyed!

I conclude that the Atlanteans discovered several relations between solar magnetism and the shifting of the zodiac. All of these are extremely disturbing. Modern scientists know that the same phenomena could bring the earth into terrible danger. To ignore these messages is suicide. Almost everybody will die during these events if precautions are not taken urgently! And above all, the survivors won't have computers and machines to rely on. Why this is so will be made clear in Part IV.

PART IV

THE
CATASTROPHE

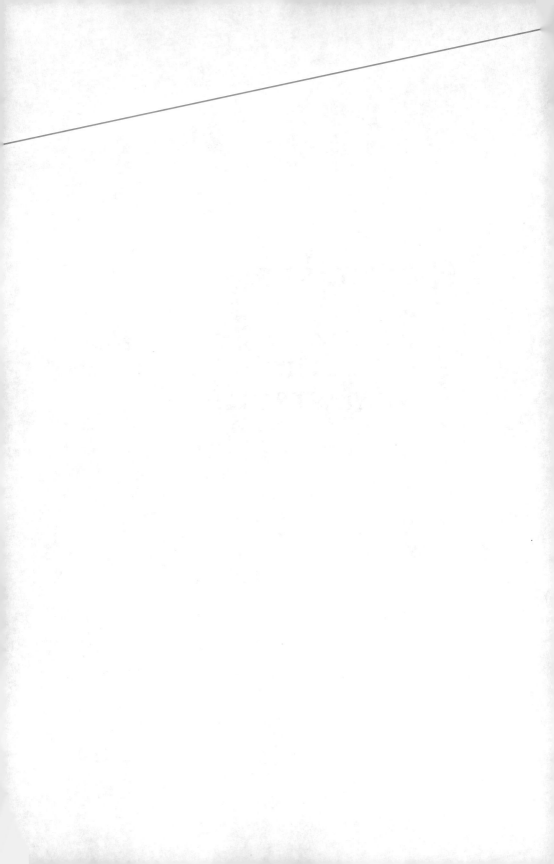

17.
A TECHNOLOGICAL
SUPER-DISASTER

Tuesday 26 December 1996. I had celebrated Christmas Eve at my brother's house, together with my mother and his girlfriend. During a walk in the freezing weather (he was walking his dog, which could barely follow us because he was very old), we talked about the coming disaster. My brother is a civil engineer in electronics and could probably advise me on some of the questions I had. I told him: "If the magnetic field of the sun would reverse, then this would cause a stream of electromagnetic particles to be thrown towards the earth. Then you'd get a short-circuit in the dynamo of the interior of the earth. The magnetic field of the earth would then reverse, with catastrophic consequences: earthquakes, volcanic eruptions and landslides."

My brother was silent for a moment. "That's much worse than I thought," he said. "The geomagnetic field of the earth is enormously powerful. If it reverses, it will generate world-wide magnetic fields. It will be a technological super-disaster!"

Surprised, I looked at him while the last misty clouds of his answer disappeared in the frosty air. "What do you mean by that?" I asked.

"When the electromagnetic field reverses, it generates potential differences. These are so large that the present sensitive electronics will be 'burned out' in one single moment."

I looked at him, stood still, and felt alarmed. I asked him, "Do you mean, literally, that all appliances will be destroyed?"

"I'm afraid so. Because of the shift of the poles, strong magnetic fields will be generated almost everywhere, creating induced currents. Depending on the size of the magnetic field, it can destroy all electronic apparatus. Electric motors can burn, etc."

It made me feel ill. I hadn't counted on this one. "What exactly

will stop functioning?" I asked.

"Practically everything: pocket calculators, watches, music boxes, radios, computers, televisions, the electronic ignition of cars, the electronic controls of trains, ships, airplanes. Wait, what else? All communication devices in satellites, radio/TV towers, radio stations, and so on."

'Damn,' I thought, 'that is an incredible super-disaster!' But I saw a possible escape and asked, "Can this be repaired quickly?"

My brother gave a scornful laugh: "Do you know what you are talking about?" he asked. "The reversal of the magnetic field is such a major event that all electronic parts will definitely be destroyed! They cannot possibly be repaired!"

"And if the apparatus aren't switched on?"

"Even then! The inner induction fields are more than enough to burn everything. I repeat, everything!"

If you had been able to see me after those words... My eyes almost popped out of their sockets, that's how shocked I was! It can't be true, I thought. It can't be true! But my brother was firm: all electronics will be gone!

"What a disaster!" I whispered. "And there is absolutely nothing one can do about it?"

"Nothing. And we're not only speaking of the destruction of all hardware, but also the erasure of all data!"

I couldn't believe my ears. As if it hadn't been enough already! And I asked in dismay, "How is that possible?"

"Due to the enormous magnetic field, which is caused by the reversed poles, all the information on the magnetic data storage media will be gone: computer tapes, floppies, music tapes, cassettes, computer hard discs. In short, all information possible, be it digital or analog."

'Oh no,' I thought to myself. All present knowledge is stored on computers. In the year 2012, it even will be even more the case than now. Essential data will no longer be in books. And all that knowledge will be destroyed in one blow! Our entire source of knowledge will disappear for good! I hadn't taken that into account at all! I had thought we would be able to save everything

on computers, and thus be able to start civilization in a period of a few hundred years.

I continued our conversation, after almost a full minute of silence. "Is there nothing, then, on which we can store our knowledge?"

"CD-ROMs should be resistant. But I repeat: all apparatus to access them will be destroyed."

"And microfilms, would they be strong enough?"

"Undoubtedly. If you put the major data on them, you have a chance that scientific knowledge will be back soon. Otherwise, you can really forget it. If you have to start from zero, I can't see it happening. Such a blow is sufficient to erase everything."

"There are stories about superior civilizations on earth which have been destroyed completely by such a cataclysm. I realize that they may be true, now that you told me this!"

"Don't forget that we are completely dependent on electronics at present. All electrical conductors such as iron, copper, aluminum, saltwater, etc., will generate induced currents, with fatal results for all apparatus. But on top of this, people can also become electrocuted. If, for instance, you are on a ship made of steel, the currents that are generated there can become so high, you will be electrocuted!"

'Oh, no,' I thought, 'Stop!' It had been my plan to defy the tidal wave on a ship, just as the Atlanteans did. But with these induced currents this appeared to be impossible.

"Surviving in a ship will not be possible then?"

"Probably not. It will be impossible to control, and it will be electrically charged to such an extend that you won't survive. On top of that, the cooling system of the nuclear power plants will have stopped, so the entire earth will be contaminated with radioactivity. I don't know if it will be that safe to live."

"Is there no possibility at all to survive on a boat?" I pushed him.

"If you were able to construct a Faraday cage around the ship, then you might get through it. But I'm telling you, that's a big 'if.' Maybe it would be possible if the ship were made of synthetic

material, and the metal parts were very well isolated. Those preparations should keep you happy for a couple of years!"

I sighed heavily. The solar wind would bring us a super-catastrophe. The magnetic field of the earth would be overcharged, then crash and reverse. During the hallucinogenic events that would follow, everything we know would be gone. Unless we take measures to save the knowledge we have at present from complete destruction. Miserable, I looked at the sun, which, because it was winter, was quite low above the horizon. The sun didn't only make life on earth possible, it also destroyed it in due time. The inner core of the earth would be turned upside-down, after which one fatal event after another would take place. And nobody could stop the clock.

18.
SUNSTORMS

20 December 2012. All is normal on earth. Planes are flying, boats are leaving the harbor, people are doing their Christmas shopping—in short the world seems to be as always. Seems. Because when you watch the people's faces, you'll see the expression of deep worry. Several books have pointed out that in one day the earth would be hit with an enormous cataclysm. Escaping it without having made preparations for it would be as good as impossible. The zodiac predictions from the Maya and Egyptians had been the only subject of discussion for weeks and months. What if it turned out to be true after all? How can we survive it? Where do we have to run? The fear was well-rooted in many, but nevertheless they hadn't taken the necessary measures. A couple of thousand did make preparations and had stored food and energy supplies. They had also built a library of books containing all the knowledge of the present day. Another copy was stored on digital videodisks that could survive a magnetic storm. Calm and self-assured, they were making the last preparations. Specially-equipped ships with supplies for a year had left the harbor a few days ago. They would survive the flood. Then an ominous message reached the satellite Heliostat, which was in orbit around the sun. It had recorded changes in the magnetic field of the sun. It was not a normal change, but something big. Only a few seconds after the Heliostat had picked it up, it was sending the data to earth at the speed of light.

After the earth's satellites and space observatories received the alarming message, panic broke out amongst the scientists. They knew the cataclysm was going to happen. In countries where no measures had been taken, the governments tried to stop the news, but in vain. A few minutes later, all stations in the world were broadcasting it. The panic was incredible. The end of the consumer society was nearing rapidly.

Millions of people still tried to escape; they ran to the harbor to board ships. Container ships, not built for this, were bombarded by wild mobs. People were screaming, fighting and killing to get on board. Armed groups of people stormed a cruise ship which was already filled with passengers. The passengers were put back on shore, and the ship steamed towards the ocean. Sailing ships, rubber boats, and so on, changed owners, accompanied by a lot of violence. The chaos was complete. Anarchy ran rampant. Groups were plundering the deserted areas. Churches were filled completely. The penetrating smell of fear—pure, naked fear—was coming from almost all people on earth. The end was near. It was beyond the point of return.

Short-Circuit on the Sun

The mass of the sun, with a volume 1,300,000 times that of the earth, shivered. The prelude to somewhat more than stormy weather on the sun. In fact, the sun should be in a low activity cycle. But the satellites encircling it were producing data for the Helio-seismologists: an event would take place that only happens every 12,000 years. The old civilization of Atlantis had discovered the codes for this cataclysm. By means of pyramids and a super-large underground temple with more than 3,000 chambers they had stored it for later civilizations. But the knowledge was lost and people thought the zodiac was meant for making fun predictions. The ultimate prediction for which it was designed was greeted with howls of derision by the scientists. Until the moment of doom had come. In amazement, the scientists watched how the magnetic lines started to change brutally. How the sun short-circuited in a gigantic way. Their hands were shaking, their hearts skipped a beat; an overwhelming fear was taking over. With disbelief they stared at the figures, but there was no way around it: with the reversal of the magnetism, the convection layer would burst into flames. A gigantic dynamo was on the move, which would cause a continuous production of magnetic fields. In no time, the sun would experience its highest activity since time immemorial.

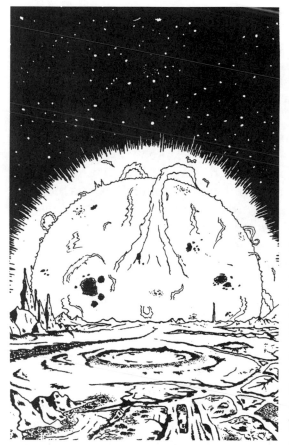

Figure 39.
The magnetic field of the sun changes abruptly and solar flares shoot up. The beginning of the end.

The inevitable happened: the inner nuclear reactions flew up. Much more hydrogen than normal fused. A gigantic amount of energy was finding its way to the surface. Two-hundred thousand kilometers from the surface, the energy was all at once transmitted to the convection layer. Complete layers of gas were suddenly heated, expanded and thrown upward through the cooler layers. Once at the sun's surface, the bubbling gas balls burst open and the normal temperature of 6,000 degrees went sky-high. Giant fountains of fire, reaching more than hundreds of thousands, and even millions, of kilometers high, set the sun on fire. Enormous amounts of radioactive rays were thrown into space. Heliostat was hit by them. 'Bleeep,' was its last transmission, and that was it; finished. Heliostat's warning of the cosmic storm of gigantic proportions was abruptly interrupted. The atomic radiation had done its murderous work. And the sun was on fire now. From all sides, the sun's surface was torn open by solar flares, similar to what would happen if all vol-

canoes on earth erupted and tortured the entire planet. It was the prelude to the overture of the downfall of the world. Magnetic and electrical fields were going berserk, a phenomenon which, up till now, was unknown except in the mysterious reaches of outer space. It was something one could observe on faraway constellations at the edge of the universe. There, unimaginably far away, probably at the outer border of immeasurable space, these dramatic events happened. But now, in our universe which is billions of years old, our sun became the center of everything. Every second, trillions of particles were spewed out. An intergalactic radio source was created as if it were nothing. Was this really the sun or an unearthly galaxy? A deadly, fascinating spectacle started to develop. Fiery tongues from the sun threw their destructive loads into space. Their explosive power can't be described in words. One such developing flame easily reaches the power of fifty billion exploding hydrogen bombs! The temperature generated in this hellish inferno is several tens of millions degrees. If the earth would fall in there, it would be almost entirely be reduced to nuclear protoplasm!

And these were only the more peaceful eruptions. Once the atomic fire oven is on full power, the stability of the sun itself is in danger. Starquakes announce the beginning of the catastrophe; layers of burning matter are thrown off from the sub-layers. An indescribable amount of light and energy is set free. Far-off spectators would watch this (in fact, incredibly beautiful) spectacle in awe. The solar flares form something of a network around the sun, caused by the wild, wriggling eruptions. They are of an unearthly beauty in the deserted space. The gone-berserk sun-plasma triggers the brain cells to their maximum: an insane excitement about so much beauty arises, coupled with a terrifying tightness knowing its super deadliness. Miraculous, but destructive, as ice evaporating instantly when put in an atomic oven. However, the dreamworld of the astrophysicists was pure reality for all people on earth. This could only end in an all-destroying catastrophe, the largest ever. An event one can only experience once in a lifetime, if, needless to say, one even survived it. Incredibly beauti-

Figure 40.
Giant fingers of fire leap high into the sky forming fiery loops, many times the size of the earth. The end of our civilization is near.

ful, and so desperately deadly. Worse than the worst nightmare.

The changes in the sun's magnetic field had now reached the earth. They traveled at the speed of light. They caused changes in the brains of all earthlings. Nothing drastic, only subtle ones. It was sufficient to push the fear to unknown heights. Everybody was now convinced that the earth's population could vanish completely. A primitive shout was in almost everybody's brain now. 'Survive, I have to survive.' Others, on the other hand, were completely stoical. Their voices sounded louder while reciting their prayers and asking their God for forgiveness. For that, it was too late. The Creator was in anger for the crimes against nature committed by humanity. With bottled up anger he had generated chaos in the billions year old sun. The Jehovah's Witnesses finally got their end of the world, the Islamites said it was Allah's will and a lot suddenly converted. In the end, the Bible proved to be right: now was the end of times.

In New York, a new day was dawning. A diffuse light, hidden behind a thick fog, lighter than the lightest light ever seen, dominated the entire atmosphere. All activity in the city had stopped, this 21st of December. The snow in the streets was melting at high speed. The temperature climbed rapidly. A lonely figure looked with his infra-red camera from the Empire State Building at the city, and then directed his eyes to the invisible sun. He shivered at this apocalyptic vision and decided to wait for the inevitable. In the meanwhile, on the ship *Atlantis*, everything was ready. The nearly 4,000 passengers, who had signed on years ago for this survival journey, were hyper alert. They closely watched what was happening. The ship weighed over 100,000 tons and was completely filled with food, clothing and energy supplies. A surgical room had been installed as well as a dentist cabin. Everybody was wearing new clothes, had their teeth in excellent condition, brought spare-glasses, etc. After the cataclysm, it would take years before the civilization would be functioning again.

From the beginning everybody was rationed, because the tidal wave would destroy practically all food supplies in the world. There were also some chickens on board, a couple of goats and a few other animals. Many animals, plants, seeds and apparatus were in a different container ship, rented for this reason. There were also hundreds of young girls on board. They were offered a free cruise holiday. They were meant to take care of repopulating of the world. They were aware of this, and had agreed to travel along on these specific days. You never know. They wouldn't regret it.

During all this, the sun eruptions continued in full force. A torrent of energized shortwave radiation was set free. This interstellar shock wave of mainly x-rays and gamma radiation would kill astronauts billions of kilometers away from the event. Later on, the sun's plasma storm would completely disorientate their spaceship. Compass needles would turn around insanely, electrical equipment would short-circuit and the radio-beacon would be wiped away by the electron storm. A dead ship would circle in space forever. Now the interstellar sun plasma shock wave was

nearing the earth's atmosphere. The electrons and protons had a much higher speed than normal, because of their fierce origin. On earth there were winds, storms, hurricanes and tornadoes. Winds didn't do a lot of damage. Storms could tear out trees, blow away your roof, and so on. Hurricanes can demolish complete blocks, villages and cities, while tornadoes just tear away everything. The same is true for sunstorms. Low activity throws out the plasma at low speed. More activity yields a serious amount of plasma and could amount to some millions of tons. But now, all

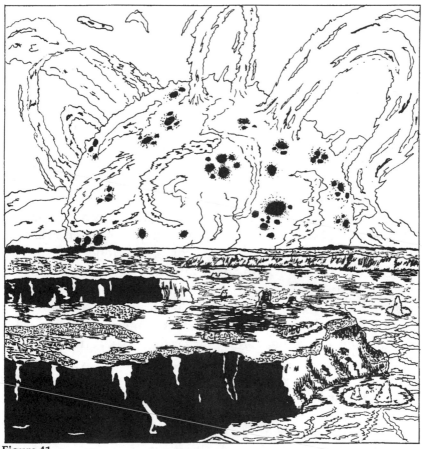

Figure 41.
Gigantic magnetic and nuclear explosions seem to disrupt the sun continuously.

records were broken. Hundreds of millions of tons of negatively charged electrons and positively charged protons were torpedoed into the vacuum of space. The first particles smashed against the magnetosphere. Most of them rebounded off and continued their journey to other targets. In normal circumstances, the magnetosphere has the shape of a teardrop: globular in the direction of the sun and elongated in the line of the shock wave. More and more particles started to storm the protective field. It had functioned perfectly for the last 11,003 years; just as the windshield of your car protects you from the wind, the magnetosphere fulfilled its protective task. The ceaseless stream of radioactive particles was, however, doing its slow, destructive job.

The Magnetic Field of the Earth Crashes

The windshield started to crack. The particles were getting larger and larger. But the screen still stood, just as how a completely cracked windshield can hold because of the strengthened layers. Trillions and trillions of charged particles managed to leak through. They overcharged the Van Allen Belts, which also surround the earth. Other particles spiraled downwards to the magnetic lines of the North and South poles. A lot of energy was thus set free because nitrogen and oxygen atoms were being excited. The result: the generation of brightly colored auroras, borealis and australis. With every minute they grew fiercer and fiercer, a warning signal of what was yet to come. The deflection shield of the earth was also becoming more and more troubled by the now-coming-to-full-power geomagnetic storm. It couldn't be otherwise: the sun had thrown the particles at turbo-speed into space. Ejected at enormous speeds, the electromagnetic particles pushed through the atmosphere with a larger than usual strength. A sort of funnel was created, where the field lines of the solar winds dove into the magnetosphere. Super strong storms were generated in the upper layers of the atmosphere. Phone conversations stopped, radio connections were abruptly disconnected, television signals were short-circuited; in short, all communication possibilities on earth were gone. It was terrifying, more terrifying

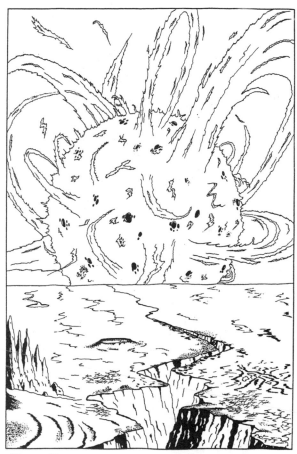

Figure 42.
The climax is reached when a gigantic network of solar flares surrounds the sun. One flare contains the same energy as a hundred billion exploding hydrogen bombs!

than anything. Without communication, this world could not survive.

The biggest solar sunstorm since the end of Atlantis was now doing its murderous job. The electron stream thundered into the poles. They found their way in. In Canada, electric transformers were overheated. A chain reaction followed of reactors falling out. The electron stream now reached hurricane strength. Further and further, it penetrated the atmosphere. Every electric and nuclear power plant on the entire planet fell out one by one. The age of the caveman was here again. In many places, combustion engines short-circuited and died. It was as if nothing functioned anymore. Jehovah's Witnesses were praying they would be among the chosen ones; others were of a deadly gray color and could only mumble thoughtlessly. They had a few hours left to live, or less. Then their lives would abruptly come to an end in an earth-

quake, volcanic eruption or tidal wave.

On the ship *Atlantis*, insulated with plastic against the induced currents and magnetic fields, one voice could be heard above the others. It was my voice. "Dear friends. The hour of truth has come. For years we have being preparing for this day. Now it is here. The earth has tumbled into an unknown, fierce magnetic storm. All connections with the outer world are gone. Now we won't know what is happening. What we do know is that in not too much time the earth's crust will disconnect and cause a world-wide catastrophe. We don't know for sure whether we are going to survive, but we might, if the tidal wave is not too high and the ocean is not ripped open by a seaquake. I would like everybody to go to their seat or room and secure themselves as well as possible against the shocks the ship will have to go through. Remember not to eat, and to drink as little as possible. Going to the bathroom while the ship is withstanding the waves can get you seriously wounded. If we get through this day, we will have seen the worst. Let us hope for the best. I assure you it will be good living in the new world we are going to start."

For a minute it was deadly silent. Then came thundering applause, and bottled-up emotions looked for a way out. It was a grand moment for all. It belonged to the few who had believed the prophecies of the zodiac, and would now be rewarded by staying alive. That they would lose everything they possessed touched them deeply. But hope came forth from the new life that would start after the catastrophe. The expansive urges of humanity had brought the earth to the verge of disaster. This event would finish it and create a new chance to do it better, this time, following the laws of nature, not following the oppressive laws of super-commerce and its destructive forces. It was worth staying alive. In one blow many problems would disappear, but many others would take their place. The belief in survival was, however, strongly present and would be the driving force behind the new existence.

In the Empire State Building, the lonely figure watched the electricity of New York die away. He knew his end was near. In-

tensely he stared at the foggy, impenetrable sky. Would the angels come and get him out of here? The air tingled, started to smell like ozone, while the temperature kept rising. It was like a day in summer, but it was winter. Dogs started barking and howling, cats screamed. It was horrifying. Everything waiting, for a painfully exaggerated time, as if seconds lasted for ages, for the imminent death.

The Catastrophe is Going to Happen

The poles could not withstand the continuous stream of particles any longer. Enormous potential differences entered the earth's crust. Giga-volts smashed into each other and generated a short-circuit on a global scale: the earthly dynamo disappeared and the magnetic protective field around the blue planet was erased in one blow. All hell broke loose. The sun-plasma now stormed the unprotected atmosphere. World-wide Bengal fire was the result. Auroras appeared everywhere at lightning speed. The generated potential differences in the atmosphere were enormous. It was as if fire dominated the sky. Nothing could now stop the fatal blow. Everybody who saw this was clearly aware of it. Billions of people would die, more than ever in all previous catastrophes put together. But also, more than ever would survive it, simply because so many people lived on the planet now. The hour of doom was getting near quickly. The outer layer of the earth shivered. Normally, it is fastened to the earth. Because of the reverse of the inner core of the earth, the chains of the outer layer were broken. The polar cap from the South Pole which had become extremely heavy during almost 12,000 years, started to do its destabilizing job. The catastrophe was close and could start any moment now. Because magnetic particles from the sun could now deeply penetrate the atmosphere, numerous magnetic fields were created. These disturbed the functioning of the brains of both animals and man. Many animals panicked blindly, while their masters became desperate. The radioactive fire burned intensely, causing irreparable damage to the reproductive organs. On board the *Atlantis* they were prepared for this. Deflection shields were an excellent

protection. Also, the separate decks stopped much of the radiation. Only the captain and some officers would get the heaviest radiation. They could not leave their places and hoped for the best. It depended on them whether the ship would come through the geological events or not. Preferably in one piece. They sweated heavily. What was in store for them? How long would it take before the first quakes?

Then the earth growled. 'This is it!' flashed through their brains. It would start now! Again the sonar picked up a growling sound. And the heavens seemed to move, because of a gigantic swing in the earth's crust.

19.
EARTH'S
POLESHIFT

What had happened? The earth's iron core acts as a dynamo. Because of the particles falling in, the dynamo short-circuited and stopped. The outer layer of the earth (the lithosphere), turning around a syrupy iron layer, disconnected. And the shiver that went through the earth didn't leave the asthenosphere untouched. The lithosphere that lies on top of it, which is the thinnest layer of the earth and on which all life depends, broke off. The weight of the ice lying on Atlantis, which had grown during more than 11,000 years to an incredible mass, set the outer earth layer into motion. Cracking, tearing and shivering, the layer started to live its own life. The earth trembled continuously. Our lonely watcher in New York was thrown in all directions. Then the tower broke off at its base and slowly started to collapse. In only a few seconds, nothing but ruins would be left of the hundreds-of-meters-high building. During his dive down, our man saw that a giant fissure was forming in the street where he was going to fall. It was as if Armageddon had started. Houses collapsed and sank into unfathomable depths. Concrete and asphalt highways were torn open over large distances. Bridges fell into the swirling waters beneath them. People disappeared all of a sudden into ruptures in the ground. Everyone who was not on a boat or somewhere high in the mountains was trapped. In fact, there was no safe place at all. Climbers on Mount Everest, which is part of the Himalayan mountain chain formed during the previous poleshift, were thrown off the shivering mountain like feathers and were buried under an avalanche. Then the mountain split in two and collapsed. End of the climb. In Hollywood, the paradisial homes of the movie stars slid into the ocean at an amazing speed. The fairy tale was over, however famous they had been. Under Disneyland, the earth

changed into some sort of quicksand. The attractions, enjoyed by hundreds of millions of people, cracked, collapsed and sank in the swampy soil that emerged. In London, the famous Tower Bridge collapsed, after which the entire city followed suit like a house of cards. Soon the financial heart was in ruins and nothing remained of the beautiful shopping precinct. Water pipes burst open, gas pipes threw up their contents, filling station tanks ripped open and clouded the atmosphere. Chaos, utter chaos. A delirious panic overpowered the survivors. There was no escape. The cities fell to ruins and the sound of the crying and moaning from the injured ones could be heard everywhere. If all the dead could have cried along, the sound would have been deafening.

The ground shivered. In other places it rolled like a wild sea. Not just for a second, but for minutes and minutes. It seemed to last forever. A tragedy of unfathomable size was announced. The earth kept shivering and trembling. It was indescribable misery. Marvelous castles cracked and collapsed and only ruins were left. Nothing could withstand this nature that had gone amok. For a minute the Eiffel tower seemed to be resistant. It swayed from one side to the other, but found its balance again. Then one of the major pillars sank away and the powerful iron skeleton collapsed completely. In Paris, nothing was the same as it had been the day before. The festive lighting was off and splintered, the Arc de Triomphe had collapsed, the bridges over the river Seine were gone, the Louvre, where the zodiac of Dendera was kept, remained for only a moment. In short, with each tremble, Paris went more and more to pieces. In the interior of the earth, the large masses of stone were still breaking continuously. Rock masses slid and glided, passing fault areas. A ceaseless trembling and shaking of the earth's crust was caused by this phenomenon. And it wouldn't come to an end quickly, because now, the entire earth was set in motion. All over the world, the seismographs hit the roof. They are used to measure the strength of earthquakes. Seismographs can register trembles at large distances, because the trembles of large earthquakes cause waves which penetrate all layers of the earth and travel over the earth's surface. Be it in America or

Europe, each tremble is recorded. Up till now. The ceaseless series of super-quakes caused permanent dysfunction of the instruments. No great loss, since most of the people using them had already died in one of the quake waves.

And still the catastrophe wasn't over. Thousand-year-old volcanoes were brought back to life again. What once happened in Atlantis repeated itself here and now. With thundering force, dozens, no hundreds of volcanoes erupted at short intervals. This could be heard thousands of kilometers away. Thousands of cubic kilometers of rock, and enormous amounts of ash and dust, were pumped into the upper layers of the atmosphere. A hellish fire, worse than the worst hell, was then thrown up through the volcanoes' mouths. Boiling hot, the lava streamed from the mountains, destroying everything in its path. The few remaining gorillas in the world knew their nemesis now. For thousands of years, they had lived a peaceful life in the high mountains of Africa. Now the earth was shaking dangerously. In blind panic, they tried to run away. Then the god of vengeance did his job. Through the cracking of the earth layers, rock became fluid. Normally, it is kept solid by the pressure of the upper layers, but because they had ripped open, the rocks melted rapidly. Soon the pressure underneath became so high that it looked for a way out through the upper layers. Stone and rock above it were pushed aside, and melted down. The "cork" flew off and tons of lava were thrown high in the sky. Terrified, the gorillas looked up; then, from the sky a rain of fire fell down on them. Poisonous gasses, falling cinders, boiling mud and ash leave no way out for the animals. The worst is the hot cloud of gasses. In only a few minutes, the gasses cover many kilometers. It's impossible to breathe in it, for there is not enough oxygen. The gasses are so hot they can cause fatal burns—if you're still alive, that is. After the cloud is gone there is oxygen again, and almost all trees, plants, houses, and so on, catch fire. And as if that weren't enough, the lava comes and covers it all.

That was the end of the gorillas. Almost 12,000 years ago, during the previous disaster, mammoths, saber-toothed tigers,

toxodonts (a South American mammal) and dozens of other species became extinct. Now it was the apes and many other strange animals, often known only to man by their presence at zoos. The air was filled with the moaning of animals threatened with complete extinction. They saw phantom images from the previous catastrophe as if they were thrown back in time. Thousands of years ago, in another enormous eruption, an entire group of mastodons was buried under volcanic ash. When they were discovered in the San Pedro valley, they were still standing in an upright position. What happened then was amazing, but belonged to a long-forgotten past. What was happening now was pure reality: volcanic activity with a destructive effect on animal and vegetable life, not local but world-wide. The ash clouds darkened the sky, as if the world was entering a dark age. That was correct, because this violence of nature not only killed all life in many regions, but made the lands uninhabitable, too. While people and animals tried to run away, the earth kept trembling, shivering and spitting fire. It was incredibly traumatizing, and those who survived would remember it forever. For generations, this super-catastrophe would be the subject of conversation. The damage had been devastating. During the previous poleshift, a large part of Peru had risen from the depths. Bellamy believed that in geologically recent times, the whole Cordillera was violently thrown upward. He is quoted in *The Path of the Pole*:

> On the basis of paleontological and hydrological evidence I state that everything has lifted up. Remarkable confirmation of the immensity of this uplift is represented by the ancient agricultural stone terraces surrounding the Titicaca basin. These structures, belonging to some bygone civilization, occur at altitudes far too high to support the growth of crops for which they were originally built. Some rise to 15,000 feet above sea level, or about 2,500 feet above the ruins of Tiahuanaco, and on Mount Illimani they occur up to 18,400 feet above sea level; that is, above the line of eternal snow.

After this uplift a large, artificial saltwater lake was born: Lake Titicaca. Even now, the fish and shellfish look more like saltwater animals than freshwater species.

In not too long a time they would join their sort again. In 2012, the lake started dropping, resulting in an enormous and traumatizing change. A few hours ago, it was still at 3,800 meters above sea level. In less than three hours, it was at less than 2,000 meters. The millions of shellfish fossils thundered and relived their previous hour of death. Tidal waves started to ravage the once peaceful lake. The wild, deserted beauty became a grave for the sailors and fishermen that were on it. The strangest lake ever known to mankind was very near its end.

The anger of the gods seemed to lessen a bit. The ceaseless trembling diminished and the volcanoes stopped throwing out their interiors. In the meantime, the heavens had already started to move. There, where it was more or less night, the stars seemed to fall down. There, where the sun was shining, the sun itself seemed to have lost its way. That was the punishment for the priests of Machu Picchu not doing the holy ritual anymore. They used to tie a rope to the large stone pillar to "guide" the sun through the heaven and to prevent the sun from going off its course. This "Intihuatana" or "pole to tie the sun" ritual hadn't been carried out in centuries. The sun god had its revenge now by leaving its course and causing death and destruction. At Stonehenge, a group of seers had come together to try to get the sun to follow its route, but without success. The rage of the sun was too fierce after so many centuries without offerings and rituals.

The Greeks had described this destruction in a mythical version. Phaeton, son of the sun, left with his father's car. But he could not keep it on its usual track. On earth, places were burnt through this change in course. To save humanity, Zeus decided to kill his son. He let go a flash of lightning in his son's direction, with the wished result. Because the fire was still burning in the newly formed track, he sent a tidal wave to extinguish the fire. In the Hebrew book Henoch, Noah shouted with bitter voice: "Tell me what is happening with the earth, now that it is so violated and quaked..."

That was exactly what the Japanese were wondering. Tokyo had collapsed. Entire islands had vanished into the sea. Lava was streaming onto the rice fields. Their end was near, so much was clear. Just as Atlantis once vanished completely, their land would sink under the waters too. Again the sun was making a strange movement in the sky and the Land of the Rising Sun sank away deeper and deeper, as if the ocean was crawling up. The saltwater streamed into the capital, surrounded it and continued to rise. Never would the sun rise here again. If they had studied the Mayan calendar, they might have escaped the raging madness of nature, just as the Atlanteans once did. But which technocrat, only interested in computers, chips and other products of the consumer society, had ever let it cross his mind? Now it was too late. The present sun cycle ended in world-wide destruction.

4 Ahau 3 Kankin: 21-22 December 2012. You only had to look around to notice and see the power of this ancient oracle. As a result of the cosmic disaster on the sun, a terrible geological disaster took place on earth. The biggest of all time. Certainly, the largest for Japan, gone forever under the wild waters.

In Egypt, the pyramids of Giza, built in the image of the Orion constellation, had come through the violence quite well up till now, thanks to their superior construction. The ancient master builders were keen on creating something that would withstand time as long as possible. If this civilization didn't succeed in decoding their message, then maybe the next would. Hence the rather good condition of the pyramids after the series of earthquakes. But their colleagues in South America, also carrying the message of destruction, were also still standing. Later astronomers could still discover that Orion is an important link in the unraveling of the destruction codes for the earth. If it would ever be necessary again. That's the ultimate question.

The world population was decimated at a speed never equaled before. Even a nuclear war couldn't be more fatal. Even with the hundreds of millions of computers modern man had been able to construct, they were unable to make this one computer that could calculate the end of the world. More than 14,000 years ago the priests of Atlantis did succeed in this. The lost knowledge was

214

now shivering and trembling, but stood strong against the powerful waves of the earth. It was as if the high priests wanted to protect their master creation. As if they wanted to say, 'Protect these holy places, don't destroy the resurrection of Orion; let it be stronger than the violence of nature.' And so it was, the damage was limited, as if the gods had had their say, while everywhere else in the world everything collapsed. If you could see the disaster from a spaceship, much would become clear. The earth had moved and was thrown from its axis. There, where once were the poles, were now other regions. Americans and Canadians would be terrified if they could see that their world was drifting towards the place where the pole once was. There was no stopping it. Canada and the United States would disappear under the polar ice just as before, 12,000 years ago, they were covered under a thick layer of ice. At Christmas, New York, the financial heart of the consumer society that went over the top, would be buried under a thick layer of ice and its climate would be an extremely cold, polar one. If, in thousands of years, excavations were carried out, thousands of intact corpses of people and animals would be discovered, because they had been frozen forever by the sudden shift of the earth's axis.

On the other side of the world, the erstwhile South Pole had shifted to a more moderate climate. Due to the enormous heat generated by the sun eruptions, large parts of the ice started to melt. Atlantis would rise again when the enormous power of the ice mass disappeared. The prediction of the clairvoyant Edgar Cayce (see: *The Mayan Prophecies* and other texts) that the science of Atlantis would be rediscovered, had come true. Now his other predictions also proved to be correct: "Not long after the discovery of the secrets of the downfall of Atlantis, the poles of the earth will reverse. There will be a slide of the earth's crust in the polar areas, which will stimulate the eruptions of volcanoes. In the western part of America, the earth falls apart and disappears under the polar cap. The upper part of Europe will change in one blow."

And that was happening now. Entire areas had a drastic change in climate in only a few hours' time, a complete doomsday sce-

nario for large population groups and animals. The polar bears and penguins should be able to make it. They can swim and can adapt to a temperature change from cold to warm. They probably originated from an earlier poleshift: they were forced to adapt after having been thrown from a warm into a cold climate. This time, that wouldn't be necessary. They would find their way to the new poles. Americans would now realize why their land was so thinly populated only a few hundred years ago. After the last slide, the ice had to melt, and only after that the growth of plants became possible. Of course, this took a few thousand years. Then the animals could multiply undisturbed. Since the people emigrated later on, the largest part of the country remained uninhabited. It would have been better if it had stayed like that. Utterly shocked, the surviving Americans would see their land slide towards the pole. Almost all their land would disappear, and they would start to realize it when they felt the first waves of cold temperatures. The once almighty dollar would come to an end for good, deep frozen to minus fifty degrees and covered under colossal amounts of ice. Hundred years from now, nobody would speak of the dollar, the Dow Jones index, the price of gold, silver and precious metals, oil crises, and so on. It will have ended for good, just as the world of Siberia suddenly came to its end during the previous slide. At that time, Siberia had a moderate climate. In a few hours' time it suddenly got intensely cold. Large numbers of mammoths died very suddenly because of the intense cold. Death had come so quickly that the plants they had eaten weren't even digested yet! Even now one can find unspoiled flowers and grasses in their stomachs. Richard Lydekker writes in *Smithsonian Reports* (1899):

> In many instances, as is well known, entire carcasses of the mammoth have been found thus buried, with the hair, skin and flesh as fresh as in frozen New Zealand sheep in the hold of a steamer. And sleigh dogs, as well as Yakuts themselves, have often made a hearty meal on mammoth flesh thousands of years old. In instances like these it is evi-

dent that mammoths must have been buried and frozen almost immediately after death; but as the majority of the tusks appear to be met with in an isolated condition, often heaped one atop another, it would seem that the carcasses were often broken up by being carried down the rivers before their final entombment. Even then, however, the burial, or at least the freezing, must have taken place comparatively quickly as exposure in their ordinary condition would speedily deteriorate the quality of the ivory.

How the mammoths were enabled to exist in a region where their remains became so speedily frozen, and how such vast quantities of them became accumulated at certain spots, are questions that do not at present seem capable of being satisfactorily answered.

The Americans got their answer now. From a gentle and fertile climate, America and Canada became lands of ice and snow. For the northern regions, it was the worst. Montreal's new location was not far from the new pole center. Without their electricity, people froze to death quickly. Hundreds of millions of people would freeze to death on the spot, in what once were the economical poles of power. Their flesh would not rot away, and in thousand of years, countless horrifying discoveries might be made. 'Why,' they would wonder, 'did this intelligent civilization not see what was coming to them? If, before, they had organized the escape of an entire nation from disaster, then why hadn't it been done now?' Questions, thousands of questions, trying to understand this catastrophe for humanity. They would not find an answer to it, or they would have to start looking for it in commercial interests, disbelief, not understanding old codes, the almighty belief in the dollar, etc.

The following passage, illustrating in a dramatic way the exceptional age of the Egyptian documents (Berlitz,1984), is now coming true:

... one of the priests, of very old age, said: "Oh Solon,

Solon, You Hellenes are only children, and there never is an old man who is a Hellene."

When Solon heard this, he said: "What do you mean?"

"I mean," he answered, "that in the mind you are all young, and no judgment has been passed on to you through ancient tradition, nor any science gray of wisdom. And I will give the reason for this: due to several causes, many destructions of humanity have happened and will happen again.

22 December 2012. While the earth shivered and trembled and the heaven glowed, these words were in the minds of those still alive. The Egyptian priest had stressed, 2,500 years ago, that his civilization possessed descriptions of important events: "All that has been written down in the past ... is kept in our temples ... [W]hen the stream will come down from the heaven as a pestilence and leave only those amongst you without culture or education ... you will have to start again as children who know nothing from what happened in the ancient times."

Frank Hoffer in *The Lost Americans,* gives a lively image of the consequences of the previous catastrophe when Atlantis was destroyed:

The muddy holes of Alaska are filled with evidence of complete death ... an image of a sudden end. ...Mammoths and bisons were torn up and rumpled as were it done by a cosmic hand in divine anger. On many places the muddy blanket of Alaska is filled tightly with the bones of animals and large quantities of other remains ... mammoth, mastodon, bison, horses, wolves, bears and lions. ...A whole animal world ... in the middle of a catastrophe ... was suddenly destroyed.

A similar cataclysm was happening now. Millions of animals died and their skeletons would cover the bottom of the sea for thousands of years. The island Llakov on the coast of Siberia is, in

fact, built with millions of skeletons, still in good condition because of the temperatures below zero. But even the fish wouldn't survive this. Close to Santa Barbara, California, the Geological Institute of the United States has discovered a bed of now-petrified fish on the former bottom of the sea, where it was estimated that more than a billion fish had died in a massive tidal wave.

20.
TIDAL WAVE

When you look at the earth from outer space, you see a blue planet, consisting mainly of water. The oceans are not only breeding grounds for life, but also—and this is what this is all about—for the destruction of life. With the earth's crust coming into motion, everything, land masses as well as oceans, obtained a certain speed. When the earth's crust fastens again and stops its movement, it evokes immense trembles. Compare it with a car driving into a wall. The faster it goes, the larger the crash. When the tectonic plates crash into each other, this is accompanied by titanic quakes, volcanic eruptions, etc. At certain places, the plates will be pressed against each other in such a way that mountains kilometers in height will form. Elsewhere, the underlying layers will rip open and entire lands will disappear in the depths. The coming apocalyptic events are unequaled. They will be so destructive that it becomes incomprehensible.

With a car crash, there are other phenomena. If you're not tied down securely you can be thrown out of the car. People not wearing their seatbelts fly straight through the windshield when crashing at high speed, with serious wounds or even death as a result. In scientific language, this is called the law of inertia. All objects with a certain velocity keep this velocity. It is a law of nature, which has always existed and will exist eternally. Car crash victims are well aware of it. This universal law also works for the earth itself. When studying closely the previous earth poleshifts in the writings of Atlantis, then you know that all this happened in only a few hours.

Scientifically, we can prove that the slide of the crust measures 29 degrees. This can be done based on the hardened magnetic rocks, which still point at the original pole! Such a slide corresponds with a shift of the earth's crust of 3,000 kilometers! Imagine having to travel 3,000 kilometers in your car in fifteen hours'

time. That's a speed of 200 kilometers per hour! From the moment the earth starts to move, one undergoes a certain level of speed. If it happens jerkily, you can be thrown all over. Once the earth reaches a constant speed, you don't notice it anymore. Now I'm reaching the crucial point. The magnetic field of the earth recovers and fastens the outer layers again. This is the most disastrous effect for all earthlings and animals. It is as if a giant wall suddenly appears and you have to stomp on the brakes of your racecar. But it is too late! With a tremendous blow, you hit the obstacle and are thrown out of your car. That's what happens with the oceans at this point in the cataclysm. Because of the law of inertia, they can't be stopped anymore. Depending on the direction, the seas start to rise at certain coastlines.

Polar Reversal

But the story is more complicated. Not only a crust slide happens, but also a reversal! This is when the earth starts turning the other way! A disaster you can't imagine. Look at the numbers. It's about 24,000 miles around the earth at the equator. Since the earth makes a complete revolution every 24 hours, that means we travel 24,000 miles every 24 hours. Divide 24 hours into 24,000 miles, and you'll come to the shocking realization that we are whirling around the global axis at about 1,000 miles an hour.

If, during the next cataclysm the United States is shifted to the present North Pole (future South Pole), it is as if the water in New York Harbor suddenly drops. In Brazil, beaches kilometers and kilometers long will appear, because the water is thrown forward with power. In the opposite land masses, the opposite will happen. At an amazing speed, the waters will rise to catastrophical heights. A tidal wave, such as never seen before, hundreds of meters (yes, even more than a kilometer) high, crashes merciless on the coastal regions. It would be impossible to escape this violence of nature. Small tidal waves of ten meters are capable to wiping away everything. Then what will this wall of water do? All, but literally, all life will perish in it. Imagine living in a coastal region and you see this tidal wave hundreds of meters high com-

ing at you. Even before you can possibly react, you're covered with billions of liters of sea-water! Don't forget, this tidal wave has a rather high speed, due to the powers that created it. This energy of motion has to be dissipated completely before the oceans can become peaceful again. That means huge destruction of life and plants. While the tidal wave is spreading over the lands, more people are killed than ever before, in all the wars of the history of the earth. In his book *Voyage dans l' Amérique méridionale*, Alcide d'Orbigny wrote:

> I argue that the terrestrial animals of South America were destroyed by an invasion of the continent by water. How otherwise can we account for this complete destruction and the homogeneity of the Pampas containing bones? I find an evident proof of this in the immense number of bones and of entire animals whose numbers are greatest at the outlets of the valleys, as Mr. Darwin shows. He found the greatest number of the remains at Bahía Blanca, at Bajada, also on the coast, and on affluents of the Río Negro, also at the outlet of the valley. This proves that the animals were floated, and hence were chiefly carried to the coast. This hypothesis necessitates that the Pampas mud was deposited suddenly as the result of violent floods of water, which carried off the soil and other superfluous debris, and mingled them together.

So the Americans and Canadians are not only getting polar temperatures, but also a flood from the mountains, crushing everything. Trees are torn out as if they weighed nothing, animals and people are lifted up and swept along, cars are taken along for kilometers; nothing, absolutely nothing will escape this violence of nature. Even numerous sea animals will die because they will be smashed violently against the remains of houses and against the ground. It will be one giant, mass grave—an assembly of hundreds of millions of people with sea animals. The remaining corpses will be kept for later generations due to the intense, freez-

ing cold as a warning for neglecting the announced forces of nature, so that this mistake would never be made again. Geologist J Harlen Bretz writes in "The Channeled Scabland of the Columbia Plateau" (*Journal of Geology*, November 1923):

The flood arrived catastrophically at the end of the last ice age. It was a great wall of water, with its crested front constantly outrunning and overrunning its basal portion. Up to 1,300 feet high, it poured over the tops of nearby ridges as giant waterfalls and cascades up to nine miles wide, and rolled boulders many feet in diameter for miles.

A massive flood cut channels hundreds of feet deep into Columbia Plateau basalt. Blasting out of the Clark Fork River valley of western Montana and racing across northern Idaho at ten cubic miles an hour, the water reached depths of 800 feet as they plunged through the Wallula Gap on the Oregon-Washington line, then tore down the Columbia on an unstoppable rampage to the Pacific.

Sweeping away as much as 100 to 200 feet of topsoil in many locations, the flood denuded fully 2,000 square miles of the Columbia Plateau of its silt cover and loess, leaving only steep-walled, trenchlike valleys up to 400 feet deep as barren reminders of its awesome power.

The flood ended as fast as it began, in a matter of days. It left giant river bars now standing as mid-channel hills more than 100 feet high, and deposited a 200-square-mile gravel delta at the junction of the Willamette and Columbia River valleys. Portland, Oregon, Vancouver and Washington now sit atop a portion of that delta.

There had already been billions of deaths, and it was not over yet. The tidal wave seemed to go on forever. It penetrated further and further inland. Only at 1,500 meters above sea-level were you safe. That is, if those parts hadn't dropped during the landslides! Nowhere, absolutely nowhere, would you be sure of survival. In this heroic battle between the powers of light and darkness, the

powers of darkness were constantly gaining in strength. The entire earth was thrown into confusion. Here and there, desperate people tried to climb to a mountaintop to be safe from the rising waters. Only a few would make it. This giant play of the sea was too powerful to fight. Harsh and merciless, the waves rolled further and further. The tidal wave reached the pyramids. But the once-mighty building didn't stand a chance against it; it was buried under an enormous flood. With thundering violence, water sped through the entrance and the shafts to the royal chamber. Millennia ago, the holy rituals of resurrection were held there. Nowadays, these chambers formed the center of the destruction of the earth—the end of the age of the fifth sun, in a cataclysm such as never witnessed before. The civilization would be thrown back to the Stone Age, if it survived at all.

The recounting of these events would determine future behavior for thousands of years. In all non-related civilizations it would be told and passed on from father to son and from mother to daughter. Immortal stories of courage and despair would accompany it, as would historical reports of what happened. Exactly as that which we read now about what happened the previous time. In Peru there is a story about an Indian warned by a llama of the flood. Together they ran to a mountain. The sea

Figure 43.
And a gigantic flood will destroy our civilization ...

225

level started to rise, and soon covered all the plains and mountains, except for the one they sat on. Five days later, the water started to drop. Similar stories can be found all over the world. Noah's is best known world-wide. In Mesopotamia there is the story of Utnapisjtim (Hancock, 1995): "Six days and nights the wind blew, torrents and storms and floods covered the world. When the seventh day came, the storm from the south subsided, the sea grew calmer, the flood calmed down. I looked at the world and there was silence. ...I sat down and cried ... because at all sides there was the wilderness of the water."

More than 500 accounts of massive, prehistoric floods are found across the entire world. Even in China an old work was found, saying the following (Berlitz,1984): "The planets changed course. The heaven dropped to the north. The sun, the moon and the stars changed their courses. The earth fell to pieces and the waters in its bosom rose and flooded the earth with violence."

These stories about apocalyptic floods leave no doubt: it has happened before, and before that, it must have happened countless times. A recurring, murderous and merciless event. Life is nothing more than a fragile little thing, which can be swept away like that. The same catastrophes must occur on countless other planets of other suns. Can't be different. Not surprising we haven't received any signs of extraterrestrial life. If all planets suffer from these mass destructions, it is a miracle that there is still life afterwards, let alone intelligent life! The reversal of the sun's magnetism with its disastrous consequences for intelligent life, therefore, has to be regarded as an incredibly restrictive factor in finding extraterrestrial life. The evidence for the downfall and disappearance of the Atlantean civilization are too large to deny it. It took more than 11,000 years to reach more or less a similar level of civilization. Pictured on the scale of the universe, this means once again a blow for the existence of extraterrestrial life. In my book *A New Space-Time Dimension,* I already proved extraterrestrial life could only exist in the central parts of the universe. Further away, one after another solar system explodes. Their planets are pulverized to a sea of plasma. Extraterrestrial life is impossible there

because planets are reduced to an atomic mess. Parallel to it, the possibility for the existence of other super-cultures is strongly diminished. Of course, that doesn't mean we are the only ones, or that our civilization is one of the great exceptions of the cosmos; but it means that the space in which life is possible measures only one-thousandth of the total volume of the universe! Added to this scary fact are the implications of the reversal of the sun's magnetism. To my astonishment, I have to conclude that life—I mean intelligent civilizations such as ours—is much more sporadic than we used to postulate. Along with the fact that the largest parts of stars die during the most violent explosions in the universe, the planets' crust slides form an important barrier for the discussion of extraterrestrial life. In the far depths of the universe, a sea of fire sweeps all life away completely, since everything is reduced to atomic ashes. Here on earth, a sea of water sweeps almost all life away, after which a dark period follows, and a real question arises as to whether or not the same level of civilization can be reached again. Before Atlantis vanished under the polar ice, the Atlanteans sailed the oceans. They possessed maps and charts so perfect that we were only able to decode them in the twentieth century. Professor Charles Hapgood writes in *Maps of the Ancient Sea Kings*:

> I turned a page and sat transfixed. As my eyes fell upon the southern hemisphere of a world map drawn by Oronteus Finaeus in 1531, I had the instant conviction that I had found here a truly authentic map of the real Antarctica.
>
> The general shape of the continent was startlingly like the outline of the continent on our modern map. ... The position of the South Pole, nearly in the center of the continent, seemed about right. The mountain ranges that had been discovered in Antarctica in recent years. It was obvious, too, that this was no slapdash creation of somebody's imagination. The mountain ranges were individualized, some definitely coastal and some not. From most of them rivers were shown flowing into the sea, following in every

case what looked like very natural and very convincing drainage patterns. This suggested, of course, that the coasts may have been ice-free when the original map was drawn. The deep interior, however, was free entirely of rivers and mountains, suggesting that the ice might have been present there.

Further, it is only now that we start to unravel their knowledge on the orbit of planets and star constellations. That shows clearly that a poleshift and the flood that accompanies it, can wash away a civilization from the globe. Nowadays our civilization has reached this level because a high priest from Atlantis had found a connection between the sunspot cycle and the magnetic field of the earth. He also found that when Venus and Orion are located in specific code positions, the next disaster would happen. Thanks to his foresight, groups of Atlanteans managed to escape the catastrophe. It is only due to this fact that now the world is so densely populated and has reached such a degree of civilization. But we should not forget that 200 years ago, we were absolutely not that far advanced at all. A lot of knowledge we have now still had to be discovered. At that time, the data we possessed was only scanty. If the Atlanteans hadn't been warned in advance of the coming cataclysm, then all their knowledge would have been lost for good.

I dare say that if that were the case, we would nowadays not be much further advanced than the Stone Age. If preparatory work on the survival arks, with the necessary knowledge on board, doesn't start soon, then I fear for the future of mankind. In the coming events, the knowledge we have now could be largely destroyed. If there are no urgent measures taken, the remaining sources of knowledge will one by one be lost in the chaos after the catastrophe. And that will be the utter end of our civilization. That is not at all impossible. In old scriptures, indications are found that 200,000 years ago, there already existed highly advanced technological civilizations on earth. If this is indeed true, then I fear for the worst for our civilization, because the high priests have postulated that the destructive powers that will hit the earth now

will be the largest in hundreds of thousands of years.

The following Scandinavian legend says a lot (Hancock,1995):

> Mountains collapsed or were split in half from the top to the bottom. The stars were adrift in the heaven and fell in the yawning depth. The giant Surt put the whole world to fire; the world was nothing more than an immense oven. All living people, all plants were destroyed. Only the barren earth remained, but just as the heaven, the earth was nothing more than cracks and fissures. Then all rivers rose, all seas flooded and the earth sank beneath the sea.

Let this be a warning for those who don't believe. The worldwide catastrophe described in the text made such a deep impression, those people wanted to warn us of it. The surviving Atlanteans built their temples with astronomical data in Egypt and Mexico. In a scarily precise way, they show the scientific codes that appear in the myths. As the tidal wave is doing its omnidestructive work, billions of people will be painfully reminded of this.

The annals say the following: "And in only one day and night the island Aha-Men-Ptah sank below the sea ..."

This happened almost 12,000 years ago, and now the same would take place. Wild movements of the earth and a tidal wave ended their civilization. They formed ugly scars on the surface of the earth and on the bottoms of its oceans. The animal and human population of the earth was almost completely washed away. An unequaled world-wide catastrophe. The rising water changed climates and land-water proportions of large parts of the world. As the waters dropped again, the skeletons of small and large sea animals, marine fauna and scallop shells remained where they had been thrown. Nowadays these are found spread over such mountain chains as the Andes, the Rocky Mountains, the Himalayas (where the bones of whales have been found), etc. A manuscript from the Maya, the "Popol Vuh," (Berlitz,1984) says the following about the previous catastrophe:

Then the will of Hoerakan brought the waters into mo-
tion, and a large flood came over the heads of these beings.
...They were flooded and a resinous fluid came down from
heaven. ...The face of the earth was darkened, and a dense,
darkening rain started—rain in the day, rain at night.
...Above their heads a great noise could be heard, sounding
as if it originated from fire. Then one could see men run-
ning, pushing one another and filled with despair: they
wanted to climb in trees, the trees shook them off; they
wanted to run into caves, but the caves closed themselves
for them. ...And the waters rose and rose.

Another chronicle from pre-Columbian America (Berlitz, 1984)
is equally noteworthy: "The face of the heavens was thrown from
one side to the other and thrown on its back. ... In one large,
sudden, strong flood the Big Serpent was kidnapped from the
Heavens. The Air fell and the Earth sank away ..."

Maybe the recollection of this knowledge of an earlier world
can be a support to the conservation of the present one. I strongly
doubt it. The size of the catastrophe is such that not much will be
left. Only the passing on of knowledge is essential, all the rest is
secondary.

While I'm writing these words, I wonder whether many peo-
ple would want to stay alive in this destroyed world. The more
people I told the story of the destruction at hand, the more peo-
ple seemed not to want to survive. They not only would miss
their loved ones, but they would also lack all creature comforts.
Nothing would remain. No food, no electricity, no clothing, etc.
Why should they stay alive? That, of course, is a question you
should decide for yourself. Should you decide to fight for your
life, then I am your man. The Atlanteans proved to possess great
foresight. We can repeat this tour de force, so humanity will thank
us forever for the initiative taken. Fight and enterprise, that's
what's needed to survive the coming flood. It is the biggest chal-

lenge ever for humanity—should we fail, all we have achieved up till now threatens to be lost for ever.

EPILOGUE

A year after the almost complete annihilation of the world population, the last survivors of the disaster died. The radioactive fallout of the melted nuclear plants, the world-wide oil spills from the oil tanks and rigs, and the poisonous gasses that came forth from the chemical weapon industry proved fatal. Herewith, a unique planetary experiment came to a definitive end.

The new age would never begin.

PART V

MATHEMATICAL
PROOF

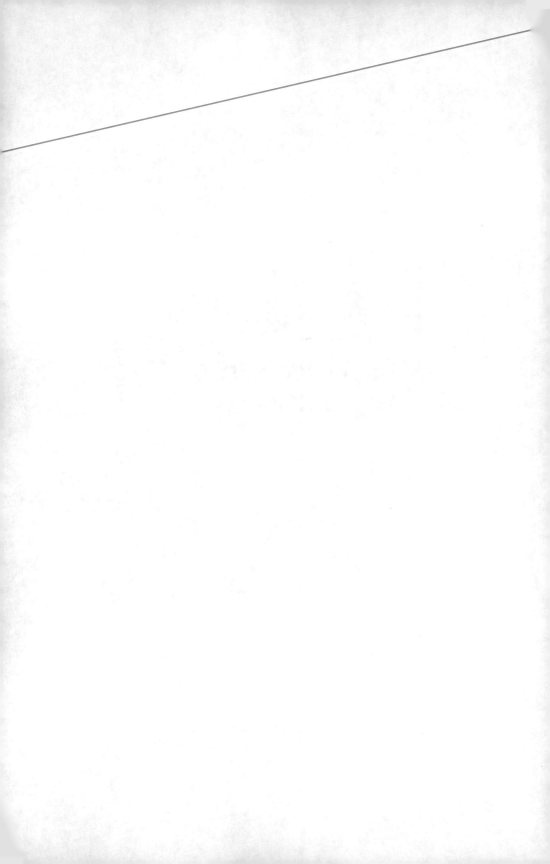

21.
MATHEMATICAL PROOF

An Important Part of the Sunspot Cycle

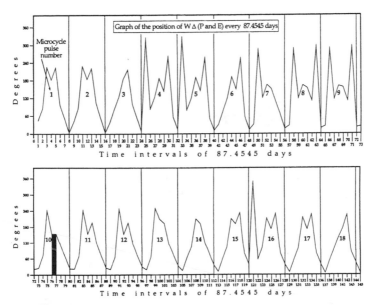

Figure 44.
The sunspot cycle theory of Maurice Cotterell.

Using some basic mathematics, you can find the essential numbers of the sunspot cycle:

68,302 ÷ 26 = 2,627
68,302 ÷ 37 = 1,846

Subtract the second number from the first:
2,627 - 1,846 = 781

781 is the number of time periods (bits) found by Cotterell in a cycle of 68,302 days. Divide the above found numbers in reverse

order by the rotation time of the magnetic fields and you'll find:

$2,627 \div 37 = 71$

$1,846 \div 26 = 71$

$71 \times 11 = 781$

A cycle has 781 bits. It is possible to divide it further:

$781 \div 11 = 71$ bits of 87.4545 days

Through this you can calculate a long cycle:

$71 \times 87.4545 = 6,209.2727$

This equals also the following (opposite calculations):

$2.3636 \times 2,627 = 6,209.2727$

$3.3636 \times 1,846 = 6,209.2727$

Thanks to this number, I was able to decipher the Dresden Codex of the Maya. By these calculations it was clear that this was an essential number of the sunspot cycle. That is why the Maya have incorporated it in their codes!

The Period of the Mangetic Fields of the Sun
Calculated from the Sunspot Cycles of the Maya

The Atlanteans, as well as their descendants the Maya, loved number games. This shall become clear after the next calculations. From the previous, we know that an important cycle has a duration of 6,209.272727 days. In this number is an infinite series of 27. Knowing the Maya, something had to be done with the number 27. They used two numbers for the duration of the sunspot cycle. When you divide these by 27, the first clue is found:

$68,328 \div 27 = 2,530.66666666$

$68,302 \div 27 = 2,529.70370370$

$2,530.66666666 - 2,529.70370370 = 0.962962$

The difference indicates what we are searching for: $962 = 37 \times 26$. The relation does not stop at this point:

$27 \times 37 = 999$

When you divide the cycles by this new found number, you'll find:

68,328 ÷ 999 = 68.396396396

68,302 ÷ 999 = 68.370370370

68.396396396 - 68.370370370 = 0.026026026

Two important numbers appear from this calculation: 26 and 37. Furthermore, the magnetic cycle from 26 days can be calculated out of the other. The infinite series of 26 is the evidence. This is also possible in reverse:

27 x 26 = 702

68,328 ÷ 702 = 97.333333333

68,302 ÷ 702 = 97.296296296

97.333333333 - 97.296296296 = 0.037037037

If this is not a brilliant game, I am insane.

Remarks: mathematical wizards should try to create such mathematical connections. After a few days, they will confess they really are brilliant! Even more important: thanks to these findings I succeeded in breaking the main code of the Dresden Codex!

The Dresden Codex Decoded

The following is extremely important: the topic of the Dresden Codex is in fact the sunspot cycle. A lot of people are not convinced after reading Maurice Cotterell's decoding. But, when correctly decoded it is clear that it concerns the sunspot cycle. This is world-shocking because this theory is extremely difficult, and astronomers are not aware of its existence!

In the Dresden Codex we find a gigantic number: 1,366,560. Behind it, hundreds of secret codes are hidden. Some of them are about solar magnetism and the sunspot cycle.

With the assistance of Venus you can find quickly the first code:

1,366,560 = 2,340 x 584

Replace 584 by 583.92, the exact number for the synodic period of Venus. The difference is 0.08. When this is multiplied by 2,340, you find: 0.08 x 2,340 = 187.2. This number is the period of the sunspot cycle!

$$1.366.560 = 5.256 \times 260 \text{ (TZOLKIN)}$$
$$= 3.796 \times 360 \text{ (TUN)} = 73 \times 52 \times 360$$
$$= 3.744 \times 365 \text{ (HAAB)} = 72 \times 52 \times 365$$
$$= 2.340 \times 584 \text{ (Venus)} = 36 \times 65 \times 584$$
$$= 39 \times 35.040 = 3 \times 13 \times 35.040$$
$$= 9 \times 151.840 = 9 \times 37.960 \times 4$$

Figure 45.
The most important page of the Dresden Codex!

The Breaking of the Dresden Codex
Within the Codex there are two numbers:
1,366,560
1,364,360
The difference: 1,366,560 − 1,364,360 = 2,200

When this is used to divide both numbers:
1,366,560 ÷ 2,200 = 621.163636363
1,364,360 ÷ 2,200 = 620.163636363

This series of numbers 0.1636363 represents a full circle of 360 degrees:
360 ÷ 2,200 = 0.163636363

The difference between both series of numbers is:
621.163636363 − 620.1636363 = 1
1 = 1 circle!

The solution has to do with a difference of 360 degrees!
This is what you know already: 3.363636 circles − 2.363636 circles = 1 circle difference.
As a primary code you have the sunspot cycle of 187.2 years = 68,328 days. Cotterell found a value of 68,302 days.

1,366,560 = 20 x 68,328 = the Mayan code for the sunspot cycle
The exact sun spot cycle is: 68,302 x 20 = 1,366,040
Divide this by 2,200:
1,366,040 ÷ 2,200 = 620.9272727

You know this number! You have found it earlier as a code of the sunspot cycle, but ten times bigger!
When this code is subtracted from the corresponding Mayan code: 621.16363 − 620.92727 = 0.236363636

The real value is 2.363636. This can be sustained as follows:
621.16363 x 11 = 6,832.8
620.92727 x 11 = 6,830.2

Multiply these by ten:
6,832.8 x 10 = 68,328 = Mayan code for the sun spot cycle
6,830.2 x 10 = 68,302 = sunspot cycle

Multiply the above numbers by ten:
621.16363 x 10 = 6,211.6363
620.92727 x 10 = 6,209.2727

The subtraction gives the correct value:
6,211.6363 − 6,209.2727 = 2.363636

This is the primary code! After 2.363636 rotations the one magnetic field of the sun catches up with the other one! Besides, the code for the other magnetic field can be retrieved: 3.363636. This is relatively easy. As you know from before, division by three numbers can find the code:
999 = 27 x 37
962 = 26 x 37
702 = 26 x 27

Divide 520 by these numbers:
520 ÷ 999 = 0.520520520 (an infinite series with 520!)
520 ÷ 962 = 0.540540540
520 ÷ 702 = 0.740740740

Divide the last two series by 2,200:
540 ÷ 2,200 = 0.245454545
740 ÷ 2,200 = 0.3363636363

The difference between the Mayan code and the real code is:
1,366,560 − 1,366,040 = 520. Divide this by 2,200:
520 ÷ 2,200 = 0.236363636

This code is 10 times too small. This is proved as follows:
740 − 520 = 220
2,200 = 220 x 10
Conclusion: 520 ÷ 220 = 2.363636

Immediately you know the right solution:
3.363636 − 2.36363636 = 1 circle difference

The Venus Codes
The known Venus numbers lead to the further revelation:
584 ÷ 2,200 = 0.26545454 (26 + infinite series 54)
576 ÷ 2,200 = 0.26181818 (26 + infinite series 18)

The following codes are behind this:
26 x 54 = 1,404
26 x 18 = 468

Adding up and subtracting confirms the correctness of these numbers:
1,404 + 468 = 1872 = code number
1,404 − 468 = 936 = code number

We have to search further. The following connection reveals more of the ancient encoded message:
54 ÷ 3.3636363 = 16.054054
1,404 ÷ 16.054054 = 87.45454545

After 87.454545 days the one polar field catches up with the other one!

Code with 936:
936 = 26 x 36
936 ÷ 87.4545 = 10.7027027

Multiply this by the revolution of the fields:
10.7027027 x 2.363636 = 25.297297
10.7027027 x 3.363636 = 36

Subtract 25.297297 from 26:
26 − 25.297297 = 0.7027027

Multiply this by the revolution of the field of the equator and you find the revolution of the field at the poles:
3.363636 x 0.7027027 = 2.363636
26 ÷ 0.7027027 = 37 = period of the magnetic field of the sun at the poles.

The Code 36 Hidden in the Venus Codes

This can be sustained by subtracting the Venus codes found above from each other:
0.26545454 − 0.26181818 = 0.003636363636

This code means something. When the values of the magnetic fields found above are divided by ten, the following is found:

$0.3363636 \div 10 = 0.033636363$
$0.2363636 \div 10 = 0.023636363$

The infinite series of numbers 0.00363636 is in the same order as in the Venus codes. To achieve this, you will have to adapt the other numbers:

$740 \div 10 = 74$
$520 \div 10 = 52$

Subtracting the second result from the first gives 22:
$74 - 52 = 22$

The Solution of the Dresden Code

The numbers found earlier lead to the following solution:
$74 \div 22 = 3.363636$
$52 \div 22 = 2.363636$

The numbers 3 and 2 also indicate a code: $32 \times 36 = 1,152 \times 10 = 11,520$ = period between previous crashes.

You see an infinite series of 36. Therefore, multiply 74 and 52 by 36:

$74 \times 36 = 2,664$ (primary code)
$52 \times 36 = 1,872$ (primary code)

When divided by the revolutions of the fields the next code is found:

$2,664 \div 3.363636 = 792$
$1,872 \div 2.363636 = 792$

This number also results from subtracting of the primary codes:
$2,664 - 1,872 = 792 = 72 \times 11$

The next division leads to an extra code:
$1,872 \div 2,664 = 0.7027027$

The Mayan number of the long solar spot cycle also gives a code:
$1,366,040 \div 740 = 1,846$
$1,366,040 \div 520 = 2,627$

These numbers are in accordance with the precession (see: Chapter 16). Attention! This is important evidence.

More evidence:
620.92727 ÷ 0.2363636 = 2,627
2,627 x 26 = 68,302 = solar spot cycle of 187 years
620.92727 ÷ 0.336363 = 1,846
1,846 x 37 = 68,302 = solar spot cycle of 187 years

The Mayan Calendar

The number 1,366,560 of the Dresden Codex equals:
1,366,560= 18,720 x 73
= 18,980 x 72

18,980 = calendar cycle of 52 years of the Maya, each 365 days
73 x 72 = 5,256
1,366,560 ÷ 5,256 = 260 = magical year

The same number is found in a different way:
18,980 – 18,720 = 260
260 is a special number. It is a connection between the different calendars and the solar rotations.

Each day, the polar field traverses: 360 ÷ 37 = 9.729729 degrees.

The equatorial field traverses each day: 360 ÷ 26 = 13.84615 degrees.

Earlier the number 0.7027027 was found several times. This also equals: 26 ÷ 37 = 0.7027027027

The 260-Day Cycle

After 260 days, the polar field has traversed 7.027027 rotations. The number of degrees for this time period is:
260 x 9.729729 = 2,529.729729

The number of rotations can be calculated as follows:
2,529.729729 ÷ 360 = 7.027027

The field is 0.027027027 rotations from its starting point. This is equal to the following number of degrees:
0.027027 x 360 = 9.729729

This means that the field is one day before its starting point, or 9.729729 degrees.

The equatorial field has made ten rotations after 260 days (!) and is at its starting point. The next code-breaking proves the

correctness of this principle:

$$10 - 9.729729 = 0.27027027027$$
$$7.027027 \div 0.27027027 = 26$$
and $7.027027 \div 0.027027027 = 260$

The above gives a code for the calendar of the Maya:

$$260 \times 72 = 18,720$$
$$260 \times 73 = 18,980$$

Multiply these by the numbers of degrees traveled in one day:

$$18,720 \times 9.729729 = 182,140.54054$$
$$18,720 \times 13.84615 = 259,200 = \text{precession number!}$$
$$18,980 \times 9.729729 = 184,670.27027$$
$$18,980 \times 13.84615 = 262,800 = \text{code number!}$$

When 72 is multiplied with the number of rotations of a cycle in 260 days (reason: $18,720 = 72 \times 260$), the following value is found:

$$72 \times 7.027027 = 505.945945$$

Make the number 1,000 times bigger (reason: the numbers found above are that much bigger): $505.945945 \times 1,000 = 505,945.945$

Here is a connection with the Mayan number: 505,440 (= $1,872,000 - 1.366,560 = 1,440 \times 351$)

Subtract this value from the the large number found above:

$$505,945.945 - 505,440 = 505.945945$$

The outcome is identical, only the unit is different, to the first number! It does not stop here. The number of degrees a field traverses in 72 days also gives a code:

$$72 \times 9.729729 = 700.54054054$$

Divided by the previous, the number of degrees the other field traverses in one day can be calculated:

$700.54054054 \div 505.945945 = 1.3846153$ ($\times 10 = $ number of degrees traversed a day of the other field)

When we reason further on the code number, the following can be found:

$700.54054 \div 360 = 1.945945$ ($\times 10 = 19.459459 = 2 \times 9.729729$)

After 18,720 days the polar field has traversed 182,140.54054 degrees. This is 19.459459 degrees less than a full circle. The equatorial field is at its starting point. Conclusion: the field is 2 x 9.729729 behind on the other. According to the Mayan way this can be described as follows: 720 − 700.54054 = 19.459459.

For a calendar cycle of 18,980 days you will find:
73 x 7.27027 = 512.972972 (as above, make it 1,000 times bigger)
Connection with the Mayan number 512,460 (= 1,460 x 351):
512,972.972 − 512,460 = 512.972972 = identical to the first number, with the exception of the unit

When this is decoded in the same manner as before:
73 x 9.729729 = 710.27027
720 − 710.27027 = 9.729729

Conclusion: the cycle of 260 days gives a difference of 9.729729 degrees between the fields. After 18,980 days this phenomenon reoccurs. The calendar cycle reflects a cycle between the solar pole and the solar equator.

Our Time Calculation and the Foundation of Atlantis

As proven, there are two different numbers of primary importance in the foundation of Atlantis. In calculations we found two important numbers: 36 and 144.

36 stands for 360 degrees, meaning in one day the earth covers a full circle. This is related to the second number, 144. 144 stands for 1,440.

Now I'd like to ask you to look at your watch or a clock. The first number you found (360) stands for a circle. Of course, the second one (1,440) is related to it. In one minute your watch covers one full circle. In one day: 1,440 circles! So the Atlanteans were at the basis of our time calculation! The correctness of this is shown below:

1,440 = number of revolutions around the circle of 360 degrees per day = number of minutes per day
1 minute = 60 seconds
1,440 x 60 = 86,400 seconds per day

You will remember 864 as the first time span through the zodiac. Our time calculation is, in fact, information given to calculate the

precession of the zodiac. To help you remember, I'm giving you here again the five major numbers that dominated the foundation of Atlantis before the first cataclysm: 12 / 72 / 864 / 2,592 / 2,448.

The number of hours per day can be calculated in three ways. To begin the first calculation, do the following operation: 2,592 − 864 = 1,728. When dividing the entire zodiac by 360, you get 25,920 ÷ 360 = 72. Then,

1,728 ÷ 72 = 24 = number of hours per day. Also,
2,592 ÷ 864 = 3 72 ÷ 3 = 24
144 − 36 = 108 2,592 ÷ 108 = 24

How they got 60 seconds and 60 minutes can be proven too. As you know, the number 5,184 is important: 72 x 72 = 5,184.

When dividing this number by 360, you get: 5,184 ÷ 360 = 14.4

A last division gives the number of seconds and/or minutes: 864 ÷ 14.4 = 60 !

Further proof can be found in the following: 12 ÷ 72 = 0.166666. This number symbolizes the number of degrees covered per second!

It was one amazement after another to me and it didn't seem to stop. "Those Who know the Numbers" had done a tremendous effective and splendid job. Mind you, the number 60 can also be calculated in another way: 1,440 ÷ 24 = 60.

To calculate the precession of the zodiac with our time calculation as starting point, you have to follow the opposite route. In one day, there are 24 hours and the earth turns 360 degrees in the zodiac. To let 24 match the 12 signs of the zodiac, you have to divide it: 12 = 24 ÷ 2. In one day you have 2 x 12 hours. By this was meant that the zodiac is passed through in 12 hours. But in reality, this corresponds with 6 signs of the zodiac: 12 ÷ 2 = 6. Multiplying this with the number of seconds in half a day, you find: 43,200 x 6 = 259,200. This number is ten times too high. You can prove this as follows: divide the number of seconds per day by 360 and you get: 86,400 ÷ 360 = 240. 240 = 24 x 10.

This means that our number 259,200 has to be divided by ten!

This also can be done with the number of minutes. In half a day you have 720 minutes: 720 x 360 = 259,200.

That everything is correct can still be proven the following way:
86,400 ÷ 360 = 240
360 − 240 = 120

$240 - 24 = 216$
$216 \times 120 = 25,920!$

In Chapter 7, I broke an important code of the zodiac. It gave me three numbers: 2,592, 2,016 and 1,440. The last two can also be found in our time calculation. The Atlanteans loved dividing, multiplying, adding and subtracting. We are doing the same: $24 \times 24 = 576$.

Subtract this from 2,592: $2,592 - 576 = 2,016$. Then do it again: $2,016 - 576 = 1,440$.

Arrange them one under the other and divide by 864.
$2,592 \div 864 = 3.0$
$2,016 \div 864 = 2.333333$
$3 - 2.333333 = 0.666666$

$1,440 \div 864 = 1.666666$
$2.333333 - 1.666666 = 0.66666$

Now, you'd have to be blind if you didn't see the code. Something has to be divided and multiplied with 6:
$864 \times 6 = 5,184$
$864 \div 6 = 144$

Both numbers are of extreme importance:
$5,184 = 72 \times 72 = 144 \times 36 = 72 \times 2 \times 36$

Proof: 72 stands for 720 minutes. $720 \times 2 = 1,440$ minutes per day. 36 stands for 360 degrees.

The above number, 5,184, was obtained by squaring the number of minutes in half a day. Now, do the same for the other number 144 (144 stands for 1,440 minutes).
$144 \times 144 = 20,736$
$20,736 = 864 \times 24$

Proof: 864 stands for 86,400 seconds. 24 stands for 24 hours.

Herewith, you prove again that our time indicates the precession of the zodiac:
$20,736 + 5,184 = 25,920$.

The Atlantean proof for this proposition goes as follows: $5{,}184 \div 24 = 216$. 216 is the number indicating the complete cycle of 25,920 years (see: The Duration of the Zodiacal Cycle).

$5{,}184 \div 36 = 144$.
$216 - 144 = 72$ or $72 + 144 = 216$.
Conclusion: Add the product of both numbers and you get the final number!

The Similarities Between the Egyptians and the Maya

After Atlantis perished, the survivors dispersed all over the world. Based on their numbers, I will prove that. To begin,

$25{,}920 = 360 \times 72$ and $72 \div 360 = 1 \div 5$

If you divide all important Atlantean numbers by five, you get the following result:

$25{,}920 \div 5 = 5{,}184$	$72 \div 5 = 14.4$	$24 \div 5 = 4.8$
$365 \div 5 = 73$	$360 \div 5 = 72$	$60 \div 5 = 12$
$12 \div 5 = 2.4$	$260 \div 5 = 52$	$30 \div 5 = 6$

The super-number 5,184 can be divided evenly by all the resulting numbers, except for 52 and 73.

$5{,}184 \div 2.4 = 2{,}160$	$5{,}184 \div 6 = 864$	$5{,}184 \div 14.4 = 360$
$5{,}184 \div 4.8 = 1{,}080$	$5{,}184 \div 12 = 432$	$5{,}184 \div 72 = 72$.

$2{,}160 \times 12 = 25{,}920$
$1{,}080 \times 24 = 25{,}920$
$864 \times 30 = 25{,}920$
$432 \times 60 = 25{,}920$
$360 \times 72 = 25{,}920$

When starting from the above series of numbers, you can find important numbers from the Maya!
$360 + 360 = 720$ $260 + 260 = 520$ $720 - 520 = 200$

When multiplying 720 by 200 you get: $720 \times 200 = 144{,}000$

Mayan numbers and number systems:

Baktun	Katun	Tun	Uinal	Kin
144,000 Days	7,200 Days	360 Days	20 Days	1 Day

7,200 = 144,000 ÷ 20 (For the Egyptians, 72 = 1,440 ÷ 20)
7,200 ÷ 20 = 360

Here is the first proof that the Egyptians and Maya originally had the same way of calculating. More solid evidence will follow immediately.

Connection Between the Venus Cycle and the Egyptian Number Series

To calculate the destruction of the earth, the Maya as well as the Egyptians used Venus for measuring the time. After searching for a very long time, I found the key. To start with, there were different calendars used in Egypt, based on 360 and 365 days. When dividing a year of 365 days by 360, you get the following number: 365 ÷ 360 = 1.01388888.

When multiplying this with 576, which is a very important code-number as has been shown in other series, then we find 576 x 1.01388888 = 584 = the sidereal time period of Venus. The sidereal time of a planet is the time it takes to return to the same place in the sky. Apparently, the Maya as well as the Egyptians worked with this number, in view of the striking similarities.

Then of course you also have the Mayan super-number 1,366,560. Divide this number by 584:
1,366,560 ÷ 584 = 2,340

Before continuing, a few extra calculations are necessary:
260 ÷ 12 = 21.6666666666
260 ÷ 30 = 8.66666666666
21.6666666666 − 8.66666666666 = 13
260 ÷ 13 = 20.

The Maya said that the reversal of the magnetic field of the sun would happen after 20 Venus passages:
2,340 ÷ 20 = 117

A series consists of 117 sidereal passages of 584 days. That this is correct is shown in the following extra calculations:
30 − 12 = 18 (the Maya had 18 months of 20 days)
18 x 20 = 360 (one year in Egypt)
18 x 12 = 216 (the precession cycle of Atlantis)
1,366,560 ÷ 360 = 3,796

249

$584 \div 18 = 32.44444$

$3,796 \div 32.4444 = 11.7 \times 10 = 117$

Further proof is as follows:

$584 \div 360 = 1.622222$

$584 \div 365 = 1.6$

$1.622222 - 1.6 = 0.0222222$

$260 \div 0.0222222 = 11,700$

$11,700 \div 100 = 117$

Further connections between the Mayan numbers and the Egyptian numbers are:

$1,366,560 \div 360 = 3,796$ \quad $3,796 \div 260 = 14.6$ \quad $14.6 = 1,460$

In Egypt 1,460 was the sidereal time period of a Sothic year. Here, a connection with the Mayan super-number is clearly shown. Further, you know that the number 144 was important in Egypt.

$1,366,560 \div 144 = 9,490$ \quad $9,490 \div 260 = 36.5$ \quad $36.5 = 365$

More data is found in the following calculation:

$1,366,560 \div 72 = 18,980$ \quad $18,980 \div 365 = 52$

The number 52 stands for $260 \div 52 = 5$. Multiply this by 18,980 and you get:

$18,980 \times 5 = 94,900$

When multiplying this last number by 14.4 you get the Mayan super-number again (1,366,560).

A last proof goes as follows. Divide the super-number by the precession cycle.

$1,366,560 \div 25,920 = 52.72222222$

Now divide the higher number 18,980, which was a holy number for the Maya, by this calculated value and you get:

$18,980 \div 52,72222222 = 360$

$52.72222222 - 52 = 0.72222222$

$260 \div 0.72222222 = 360$

I believe that this is evidence enough that there exists a clear connection between the Maya and the Egyptians.

Mayan Sunspot Cycle Calculated from the Egyptian Zodiac

Previously, we found two "special" numbers: 5,184 could not be divided by them. They were 73 and 52. Multiply them by one another, and you get 73 x 52 = 3,796. That's a number you find also when calculating the Mayan super-number of the destruction. 3,796 x 360 = 1,366,560. Here one can clearly speak of a connection.

In his book *The Mayan Prophecies*, Cotterell states that a sunspot cycle equals 117 passages of Venus (117 x 584 = 68,328).

As found above, the number 52 is a special one. Based on this you can find the cycle of the sunspots. Multiply this number with 36 and 36.5 (which are the de facto equivalents of 360 and 365, respectively):

52 x 36 = 1,872
52 x 36.5 = 1,898

The number 1,872 stands for the shortest time of the zodiac. The longest is 2,592 years.

2,592 − 1,872 = 720.

Multiply 720 by 1,898 and you get: 1,898 x 720 = 1,366,560. This cycle is too large. You can prove this as follows:

360 x 72 = 25,920 = precession of the zodiac.
365 x 72 = 26,280 = too large.

Multiply this last number with 52 and you find the super long Mayan number. 26,280 x 52 = 1,366,560.

The number 73 can be calculated from the cycle which is too long: 26,280 ÷ 14.4 = 1,825 1,898 − 1,825 = 73.

You know that the precession of the zodiac takes 25,920 years. 26,820 points to a higher number than necessary. How much too high is something that can be calculated.

1,898 − 1,872 = 26 and
1,898 ÷ 73 = 26

This counts for the short cycle which equals 68,328 days. To recount to the super long count you have to multiply by 20.

26 x 20 = 520 days. The period indicating the reversal of the magnetic field of the sun is then the following: 1,366,560 − 520 = 1,366,040 days.

251

How beautiful everything is put together can be shown as follows: $1,898 - 1,872 = 26$.

A short cycle has exact 68,302 days.
This equals $68,328 - 26 = 68,302$ days.
The too long cycle can be calculated as follows:
$1,872 \times 36.5 = 68,328$
$1,898 \times 36 = 68,328$

Every 187 years the number of sunspots increases or diminishes. The Maya and the Egyptians knew this:
$68,302 \div 365.25 = 187$ years.

For their calculations they used "holy" numbers. Therefore you first have to step into their thinking pattern before you can break a code. That their calculation counts 26 days too many, can be found in various ways. Here are some of them:
$68,382 \div 26 = 2,628$

Subtract from this the first numbers we found.

$2,628 - 1,872 = 756$	$2,628 - 1,898 = 730$
$756 - 730 = 26$	$730 =$ holy number in Egypt.
$68,328 \div 365 = 187.2$	$187.2 \div 72 = 2.6$
$1,872 = 26 \times 72$	
$68,328 \div 144 = 474.5$	$2,628 \div 144 = 18.25$

Divide both numbers by each other and you find:
$474.5 \div 18.25 = 26$

One can get still further data from their "numbers game" as follows:
$18.25 \times 2 = 36.5$
$36.5 \times 5 = 182.5$
$182.5 \times 2 = 365$
$365 \times 5 = 1825$

And finally you return here for a moment to the zodiac.
The shortest and longest cycle are mathematically given as follows:

$36 \times 72 = 2,592$ \qquad $36 \times 52 = 1,872$ \qquad $72 - 52 = 20.$

Again this means that the short cycle has to be multiplied by

20 to calculate a reversal of the magnetism of the sun! If someone is still saying they weren't extraordinarily brilliant, he should have his head examined!

Measurements with the GPS II in Egypt

Dendera. Above the Zodiac. 25 March 1997
 N: 25°08′18″
 E: 32°40′22″
 LAT: 131°

Esna. At the Entrance of the Temple. 26 March 1997
 N: 25°17′24″
 E: 32°33′32″
 LAT: 132°

Hawara. In the Middle of the North-South Axis of the Pyramid.
2 April 1997
 N: 29°16′16″
 E: 30°54′05″
 LAT: 130°

Cheops. 31 March 1997
1) N: 29°58′39″
 E: 31°08′19″
 LAT: 129°

2) N: 29°58′31″
 E: 31°08′18″
 LAT: 129°

3) N: 29°58′30″
 E: 31°08′09″
 LAT: 129°

4) N: 29°58′37″
 E: 31°08′08″
 LAT: 129°

Chephren. 31 March 1997
1) N: 29°58′26″
 E: 31°08′05″
 LAT: 129°

2) N: 29°58'17"
 E: 31°08'05"
 LAT: 129°

3) N: 29°58'19"
 E: 31°07'57"
 LAT: 129°

4) N: 29°58'25"
 E: 31°07'58"
 LAT: 129°

Mycerinos. 31 March 1997
1) N: 29°58'22"
 E: 31°07'57"
 LAT: 129°

2) Not measured

3) N: 29°58'08"
 E: 31°07'50"
 LAT: 129°

4) N: 29°58'11"
 E: 31°07'51"
 LAT: 129°

More Secret Codes of the Zodiac of Atlantis

When enumerating the secret codes of the zodiac of Atlantis up to the present era, you obtain the following series of numbers:

Duration	Age	Cumulative Duration	
1,440	Leo	27,360	$27,360 \div 2,592 = 10.555555$
1,872	Cancer	29,232	$29,232 \div 2,592 = 11.2777777$
1,872	Gemini	31,104	$31,104 \div 2,592 = 12.0$
2,304	Taurus	33,408	$33,408 \div 2,592 = 12.888888$
2,304	Aries	35,712	$35,712 \div 2,592 = 13.777777$
2,016	Pisces	37,728	$37,728 \div 2,592 = 14.555555$

With the calculation of this last number, I stumbled upon a big question mark. The three following cataclysms took place in an

era which, divided by 2,592, gives us a series of numbers. In first the instance I had entered 2,012 in my pocket calculator, because the Age of Pisces started in the year before Christ. With this you arrive at the number 37,724 as the year. When dividing this by 2,592, I obtained 37,724 ÷ 2,592 = 14.554012.

Then I tried other numbers (such as 2,002, 2,004, and so on), but without any result. Only 2,016 gives a series of numbers! How is this connected to the date 2,012? There are three possibilities:

1) The code was a coincidence.
2) The code is no longer in line after such a long time.
3) The coming cataclysm is so big, that the code is warning us. Still more codes are connected to these numbers.

When calculating the same thing, but starting from each crash, you arrive at the following:

Duration	Age	Cumulative Duration	
1,440	Leo	1,440	1,440 ÷ 2,592 = 0.555555
2,592	Virgo	4,032	4,032 ÷ 2,592 = 1.555555
1,872	Libra	5,904	5,904 ÷ 2,592 = 2.2777777
1,872	Scorpio	7,776	7,776 ÷ 2,592 = 3.0
720	Sagittarius	8,496	8,496 ÷ 2,592 = 3.2777777
576	Aquarius	576	576 ÷ 2,592 = 0.222222
2,016	Pisces	2,592	2,592 ÷ 2,592 = 1
2,304	Aries	4,896	4,896 ÷ 2,592 = 1.888888
2,304	Taurus	7,200	7,200 ÷ 2,592 = 2.777777
1,872	Gemini	9,072	9,072 ÷ 2,592 = 3.5
1,872	Cancer	10,944	10,944 ÷ 2,592 = 4.222222
576	Leo	11,520	11,520 ÷ 2,592 = 4.444444
1,440	Leo	1,440	1,440 ÷ 2,592 = 0.555555
1,872	Cancer	3,312	3,312 ÷ 2,592 = 1.2777777
1,872	Gemini	5,184	5,184 ÷ 2,592 = 2.0
2,304	Taurus	7,488	7,488 ÷ 2,592 = 2.888888
2,304	Aries	9,792	9,792 ÷ 2,592 = 3.777777
2,012	Pisces	11,804	11,804 ÷ 2,592 = 4.5540123

Once again we notice that the expected date doesn't match the series of numbers. Will this be the largest catastrophe ever?

APPENDIX

Calculations from Chapter 6

There are two numbers describing the "creation" of Atlantis, 864 and 12. With these you can calculate several other numbers. If you continue using them in your calculations, you arrive at 25,920 years, the period of the entire zodiac. You have proven it before, but now you will do it differently, to learn to understand the Atlantean way of reasoning:

$$\frac{864}{12} = 72 \qquad \frac{72}{12} = 6$$

$$864 \times 12 = 10,368$$
$$864 \times 6 = 5,184 = 72 \times 72$$

With the above numbers you can find an important number for the completion of the zodiacal code:

$$\frac{10,368}{72} = 144$$

This number is found several times in the Egyptian buildings, as well as in later calculations.

144 equals 72 x 2 and 12 x 12. This number is special, and further calculations give us:

$$\frac{5,184}{144} = 36 \qquad \frac{36}{144} = 5$$

With this, you are at the end of our story: 10,368 x 0.25 = 2,592 = 1/10 cycle.

Now you have made a start in the Atlantean way of thinking. I have to admit, it took me months to understand this, so don't expect to get it just like that.

From the following you can comprehend that the cycle has a period of 25,920 years:

36 stands for 360 degrees (full zodiacal circle)

2,592 stands for 25,920 years = full cycle

The Correct Duration for the End of a Great Cycle

The following is yet another proof:

144 x 144 = 20,736
20,736 + 5,184 = 25,920

The Egyptians used a cycle of 25,920 years in their calculations. But the exact duration at the end is 25,776. You can be sure they knew this too. You can find it at the beginning of their era. This is as follows: 864 / 2,592 / 2,448 = cataclysms.

2,592 stands for a full zodiacal cycle = 25,920 years
2,448 = cycle of the cataclysm

When subtracting 2,448 from 2,592, you get 2,592 – 2,448 = 144 = 12 x 12. So, the square of twelve has something to do with the solution. That's why I decided to do the opposite, dividing by twelve:

$$\frac{2,592}{12} = 216 \qquad \frac{2,448}{12} = 204$$

(216 = code for precession cycle from Atlantis)

When subtracting these results, you get twelve again!
216 – 204 = 12

The zodiacal cycle for calculating the end is then the following: 25,920 – 144 = 25,776. Translation: to obtain a correct cycle, you have to subtract the difference between both numbers from the entire cycle. That this is correct is proven in further calculations. Heretofore, I used the number 72, which I had found previously. When dividing the two cycles by seventy-two, I obtained:

$$\frac{25,920}{72} = 360 \qquad \frac{25,776}{72} = 358$$

The difference gave me the number two: 360 – 358 = 2. Multiplying the quotients of these two divisions, you get: 358 x 360 = 128,880. Then I still had to do something with the number two. A short multiplication gave the result I was expecting!

128,880 x 2 = 257,760
257,760 ÷ 10 = 25,776

Calculations from Chapter 14

Imagine my amazement when I learned that there is a connection between the codes of Venus and the Sothic cycle from Egypt. These discoveries were hidden in the time between the cataclysm of 21,312 BC and 9792 BC. If you subtract them you'll find it is 11,520 years.

The number represented a language of symbolism that conveys events in the real world. It describes history, astronomy, etc., without the use of a dedicated language, for future peoples like ourselves. By adding or subtracting another 'holy number' they found other numbers that make further decoding possible.

Not surprisingly, the choice of the Sothic cycle has confounded scholars for more than three centuries. By studying the decoding, you will see how they developed an incredibly clever system of clues. What this shows is that the Egyptians did not wish the meaning of their cycles to be revealed, except to the researcher who understood the astronomical importance of the numbers 1,460-1,461 of the Sothic cycle of the star Sirius.

The correct length for a solar year is 365.2422 days, but the Maya estimated it at 365.242. This is only 17.28 seconds from the real value. As I have stated, they must have known a solar year is 365.2422 days! Their calculation falls only .08 seconds from the real value! A fault of 0.000000003%!

Conclusion: my starting point was that there is a connection between Venus and the time between the previous cataclysms. In my calculations I found similarities between the Sothic cycle of Egypt and the Venus cycle. I can prove this is unquestionably true through deduction. The time between the previous cataclysms is 11,520 years (21,312 -9,792 = 11,520).

Multiply by the days in a year: 11,520 x 365.25 = 4,207,680
11,520 x 365 = 4,204,800
11,520 x 360 = 4,147,200

Divide by the holy number 72 (in 21,312 BC the earth turned 72 degrees in the Zodiac!):
4,207,680 ÷ 72 = 58,440
4,204,800 ÷ 72 = 58,400
4,147,200 ÷ 72 = 57,600

584 = the synodical time of Venus

576 = Venus' number (see: Dresden Codex chapter). Venus disappears eight days after the sun (584 – 8 = 576).

58,440 – 58,400 = 40

58,440 ÷ 40 = 1,461 = Sothic cycle
58,400 ÷ 40 = 1,460 = Sothic cycle

A full circle is 360 degrees: 72 + 288 = 360. Divide by 288:
4,207,680 ÷ 288 = 14,610
4,204,800 ÷ 288 = 14,600
1,460 and 1,461 = Sothic cycle from Egypt!

In the Dresden Codex the Maya used 365 days:
11,520 x 365 = 4,204,800.

This is :
584 x 7,200 = 4,204,800
576 x 7,300 = 4,204,800

The Maya knew the right number for Venus: 583.92:
7,200 x 583.92 = 4,204,224.

Subtract this from the number found above:
4,204,800 – 4,204,224 = 576 = Venus' number

The Maya knew a year is 365.242 days but with this you can prove that they knew that a year is 365.2422 days!

11,520 x 365.242 = 4,207,587.84 and 11,520 x 365.2422 = 4,207,590.144

Subtract this from the number found above:
4,207,590.144 – 4,204,224 = 3366.144
4,207,587.84 – 4,204,224 = 3363.84 = Mayan number calculated from their year

The difference is:
3366.144 – 3363.84 = 2.304

Divide this:
3366.144 ÷ 2.304 = 1,461 = Sothic cycle
3363.84 ÷ 2.304 = 1,460 = Sothic cycle

You can prove that the decoding is right with the Mayan number:
3363.84 ÷ 576 = 584!

Using the same method, you can decode all the Mayan calendars!

Calculations from Chapter 16

Here is the proof of the connection between the sunspot cycle and the shifting of the zodiac. The number 72 is reworked in the precession: 72 x 360 = 25,920. After this, many questions were answered quickly. Soon I saw the connection with the number found in the cycle of the zodiac. When you subtract 72 from 2,664, you find the precession number, but ten times smaller: 2,664 -72 = 2,592. Until now I used two times 72 and only ones 360. I wondered if there was another connection, and there was.

Subtract the times of each other: 2,664 − 1,872 = 792. Since I found a ten times smaller precession cycle, I multiplied this number with 36: 792 x 36= 28,512. I know the tables of multiplication until 20 x 20, which helped to look at the code in another way. When you subtract the precession number from this number, you will find the previously-found smaller number: 28,512 − 25,920 = 2,592. This is one tenth of a cycle. Does this mean that the circles produce a cycle, which is ten percent too great? Indeed. Some research acknowledges this assumption. Every 68,302 days a sunspot goes through its cycle. In Chapter 15, we calculated the number of rotations of the magnetic fields using this. When we use the method of subtracting covered above, we find the following:
1,872 − 1,846 = 26
2,664 − 2,627 = 37

BIBLIOGRAPHY

Below is a selected bibliography. All data referred to can be found in these books. Because of the exceptional importance of this book, only the relevant books are mentioned, so readers and researchers won't waste time needlessly.

Bauval, Robert, and Graham Hancock, *Keeper of Genesis*, Heinemann, 1997

Berlitz, Charles, *Atlantis*, G.P. Putnam & Sons, New York, 1984

Cotterell, Maurice M., and Gilbert Adrian, *The Mayan Prophecies*, Element Books, 1995

Felix, W. Robert, *Not by Fire but by Ice*, Sugarhouse Publishing, 2000

Flem-Ath, Rand and Rose, *When the Sky Fell*, Weidenfeld, 1995

Hapgood, Charles, *Maps of the Ancient Sea Kings*, Adventures Unlimited Press, 1995

Hapgood, Charles, *The Path of the Pole*, Adventures Unlimited Press, 1999

Hancock, Graham, *Fingerprints of the Gods*, Heinemann, 1995

Hoffer, Frank, *Lost Americans*, New York, 1961

Moore, Patrick, *The Atlas of the Universe*, Mitchell Bearly Ltd, 1970

Morton Chris and Ceri Louise Thomas, *The Mystery of the Crystal Skulls*, Thorsons, 1979

Poechan, Andre, *L'Enigme de la Grande Pyramide*, Laffont, 1971

Sagan, Carl, *Cosmos*, Carl Sagan Productions, 1980

Slosman, Albert, *Le grand cataclysme*, Laffont,1976

Slosman, Albert, *Le livre de l'au-delà-de la vie*, Baudouin, 1979

West, John Anthony, *Serpent in the Sky*, Wildwood House, 1979

Wilson, Colin, *From Atlantis to the Sphinx*, Virgin, 1996

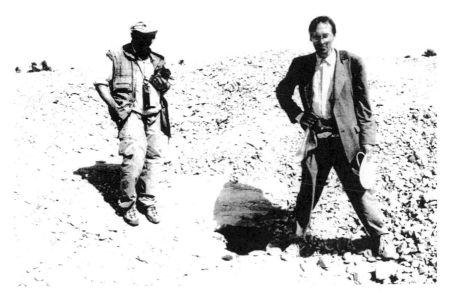

About the author:

Find Patrick Geryl's Web Pages
With updates about his latest research at:

http://www.awakening-spirit.com

Travel with your Author, Kim Wellens and others!

Step off the beaten track and explore together!

In the coming years, Patrick Geryl plans to make several exploration journeys to various parts of the world for research. People interested in participating in his work and journeys can explore this together with him!

In contrast to organized tours, these journeys won't be completely pre-set, but dates and places will vary according to the discoveries and insights acquired. The overall direction and area of the trip and the departure and return date will be confirmed in advance.

These tours may get adventurous at times, reaching places with no comfort available. Therefore, you'll need to be motivated to overcome possible physical hardships. Many places visited will have nothing in common with traditional tourist destinations, and some may not have much infrastructure at all.

The purpose of the tour will be to learn from each other's insights while exploring new sites. The number of participants will be limited to foster a close interaction between participants and the author. To join, you do not need any specialized degree, just a motivation to support and contribute. We will attempt to arrange a versatile mix of people with very diversified backgrounds to synergise your insights and learn more together than we would on our own.

More details of the conditions and the departure date of the next exploration journey can be found at:

http://www.awakening-spirit.com.

On the longer run, the acquired insights will be transformed into a more organized way of travel. Please find the information on the same website later on.

About the company:

My name is Kim Wellens, and I'm Belgian and 29 years old. I have extensive experience as a tour guide in Egypt, India, Sri Lanka, Nepal and South Africa, and beyond my professional knowledge of these countries, I also have a lot of personal travel experience elsewhere.

While Patrick Geryl will take care of the initial 'content' of the exploration tour, I'll organize the more practical aspects of the journey.

While doing the work of a tour guide, I felt a deeper dimension was lacking in group travel. It lacks real 'life,' or 'soul.' All the experiences that the participants acquire are strictly pre-arranged in a very tight schedule. There is little room for change or flexibility.

So my task will be to use my travel-expertise to first arrange for the practical needs of the group, such as getting safe meals and having a basic place to sleep, while leaving enough flexibility for the unexpected and for synchronicity to occur.

I wish to contribute too by allowing a more holistic way of connecting with the visited area, and to foster a deeper interaction between participants. As such, I hope to bring a more spiritual aspect into the tour.

My personal goal is to use the experience gained in the exploration tours to eventually broaden the scope of the journeys I organize toward themes of personal and spiritual growth, combined with the visiting of these ancient sacred sites. For that purpose, I'm also currently following training as a body-oriented therapist.

I hope to create journeys with you that will develop into life-transcending experiences!

NEW BOOKS

NEW BOOKS

THE A.T. FACTOR
Piece for a Jigsaw Part 3
by Leonard Cramp

British aerospace engineer Cramp began much of the scientific anti-gravity and UFO propulsion analysis back in 1955 with his landmark book *Space, Gravity & the Flying Saucer* (out-of-print and rare). His next books (available from Adventures Unlimited) *UFOs & Anti-Gravity: Piece for a Jig-Saw* and *The Cosmic Matrix: Piece for a Jig-Saw Part 2* began Cramp's in depth look into gravity control, free-energy, and the interlocking web of energy that pervades the universe. In this final book, Cramp brings to a close his detailed and controversial study of UFOs and anti-gravity.
324 PAGES. 6x9 PAPERBACK. ILLUSTRATED. BIBLIOGRAPHY. INDEX. $16.95. CODE: ATF

K2—QUEST OF THE GODS
by Ralph Ellis

This sequel to *Thoth, Architect of the Universe* explains the design of the Great Pyramid in great detail, and it appears that its architect specified a structure that contains a curious blend of technology, lateral thinking and childish fun—yet this design can also point out the exact location of the legendary 'Hall of Records' to within a few meters! The 'X' marks the spot location has been found at last. Join the author on the most ancient quest ever devised, a dramatic journey in the footsteps of Alexander the Great on his search for the legendary Hall of Records, then on to the highest peaks at the top of the world to find the 'The Great Pyramid in the Himalayas'; more.
280 PAGES. 6x9 PAPERBACK. ILLUSTRATED. COLOR SECTION. BIBLIOGRAPHY. $16.00. CODE: K2QD

TEMPEST & EXODUS
by Ralph Ellis

Starts with the dramatic discovery of a large biblical quotation on an ancient Egyptian stele which tells of a conference in Egypt discussing the way in which the biblical Exodus should be organized. The quotation thus has fundamental implications for both history and theology because it explains why the Tabernacle and the Ark of the Covenant were constructed, why the biblical Exodus started, where Mt. Sinai was located, and who the god of the Israelites was. The most dramatic discovery is that the central element of early Israelite liturgy was actually the Giza pyramids, and that Mt. Sinai was none other than the Great Pyramid. Mt. Sinai was described as being both sharp and the tallest 'mountain' in the area, and thus the Israelite god actually resided deep within the bowels of this pyramid. Furthermore, these new translations of ancient texts, both secular and biblical, also clearly demonstrate that the Giza pyramids are older than the first dynasty—the ancestors of the Hyksos were writing about the Giza pyramids long before they are supposed to have been constructed! Includes: Mt. Sinai, the Israelite name for the Great Pyramid of Egypt; the biblical Exodus inscribed on an Egyptian stele of Ahmose I; the secret name of God revealed; Noah's Ark discovered, more.
280 PAGES. 6x9 PAPERBACK. ILLUSTRATED. COLOR SECTION. BIBLIOGRAPHY & INDEX. $16.00. CODE: TEXO

THE WORLD'S SIXTEEN CRUCIFIED SAVIORS
Christianity Before Christ
by Kersey Graves, foreword by Acharya S.

A reprint of Kersey Graves' classic and rare 1875 book on Christianity before Christ, and the 16 messiahs or saviors who are known to history before Christ! Chapters on: Rival Claims of the Saviors; Messianic Prophecies; Prophecies by the Figure of a Serpent; Virgin Mothers and Virgin-Born Gods; Stars Point Out the Time and the Saviors' Birthplace; Sixteen Saviors Crucified; The Holy Ghost of Oriental Origin; Appollonius, Osiris, and Magus as Gods; 346 Striking Analogies Between Christ and Krishna; 25th of December as the birthday of the Gods; more. 45 chapters in all.
436 PAGES. 6x9 PAPERBACK. ILUSTRATED. $19.95. CODE: WSCS

SAUNIER'S MODEL AND THE SECRET OF RENNES-LE-CHATEAU
The Priest's Final Legacy
by André Douzet

Berenger Saunière, the enigmatic priest of the French village of Rennes-le-Château, is rumored to have found the legendary treasure of the Cathars. But what became of it? In 1916, Sauniere created his ultimate clue: he went to great expense to create a model of a region said to be the Calvary Mount, indicating the "Tomb of Jesus." But the region on the model does not resemble the region of Jerusalem. Did Saunière leave a clue as to the true location of his treasure? And what is that treasure? After years of research, André Douzet discovered this model—the only real clue Saunière left behind as to the nature and location of his treasure—and the possible tomb of Jesus.
116 PAGES. 6x9 PAPERBACK. ILLUSTRATED. BIBLIOGRAPHY. $12.00. CODE: SMOD

TIME AND THE BIBLE'S NUMBER CODE
An Exciting Confirmation of God's Time-Line
by Bonnie Gaunt

Bonnie Gaunt's latest research confirms the authenticy of the Bible's Number Code (Gematria) in this latest book of all new material. Gaunt delves into the fascinating patterns of time and numbers that reveal, she says, the master plan of the "Great Mathematician" to create the Kingdom of God on Earth. Confirming the time-line using the Number Code and the beautiful Golden Proportion is the exciting theme of this book. Chapters include: Finding a New Method; Why 6,000 Years?; The Year 1999 and 5760; The Pilgrim Festivals; Confirmation of Time Blocks; Jubilees—a Countdown; "Seven Times" (The Amazing Golden Proportion); Putting It All Together; more.
200 PAGES. 5x8 PAPERBACK. ILLUSTRATED. APPENDIX. $14.95. CODE: TBNC

A HITCHHIKER'S GUIDE TO ARMAGEDDON
by David Hatcher Childress

With wit and humor, popular Lost Cities author David Hatcher Childress takes us around the world and back in his trippy finalé to the Lost Cities series. He's off on an adventure in search of the apocalypse and end times. Childress hits the road from the fortress of Megiddo, the legendary citadel in northern Israel where Armageddon is prophesied to start. Hitchhiking around the world, Childress takes us from one adventure to another, to ancient cities in the deserts and the legends of worlds before our own. Childress muses on the rise and fall of civilizations, and the forces that have shaped mankind over the millennia, including wars, invasions and cataclysms. He discusses the ancient Armageddons of the past, and chronicles recent Middle East developments and their ominous undertones. In the meantime, he becomes a cargo cult god on a remote island off New Guinea, gets dragged into the Kennedy Assassination by one of the "conspirators," investigates a strange power operating out of the Altai Mountains of Mongolia, and discovers how the Knights Templar and their off-shoots have driven the world toward an epic battle centered around Jerusalem and the Middle East.
320 PAGES. 6x9 PAPERBACK. ILLUSTRATED. BIBLIOGRAPHY. INDEX. $16.95. CODE: HGA

ATLANTIS STUDIES

TECHNOLOGY OF THE GODS
The Incredible Sciences of the Ancients
by David Hatcher Childress

Popular *Lost Cities* author David Hatcher Childress takes us into the amazing world of ancient technology, from computers in antiquity to the "flying machines of the gods." Childress looks at the technology that was allegedly used in Atlantis and the theory that the Great Pyramid of Egypt was originally a gigantic power station. He examines tales of ancient flight and the technology that it involved; how the ancients used electricity; megalithic building techniques; the use of crystal lenses and the fire from the gods; evidence of various high tech weapons in the past, including atomic weapons; ancient metallurgy and heavy machinery; the role of modern inventors such as Nikola Tesla in bringing ancient technology back into modern use; impossible artifacts; and more.

356 PAGES. 6x9 PAPERBACK. ILLUSTRATED. BIBLIOGRAPHY. $16.95. CODE: TGOD

VIMANA AIRCRAFT OF ANCIENT INDIA & ATLANTIS
by David Hatcher Childress, introduction by Ivan T. Sanderson

Did the ancients have the technology of flight? In this incredible volume on ancient India, authentic Indian texts such as the *Ramayana* and the *Mahabharata* are used to prove that ancient aircraft were in use more than four thousand years ago. Included in this book is the entire Fourth Century BC manuscript *Vimaanika Shastra* by the ancient author Maharishi Bharadwaaja, translated into English by the Mysore Sanskrit professor G.R. Josyer. Also included are chapters on Atlantean technology, the incredible Rama Empire of India and the devastating wars that destroyed it. Also an entire chapter on mercury vortex propulsion and mercury gyros, the power source described in the ancient Indian texts. Not to be missed by those interested in ancient civilizations or the UFO enigma.

334 PAGES. 6x9 PAPERBACK. ILLUSTRATED. $15.95. CODE: VAA

LOST CONTINENTS & THE HOLLOW EARTH
I Remember Lemuria and the Shaver Mystery
by David Hatcher Childress & Richard Shaver

Lost Continents & the Hollow Earth is Childress' thorough examination of the early hollow earth stories of Richard Shaver and the fascination that fringe fantasy subjects such as lost continents and the hollow earth have had for the American public. Shaver's rare 1948 book *I Remember Lemuria* is reprinted in its entirety, and the book is packed with illustrations from Ray Palmer's *Amazing Stories* magazine of the 1940s. Palmer and Shaver told of tunnels running through the earth—tunnels inhabited by the Deros and Teros, humanoids from an ancient spacefaring race that had inhabited the earth, eventually going underground, hundreds of thousands of years ago. Childress discusses the famous hollow earth books and delves deep into whatever reality may be behind the stories of tunnels in the earth. Operation High Jump to Antarctica in 1947 and Admiral Byrd's bizarre statements, tunnel systems in South America and Tibet, the underground world of Agartha, the belief of UFOs coming from the South Pole, more.

344 PAGES. 6x9 PAPERBACK. ILLUSTRATED. $16.95. CODE: LCHE

LOST CITIES OF NORTH & CENTRAL AMERICA
by David Hatcher Childress

Down the back roads from coast to coast, maverick archaeologist and adventurer David Hatcher Childress goes deep into unknown America. With this incredible book, you will search for lost Mayan cities and books of gold, discover an ancient canal system in Arizona, climb gigantic pyramids in the Midwest, explore megalithic monuments in New England, and join the astonishing quest for lost cities throughout North America. From the war-torn jungles of Guatemala, Nicaragua and Honduras to the deserts, mountains and fields of Mexico, Canada, and the U.S.A., Childress takes the reader in search of sunken ruins, Viking forts, strange tunnel systems, living dinosaurs, early Chinese explorers, and fantastic lost treasure. Packed with both early and current maps, photos and illustrations.

590 PAGES. 6x9 PAPERBACK. ILLUSTRATED. FOOTNOTES & BIBLIOGRAPHY. $16.95. CODE: NCA

LOST CITIES & ANCIENT MYSTERIES OF SOUTH AMERICA
by David Hatcher Childress

Rogue adventurer and maverick archaeologist David Hatcher Childress takes the reader on unforgettable journeys deep into deadly jungles, high up on windswept mountains and across scorching deserts in search of lost civilizations and ancient mysteries. Travel with David and explore stone cities high in mountain forests and hear fantastic tales of Inca treasure, living dinosaurs, and a mysterious tunnel system. Whether he is hopping freight trains, searching for secret cities, or just dealing with the daily problems of food, money, and romance, the author keeps the reader spellbound. Includes both early and current maps, photos, and illustrations, and plenty of advice for the explorer planning his or her own journey of discovery.

381 PAGES. 6x9 PAPERBACK. ILLUSTRATED. FOOTNOTES. BIBLIOGRAPHY. $14.95. CODE: SAM

LOST CITIES & ANCIENT MYSTERIES OF AFRICA & ARABIA
by David Hatcher Childress

Across ancient deserts, dusty plains and steaming jungles, maverick archaeologist David Childress continues his world-wide quest for lost cities and ancient mysteries. Join him as he discovers forbidden cities in the Empty Quarter of Arabia; "Atlantean" ruins in Egypt and the Kalahari desert; a mysterious, ancient empire in the Sahara; and more. This is the tale of an extraordinary life on the road: across war-torn countries, Childress searches for King Solomon's Mines, living dinosaurs, the Ark of the Covenant and the solutions to some of the fantastic mysteries of the past.

423 PAGES. 6x9 PAPERBACK. ILLUSTRATED. FOOTNOTES & BIBLIOGRAPHY. $14.95. CODE: AFA

24 hour credit card orders—call: 815-253-6390 fax: 815-253-6300

email: auphq@frontiernet.net www.adventuresunlimitedpress.com www.wexclub.com

LOST CITIES

LOST CITIES OF ATLANTIS, ANCIENT EUROPE & THE MEDITERRANEAN
by David Hatcher Childress
Atlantis! The legendary lost continent comes under the close scrutiny of maverick archaeologist David Hatcher Childress in this sixth book in the internationally popular *Lost Cities* series. Childress takes the reader in search of sunken cities in the Mediterranean; across the Atlas Mountains in search of Atlantean ruins; to remote islands in search of megalithic ruins; to meet living legends and secret societies. From Ireland to Turkey, Morocco to Eastern Europe, and around the remote islands of the Mediterranean and Atlantic, Childress takes the reader on an astonishing quest for mankind's past. Ancient technology, cataclysms, megalithic construction, lost civilizations and devastating wars of the past are all explored in this book. Childress challenges the skeptics and proves that great civilizations not only existed in the past, but the modern world and its problems are reflections of the ancient world of Atlantis.
524 PAGES. 6X9 PAPERBACK. ILLUSTRATED WITH 100S OF MAPS, PHOTOS AND DIAGRAMS. BIBLIOGRAPHY & INDEX. $16.95. CODE: MED

LOST CITIES OF CHINA, CENTRAL INDIA & ASIA
by David Hatcher Childress
Like a real life "Indiana Jones," maverick archaeologist David Childress takes the reader on an incredible adventure across some of the world's oldest and most remote countries in search of lost cities and ancient mysteries. Discover ancient cities in the Gobi Desert; hear fantastic tales of lost continents, vanished civilizations and secret societies bent on ruling the world; visit forgotten monasteries in forbidding snow-capped mountains with strange tunnels to mysterious subterranean cities! A unique combination of far-out exploration and practical travel advice, it will astound and delight the experienced traveler or the armchair voyager.
429 PAGES. 6X9 PAPERBACK. ILLUSTRATED. FOOTNOTES & BIBLIOGRAPHY. $14.95. CODE: CHI

LOST CITIES OF ANCIENT LEMURIA & THE PACIFIC
by David Hatcher Childress
Was there once a continent in the Pacific? Called Lemuria or Pacifica by geologists, Mu or Pan by the mystics, there is now ample mythological, geological and archaeological evidence to "prove" that an advanced and ancient civilization once lived in the central Pacific. Maverick archaeologist and explorer David Hatcher Childress combs the Indian Ocean, Australia and the Pacific in search of the surprising truth about mankind's past. Contains photos of the underwater city on Pohnpei; explanations on how the statues were levitated around Easter Island in a clockwise vortex movement; tales of disappearing islands; Egyptians in Australia; and more.
379 PAGES. 6X9 PAPERBACK. ILLUSTRATED. FOOTNOTES & BIBLIOGRAPHY. $14.95. CODE: LEM

ANCIENT TONGA
& the Lost City of Mu'a
by David Hatcher Childress
Lost Cities series author Childress takes us to the south sea islands of Tonga, Rarotonga, Samoa and Fiji to investigate the megalithic ruins on these beautiful islands. The great empire of the Polynesians, centered on Tonga and the ancient city of Mu'a, is revealed with old photos, drawings and maps. Chapters in this book are on the Lost City of Mu'a and its many megalithic pyramids, the Ha'amonga Trilithon and ancient Polynesian astronomy, Samoa and the search for the lost land of Havai'iki, Fiji and its wars with Tonga, Rarotonga's megalithic road, and Polynesian cosmology. Material on Egyptians in the Pacific, earth changes, the fortified moat around Mu'a, lost roads, more.
218 PAGES. 6X9 PAPERBACK. ILLUSTRATED. COLOR PHOTOS. BIBLIOGRAPHY. $15.95. CODE: TONG

ANCIENT MICRONESIA
& the Lost City of Nan Madol
by David Hatcher Childress
Micronesia, a vast archipelago of islands west of Hawaii and south of Japan, contains some of the most amazing megalithic ruins in the world. Part of our *Lost Cities* series, this volume explores the incredible conformations on various Micronesian islands, especially the fantastic and little-known ruins of Nan Madol on Pohnpei Island. The huge canal city of Nan Madol contains over 250 million tons of basalt columns over an 11 square-mile area of artificial islands. Much of the huge city is submerged, and underwater structures can be found to an estimated 80 feet. Islanders' legends claim that the basalt rocks, weighing up to 50 tons, were magically levitated into place by the powerful forefathers. Other ruins in Micronesia that are profiled include the Latte Stones of the Marianas, the menhirs of Palau, the megalithic canal city on Kosrae Island, megaliths on Guam, and more.
256 PAGES. 6X9 PAPERBACK. ILLUSTRATED. COLOR PHOTOS. BIBLIOGRAPHY. $16.95. CODE: AMIC

24 hour credit card orders—call: 815-253-6390 fax: 815-253-6300
email: auphq@frontiernet.net www.adventuresunlimitedpress.com www.wexclub.com

FREE ENERGY SYSTEMS

LOST SCIENCE
by Gerry Vassilatos

Rediscover the legendary names of suppressed scientific revolution—remarkable lives, astounding discoveries, and incredible inventions which would have produced a world of wonder. How did the aura research of Baron Karl von Reichenbach prove the vitalistic theory and frighten the greatest minds of Germany? How did the physiophone and wireless of Antonio Meucci predate both Bell and Marconi by decades? How does the earth battery technology of Nathan Stubblefield portend an unsuspected energy revolution? How did the geoaetheric engines of Nikola Tesla threaten the establishment of a fuel-dependent America? The microscopes and virus-destroying ray machines of Dr. Royal Rife provided the solution for every world-threatening disease. Why did the FDA and AMA together condemn this great man to Federal Prison? The static crashes on telephone lines enabled Dr. T. Henry Moray to discover the reality of radiant space energy. Was the mysterious "Swedish stone," the powerful mineral which Dr. Moray discovered, the very first historical instance in which stellar power was recognized and secured on earth? Why did the Air Force initially fund the gravitational warp research and warp-cloaking devices of T. Townsend Brown and then reject it? When the controlled fusion devices of Philo Farnsworth achieved the "break-even" point in 1967 the FUSOR project was abruptly cancelled by ITT.
304 PAGES. 6x9 PAPERBACK. ILLUSTRATED. BIBLIOGRAPHY. $16.95. CODE: LOS

SECRETS OF COLD WAR TECHNOLOGY
Project HAARP and Beyond
by Gerry Vassilatos

Vassilatos reveals that "Death Ray" technology has been secretly researched and developed since the turn of the century. Included are chapters on such inventors and their devices as H.C. Vion, the developer of auroral energy receivers; Dr. Selim Lemstrom's pre-Tesla experiments; the early beam weapons of Grindell-Mathews, Ulivi, Turpain and others; John Hettenger and his early beam power systems. Learn about Project Argus, Project Teak and Project Orange; EMP experiments in the 60s; why the Air Force directed the construction of a huge Ionospheric "backscatter" telemetry system across the Pacific just after WWII; why Raytheon has collected every patent relevant to HAARP over the past few years; more.
250 PAGES. 6x9 PAPERBACK. ILLUSTRATED. $15.95. CODE: SCWT

THE TIME TRAVEL HANDBOOK
A Manual of Practical Teleportation & Time Travel
edited by David Hatcher Childress

In the tradition of *The Anti-Gravity Handbook* and *The Free-Energy Device Handbook*, science and UFO author David Hatcher Childress takes us into the weird world of time travel and teleportation. Not just a whacked-out look at science fiction, this book is an authoritative chronicling of real-life time travel experiments, teleportation devices and more. *The Time Travel Handbook* takes the reader beyond the government experiments and deep into the uncharted territory of early time travellers such as Nikola Tesla and Guglielmo Marconi and their alleged time travel experiments, as well as the Wilson Brothers of EMI and their connection to the Philadelphia Experiment—the U.S. Navy's forays into invisibility, time travel, and teleportation. Childress looks into the claims of time travelling individuals, and investigates the unusual claim that the pyramids on Mars were built in the future and sent back in time. A highly visual, large format book, with patents, photos and schematics. Be the first on your block to build your own time travel device!
316 PAGES. 7x10 PAPERBACK. ILLUSTRATED. $16.95. CODE: TTH

THE TESLA PAPERS
Nikola Tesla on Free Energy & Wireless Transmission of Power
by Nikola Tesla, edited by David Hatcher Childress

David Hatcher Childress takes us into the incredible world of Nikola Tesla and his amazing inventions. Tesla's rare article "The Problem of Increasing Human Energy with Special Reference to the Harnessing of the Sun's Energy" is included. This lengthy article was originally published in the June 1900 issue of *The Century Illustrated Monthly Magazine* and it was the outline for Tesla's master blueprint for the world. Tesla's fantastic vision of the future, including wireless power, anti-gravity, free energy and highly advanced solar power. Also included are some of the papers, patents and material collected on Tesla at the Colorado Springs Tesla Symposiums, including papers on: •The Secret History of Wireless Transmission •Tesla and the Magnifying Transmitter •Design and Construction of a Half-Wave Tesla Coil •Electrostatics: A Key to Free Energy •Progress in Zero-Point Energy Research •Electromagnetic Energy from Antennas to Atoms •Tesla's Particle Beam Technology •Fundamental Excitatory Modes of the Earth-Ionosphere Cavity
325 PAGES. 8x10 PAPERBACK. ILLUSTRATED. $16.95. CODE: TTP

THE FANTASTIC INVENTIONS OF NIKOLA TESLA
by Nikola Tesla with additional material by David Hatcher Childress

This book is a readable compendium of patents, diagrams, photos and explanations of the many incredible inventions of the originator of the modern era of electrification. In Tesla's own words are such topics as wireless transmission of power, death rays, and radio-controlled airships. In addition, rare material on German bases in Antarctica and South America, and a secret city built at a remote jungle site in South America by one of Tesla's students, Guglielmo Marconi. Marconi's secret group claims to have built flying saucers in the 1940s and to have gone to Mars in the early 1950s! Incredible photos of these Tesla craft are included. The Ancient Atlantean system of broadcasting energy through a grid system of obelisks and pyramids is discussed, and a fascinating concept comes out of one chapter: that Egyptian engineers had to wear protective metal head-shields while in these power plants, hence the Egyptian Pharoah's head covering as well as the Face on Mars! •His plan to transmit free electricity into the atmosphere. •How electrical devices would work using only small antennas. •Why unlimited power could be utilized anywhere on earth. •How radio and radar technology can be used as death-ray weapons in Star Wars.
342 PAGES. 6x9 PAPERBACK. ILLUSTRATED. $16.95. CODE: FINT

24 hour credit card orders—call: 815-253-6390 fax: 815-253-6300
email: auphq@frontiernet.net www.adventuresunlimitedpress.com www.wexclub.com

THE FREE-ENERGY DEVICE HANDBOOK
A Compilation of Patents and Reports
by David Hatcher Childress

A large-format compilation of various patents, papers, descriptions and diagrams concerning free-energy devices and systems. *The Free-Energy Device Handbook* is a visual tool for experimenters and researchers into magnetic motors and other "over-unity" devices. With chapters on the Adams Motor, the Hans Coler Generator, cold fusion, superconductors, "N" machines, space-energy generators, Nikola Tesla, T. Townsend Brown, and the latest in free-energy devices. Packed with photos, technical diagrams, patents and fascinating information, this book belongs on every science shelf. With energy and profit being a major political reason for fighting various wars, free-energy devices, if ever allowed to be mass distributed to consumers, could change the world! Get your copy now before the Department of Energy bans this book!
292 PAGES. 8X10 PAPERBACK. ILLUSTRATED. BIBLIOGRAPHY. $16.95. CODE: FEH

THE ANTI-GRAVITY HANDBOOK
edited by David Hatcher Childress, with Nikola Tesla, T.B. Paulicki, Bruce Cathie, Albert Einstein and others

The new expanded compilation of material on Anti-Gravity, Free Energy, Flying Saucer Propulsion, UFOs, Suppressed Technology, NASA Cover-ups and more. Highly illustrated with patents, technical illustrations and photos. This revised and expanded edition has more material, including photos of Area 51, Nevada, the government's secret testing facility. This classic on weird science is back in a 90s format!
• **How to build a flying saucer.**
•**Arthur C. Clarke on Anti-Gravity.**
• **Crystals and their role in levitation.**
• **Secret government research and development.**
• **Nikola Tesla on how anti-gravity airships could
 draw power from the atmosphere.**
• **Bruce Cathie's Anti-Gravity Equation.**
• **NASA, the Moon and Anti-Gravity.**
230 PAGES. 7X10 PAPERBACK. BIBLIOGRAPHY/INDEX/APPENDIX. HIGHLY ILLUSTRATED. $14.95. CODE: AGH

ANTI-GRAVITY & THE WORLD GRID

Is the earth surrounded by an intricate electromagnetic grid network offering free energy? This compilation of material on ley lines and world power points contains chapters on the geography, mathematics, and light harmonics of the earth grid. Learn the purpose of ley lines and ancient megalithic structures located on the grid. Discover how the grid made the Philadelphia Experiment possible. Explore the Coral Castle and many other mysteries, including acoustic levitation, Tesla Shields and scalar wave weaponry. Browse through the section on anti-gravity patents, and research resources.
274 PAGES. 7X10 PAPERBACK. ILLUSTRATED. $14.95. CODE: AGW

ANTI-GRAVITY & THE UNIFIED FIELD
edited by David Hatcher Childress

Is Einstein's Unified Field Theory the answer to all of our energy problems? Explored in this compilation of material is how gravity, electricity and magnetism manifest from a unified field around us. Why artificial gravity is possible; secrets of UFO propulsion; free energy; Nikola Tesla and anti-gravity airships of the 20s and 30s; flying saucers as superconducting whirls of plasma; anti-mass generators; vortex propulsion; suppressed technology; government cover-ups; gravitational pulse drive; spacecraft & more.
240 PAGES. 7X10 PAPERBACK. ILLUSTRATED. $14.95. CODE: AGU

ETHER TECHNOLOGY
A Rational Approach to Gravity Control
by Rho Sigma

This classic book on anti-gravity and free energy is back in print and back in stock. Written by a well-known American scientist under the pseudonym of "Rho Sigma," this book delves into international efforts at gravity control and discoid craft propulsion. Before the Quantum Field, there was "Ether." This small, but informative book has chapters on John Searle and "Searle discs;" T. Townsend Brown and his work on anti-gravity and ether-vortex turbines. Includes a forward by former NASA astronaut Edgar Mitchell.
108 PAGES. 6X9 PAPERBACK. ILLUSTRATED. $12.95. CODE: ETT

TAPPING THE ZERO POINT ENERGY
Free Energy & Anti-Gravity in Today's Physics
by Moray B. King

King explains how free energy and anti-gravity are possible. The theories of the zero point energy maintain there are tremendous fluctuations of electrical field energy imbedded within the fabric of space. This book tells how, in the 1930s, inventor T. Henry Moray could produce a fifty kilowatt "free energy" machine; how an electrified plasma vortex creates anti-gravity; how the Pons/Fleischmann "cold fusion" experiment could produce tremendous heat without fusion; and how certain experiments might produce a gravitational anomaly.
170 PAGES. 5x8 PAPERBACK. ILLUSTRATED. $9.95. CODE: TAP

24 hour credit card orders—call: 815-253-6390 fax: 815-253-6300

email: auphq@frontiernet.net www.adventuresunlimitedpress.com www.wexclub.com

One Adventure Place
P.O. Box 74
Kempton, Illinois 60946
United States of America
Tel.: 815-253-6390 • Fax: 815-253-6300
Email: auphq@frontiernet.net
http://www.adventuresunlimitedpress.com
or www.wexclub.com/aup

ORDERING INSTRUCTIONS

✓ Remit by USD$ Check, Money Order or Credit Card
✓ Visa, Master Card, Discover & AmEx Accepted
✓ Prices May Change Without Notice
✓ 10% Discount for 3 or more Items

SHIPPING CHARGES

United States

✓ Postal Book Rate { $3.00 First Item
50¢ Each Additional Item
✓ Priority Mail { $4.00 First Item
$2.00 Each Additional Item
✓ UPS { $5.00 First Item
$1.50 Each Additional Item
NOTE: UPS Delivery Available to Mainland USA Only

Canada

✓ Postal Book Rate { $6.00 First Item
$2.00 Each Additional Item
✓ Postal Air Mail { $8.00 First Item
$2.50 Each Additional Item
✓ Personal Checks or Bank Drafts MUST BE
USD$ and Drawn on a US Bank
✓ Canadian Postal Money Orders OK
✓ Payment MUST BE USD$

All Other Countries

✓ Surface Delivery { $10.00 First Item
$4.00 Each Additional Item
✓ Postal Air Mail { $14.00 First Item
$5.00 Each Additional Item
✓ Payment MUST BE USD$
✓ Checks and Money Orders MUST BE USD$
and Drawn on a US Bank or branch.
✓ Add $5.00 for Air Mail Subscription to
Future Adventures Unlimited Catalogs

SPECIAL NOTES

✓ RETAILERS: Standard Discounts Available
✓ BACKORDERS: We Backorder all Out-of-
Stock Items Unless Otherwise Requested
✓ PRO FORMA INVOICES: Available on Request
✓ VIDEOS: NTSC Mode Only. Replacement only.
✓ For PAL mode videos contact our other offices:

European Office:
Adventures Unlimited, Panewaal 22,
Enkhuizen, 1600 AA, The Netherlands
http: www.adventuresunlimited.nl
Check Us Out Online at:
www.adventuresunlimitedpress.com

Please check: ☑

☐ This is my first order ☐ I have ordered before ☐ This is a new address

Name					
Address					
City					
State/Province			Postal Code		
Country					
Phone day		Evening			
Fax					

Item Code	Item Description	Price	Qty	Total

Please check: ☑

☐ Postal-Surface
☐ Postal-Air Mail
 (Priority in USA)
☐ UPS
 (Mainland USA only)

Subtotal ➡	
Less Discount-10% for 3 or more items ➡	
Balance ➡	
Illinois Residents 6.25% Sales Tax ➡	
Previous Credit ➡	
Shipping ➡	
Total (check/MO in USD$ only)➡	

☐ Visa/MasterCard/Discover/Amex

Card Number

Expiration Date

10% Discount When You Order 3 or More Items!

Comments & Suggestions	Share Our Catalog with a Friend